The Art of
MOSAICS

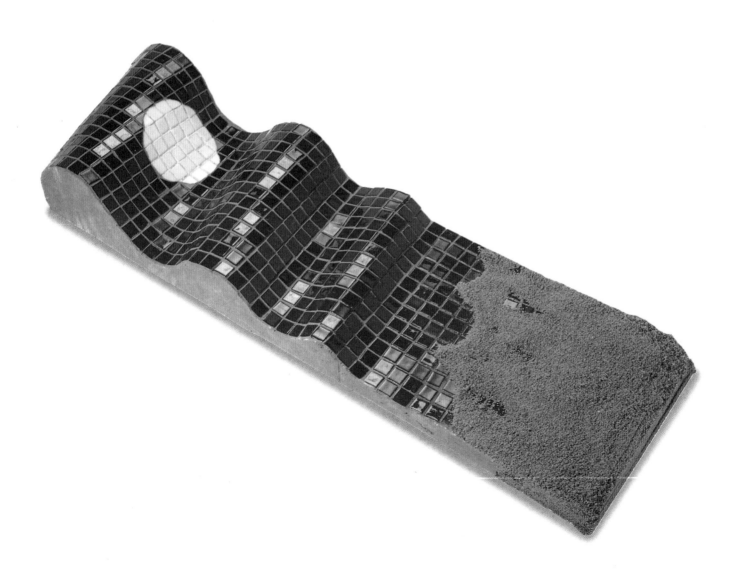

Watson-Guptill Publications/New York

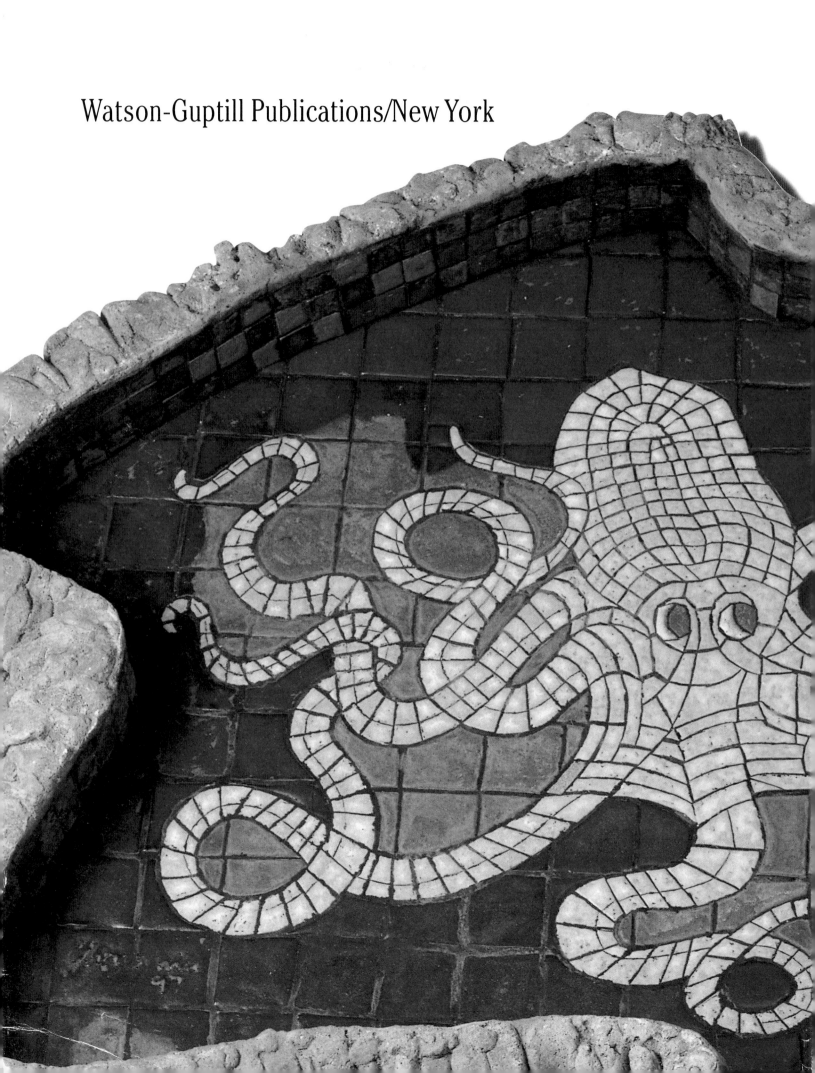

The Art of
MOSAICS

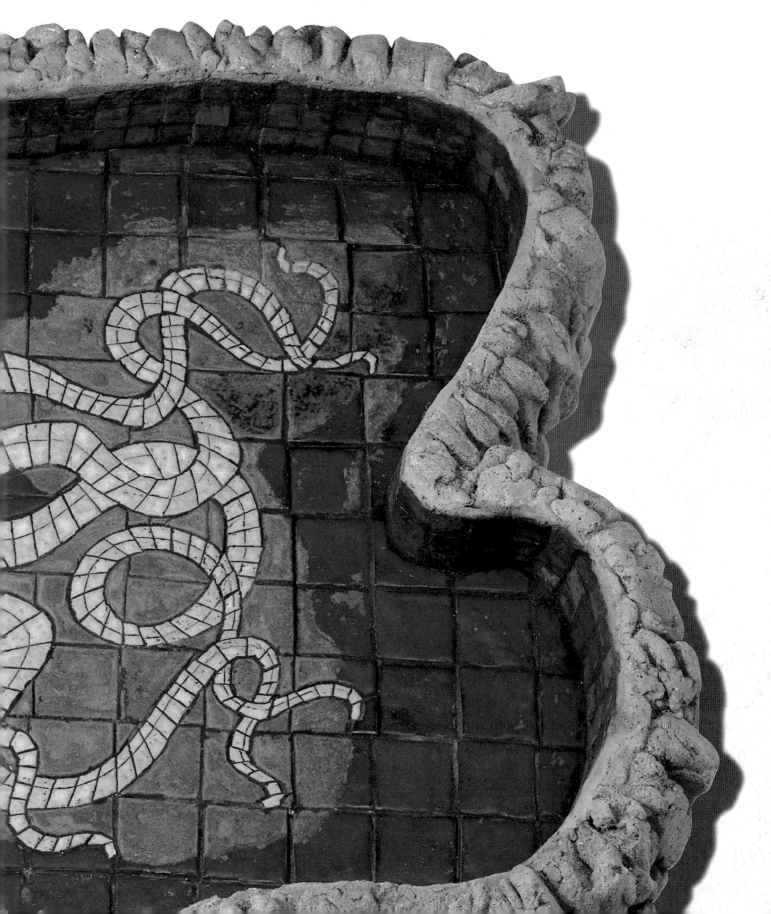

The Art of Mosaics

Editorial Director: María Fernanda Canal

Text: Joaquim Chavarria

Exercises: Joaquim Chavarria

Design: Josep Guasch

Photographs: Nos & Soto
Illustrations: Jordi Segú
Documentation: M. Carmen Ramos

First Published in the United States
by Watson-Guptill Publications
a division of BPI Communications, Inc.
1515 Broadway, New York, N.Y. 10036

Editor, English Language Edition: Amy Handy

Copyright © Parramón Ediciones, S.A.

Produced by Parramón Ediciones, S.A.
Gran Via de Les Corts Catalanes, 322-324
08004 Barcelona, Spain

Production: Rafael Marfil

ISBN 0-8230-5864-6
Library of Congress Catalog Card Number
1 2 3 4 5 6 7 8 9/07 06 05 04 03 02 01 00 99

Contents

INTRODUCTION

The purpose of this manual on mosaic techniques is to offer different ways of making mosaics. I have not attempted to reproduce "Roman" or "Byzantine" mosaics or those of other ages, though this does not mean we should entirely forget how those mosaicists worked. The basic method of mosaic making has remained unchanged and is based on laying stone or glass paste tesserae onto a given base, either a floor or wall, or as a cladding for a sculpture or other object. The best way of learning about this subject is to journey briefly through history, taking a quick look at mosaic making from ancient times to the present century.

The book then explains the available materials, from the hardest such as a granite, to glass paste, ceramics, and semiprecious stones. Readers may choose to utilize only traditional materials, or they may discover others that better suit their specific aims and artistic criteria.

From pebbles to slabs of marble, granite to slate, glass pastes to ceramic tiles, all require the appropriate tools. In addition to our most basic tools—our hands—we will need certain implements, either manual or powered, since the very nature of creating mosaics requires that hard materials be broken up into small pieces.

The mosaic-making process is explained in a simple, readily understandable fashion. I love to find solutions for things, whether simple or complicated. The initial idea that will form the basis for a work requires a preliminary study, and it is here we will find the solutions. My fondness for solving problems is partly due to the questions raised by my students, to whom I am grateful for the experience of being able to teach them, and I hope my experience has been equally useful to them.

Although in theory mosaics appear so easy that it seems anyone can make them, in practice mosaics require careful preparation, using sketches, drawings, and projects, studies of the materials suitable for each kind of

mosaic, and the proper technique for laying each type.

Mosaics are made "tessera by tessera," and this is the way we will approach our mosaics: step by step. The book's final section proposes a series of works using different methods and materials for making the tesserae themselves, and different supports, glues, mortars, and frames.

Beginners will find here the necessary guidance to delve into this centuries-old art, which requires a certain practice period to hone one's skills. Professionals will find other, rather less orthodox methods that will help to broaden their experience and help them in their work. Everything included here is the result of years of study and work, not only as a professional mosaicist but also as a teacher.

The learning of an art should never be considered a race to the finish, and mosaics are no exception. All mosaic work is slow, from the preparation of the tesserae to laying them. The patience and calm nature of an angler is necessary, in addition to large amounts of imagination. Like our "colleagues" of old, we are privileged to be able to create our own imaginary world.

Finally, I should like to express my gratitude and acknowledgment to my old teacher and later companion Antoni Domingo (History of Art) and my fondest memories of Pau Macià (Mosaics) and Josep Brunet (Drawing).

Dedicated to my daughters, Mònica, Marta, and Mireia

Joaquim-Manuel Chavarria Climent

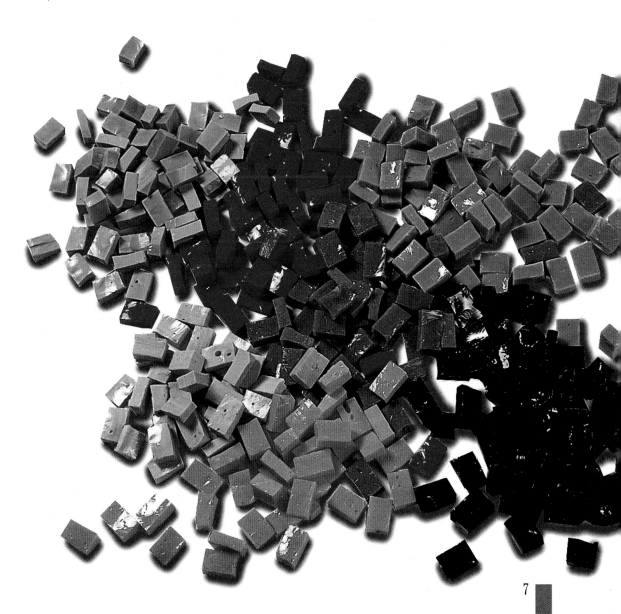

HISTORY

To give a thorough account of the history of the art of mosaics is far beyond the scope of this book. The aim here is a simpler one: to skim through the different periods and cultures that have formed part of the history of mosaics.

Unlike other, more universal arts such as painting and sculpture, mosaics have a geographical territory limited to Europe, North Africa, and the Near East, and it is here that they have flourished. Although the pre-Columbian cultures had interesting examples of this art, they used it solely for covering ritual religious objects, for domestic purposes, and for funerary masks.

Greek and Roman mosaics were used almost exclusively on floors. The rise of Christianity led to the development of wall mosaics, which, because they did not have to fulfil the functional purpose of flooring, made use of glass tesserae. This represented a considerable technical and artistic step forward in the art of mosaics.

The information in the following section is the result of my studies, of the lessons imparted by my teachers, and also of reading books on the history of art in general and on this subject in particular. It results, too, from my direct knowledge of the mosaics that I have been able to observe and admire in archaeological sites, museums, churches and mosques, public and private buildings, and in a number of streets in medieval towns.

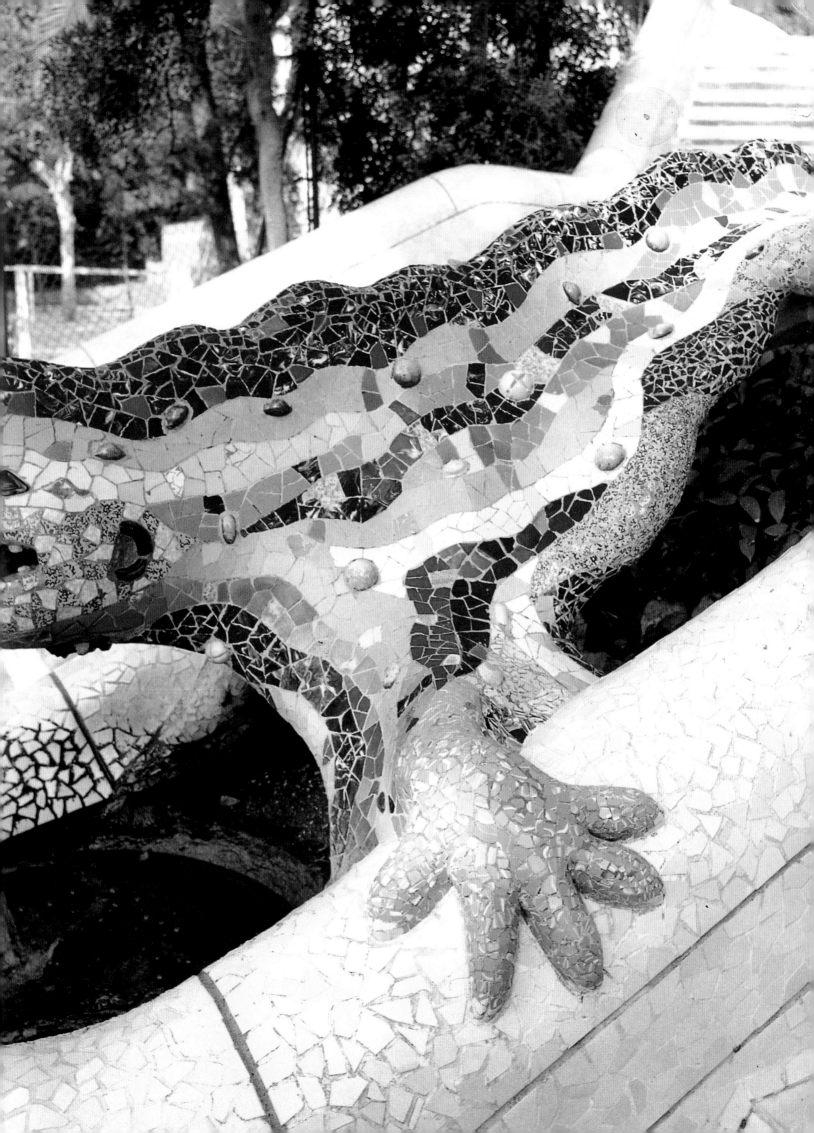

PIECE BY PIECE, TO THE PRESENT DAY

At first, cut stone was used, such as in the figurative scenes of Sumeria, and the mosaic floors in Greece were made of pebbles. The Romans achieved the splendor of marble tesserae. The Byzantines then transferred mosaics to the walls and used a glass paste for their tesserae. The art was continued in later centuries, but without its earlier vigor. Today, alongside the introduction of abstract themes, new materials have been added, with tesserae in varied shapes and large dimensions, something that was unthinkable in earlier eras.

Mesopotamia

As in other arts, the region of the Tigris and the Euphrates contains remains of what we might call mosaics, although they were not used for paving streets or for the floors of buildings. Near Ur there was a small sanctuary or temple dedicated to the goddess Nin-Kursag, at the doors of which were columns formed of the trunks of palm trees

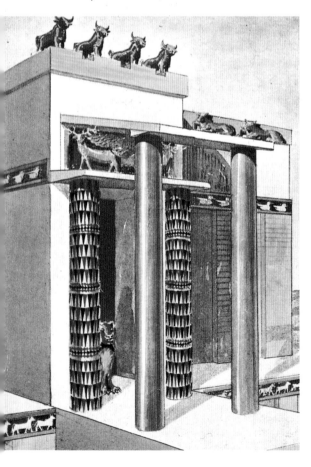

▼ Artist's conception of an archaic Sumerian temple in Al-Ubaid, Ur.

covered with bitumen and decorated with mosaics of mother-of-pearl, black stones, and red marble. The copper lions sculpted on the doors also had encrustations of mother-of-pearl for their eyes. Inside there were mosaic friezes with figures of birds, domesticated animals, and herdsmen, outlined in black and white, forming lines of cows and ducks cut out in white stone and embedded in a dark-colored mortar. In these friezes of figures, the Sumerian artists depicted pastoral and agricultural activities.

Another example of what has come down to us from this civilization is the *Royal Standard of Ur,* worked on both sides. One side shows scenes of war, with the king and his bodyguard on a chariot running over his enemies; the conquerors bring the prisoners, tied together in pairs, before the king, who is accompanied by high-ranking officials. On the other side are scenes from the domestic life of one of the Sumerian kings. The monarch is seated, presiding over a council of six dignitaries, who are drinking from stemmed glasses and are attended by servants as they listen to a singer and a musician playing the harp. There is also a scene of goatherds, fishermen, cowherds, and peasants taking their produce to the palace. Then come donkeys pulling chariots of war, driven by slaves; other slaves are loading up domestic animals with sheaves of corn, on ivory and lapis lazuli plaques.

It was in Ur too that the household articles of Queen Subad were found, consisting of silver, gold, and alabaster goblets, and harps, coffers, and board

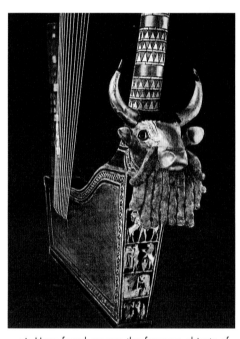

▲ Harp found among the funerary objects of Queen Subad in Ur, 2500 B.C.

games set with mosaics of mother-of-pearl and lapis lazuli. These musical instruments had mosaic decorations in the form of a gold, mother-of-pearl, or lapis lazuli frieze, with a motif formed of trunks of palm trees alternating with triangles in which the gold contrasted with the lapis lazuli.

These Sumerian harps were decorated with a symbolic animal, although they might be priests in disguise covered with skins. Beneath this animal there is a decoration in mosaic with ritual scenes (mysteries or magic) or theatrical performances with masked characters acting as demi-gods, the whole thing a mixture of religion, art, and magic cults.

Floors set with pebbles are so ancient that they are lost in the dawn of time, but in Gordium, a city in Phrygia, Asia Minor, on the banks of the river Sakarya, remains of these pavements were found dating back to the eighth century B.C.

In the fourth century B.C., in Pella, Macedonia, the city in which Alexander the Great was born, floors were made with white and dark blue pebbles, but gray ones were also used for the shading, and other colors for specific details, giving volume to the figures, which are outlined in narrow strips of lead sunk into the surface.

One of the oldest documents on mosaic art is dated around the middle of the third century B.C. Written on a piece of papyrus, it describes the method of making a mosaic floor for a bathroom. Also around this time, Hieron II of Syracuse sent to Alexandria his ship the *Syracuse*, in which the cabin floors were decorated with motifs from the *Iliad*, produced with tesserae made from different stones, some of them semiprecious.

During the Hellenistic period, mosaics were made with cut stones, and Eumenes II (197–159 B.C.), king of Pergamon in Asia Minor, had the rooms in his palace decorated by two great artists, Hephestium and Soso of Pergamon. Hephestium made a

▼ *The Child Dionysius Riding a Panther*, 64 × 64 in. (163 × 163 cm). Mosaic in the Hellenistic tradition, from House of the Faun, Pompeii. National Archaeological Museum, Naples.

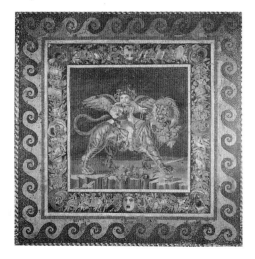

▲ *Hunting the Lion* (detail), 375–300 B.C. Pebble mosaic set in encrusted strips of lead. Pella, Macedonia.

tessellated floor bordered by a frieze with a black background on which grasshoppers and other insects were depicted, while the central space was filled with branches and fruits scattered over a white background.

Soso of Pergamon produced a mosaic known as the "Unswept Room," filled with what seem to be the remains of food left over from a banquet that have fallen onto the floor, represented in a very realistic manner and made of very small colored tesserae on a white background. Other tesserae have been placed to resemble the shadows of these remains, which gives volume to the composition. The artist also designed a mosaic for another room, in which doves are shown drinking from a bowl, and here again the execution is very realistic.

In Olynthus, in Chalcidice, there are floors made of pebble mosaic, with rounded edges, set in a cement mortar. The white figures and drawings are seen against a black background, the principal motif of the composition surrounded by friezes. In some of the motifs the artists used colored pebbles, which represented a step forward in the exploration of pictorial effects.

In Eretria, on the island of Euboea,

the favorite themes of the stone mosaics are mythological figures, with Dionysian scenes, griffins, and chimera, among others. These motifs are repeated in Olympia. On the island of Delos, in the second half of the second century B.C., pebble mosaics are infrequent, but tessellated floors were found in a wide range of colors, produced from colored stones and red and green glass tesserae.

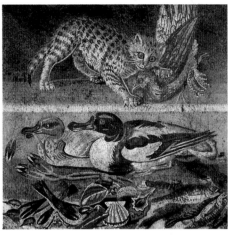

▲ *Cat Catching a Chicken*. Mosaic in the Hellenistic tradition, from the House of the Faun, Pompeii. National Archaeological Museum, Naples.

▼ Dioscorides of Samos, *The Musicians* (detail), 17 × 16 in. (43 × 41 cm). Mosaic in the Hellenistic tradition, from Cicero's Villa, Pompeii. National Archaeological Museum, Naples.

Rome

During the Roman period, the art of mosaics spread to temples, theaters, public establishments, thermal baths, and even to shops, under porticoes and in the marketplace. They were mosaics in black and white, but there were also others in more varied colors. Numerous types of decoration were employed: checkered with a double border; checkered with double convex scales, also with a double border; plaits of two and four strands; pointed arches with a double border; plaited triangles; lines of quadrangular prisms in perspective; and spiral and other motifs. There were mosaics with scenes from the *Aeneid,* of hunting, theatrical representations, musicians, mythology, and maritime scenes with fish and sea monsters.

The mosaics were made of marble from the local area and from more distant lands, such as Africa, in rich colors. A workman known as a *tessellarius* was responsible for preparing the tesserae, cutting the material into general cubes, which were then recut to the precise shape by the mosaicist.

Three main types of floors were produced: the *opus tessellatum,* the *opus vermiculatum,* and the *opus sectile.* The principal motif of the mosaics was the *emblema,* which was made in *opus vermiculatum;* the background was done in *opus*

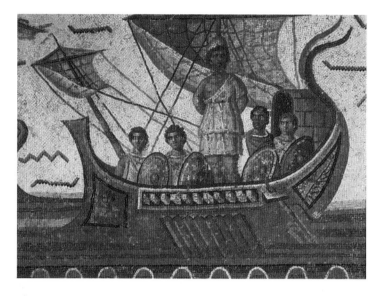

◄ *Ulysses and the Sirens,* 3rd century. Dougga, Tunisia.

tessellatum. The support or base for the *emblema* was a slab of marble, generally small in size, about 36 x 36 in. (90 x 90 cm), and made in the mosaicist's workshop, known as the *officina.* The background for the floor was composed in situ.

Once the mosaic panel was complete, leaving a gap of the same size as the *emblema,* it was transported to the building and embedded in the floor, and the joints were sealed to produce a unified piece. This mosaic floor had to endure being trodden on, so it had to be smooth and polished in order to serve its very functional purpose.

The colors of the tessellatum were

black and white and the tesserae were larger in size; consequently the designs were geometrical. In the vermiculatum, on the other hand, the very small (sometimes even diminutive) tesserae were adapted with meticulous care to the outline of the motif.

In all Roman cities, both in the capital and in the provinces, there were numerous buildings containing mosaics, but it is at Pompeii where mosaics of immense artistic value have been found, particularly in the House of the Faun. The house is entered through the vestibule, which is decorated with a mosaic of geometrical composition. This leads to the principal atrium, in which the *impluvium* is surrounded by a molded frame in white marble, with the base covered in rhomboid and triangular shapes in colored limestone, and with the typical encrusted motifs of floor decoration in *opus sectile.* In the center is a bronze figure 28 in. (70 cm) high, representing a dancing faun, hence the name of the house. This atrium also has two *alae.* On one of these is a mosaic divided into two sections, the upper one representing a cat that has just leapt on to a chicken with its legs tied together. In the lower part is a still life composed of ducks from the Nile valley, lotus, molluscs, fish, and birds.

The principal atrium gives on to the tetrastyle atrium on the right. At the

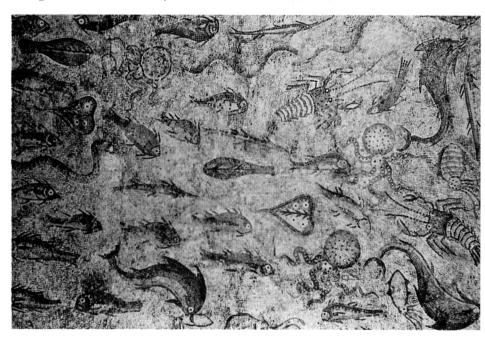

◄ *Fish.* Museo Arqueológico, Tarragona.

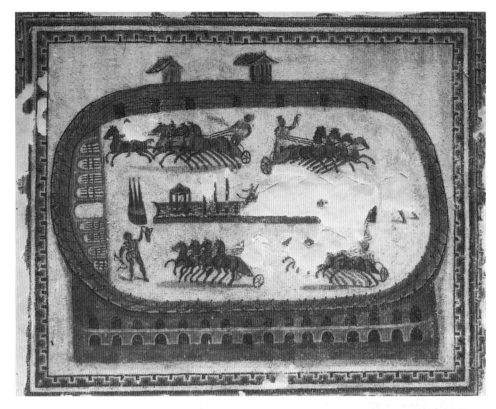

back of the first atrium, between the alae, is the *tablinum*, in which the floor in paved with a mosaic made of travertine, slate, and green limestone. Rhombuses and rhomboids in different colors alternate to create the effect of cubes seen in perspective, in opus sectile, while the rest of the mosaic is in opus tessellatum. The two *triclinia* flanking the tablinum in the atrium have emblemae framed in wreaths. In one of them, on a black background, is Dionysius riding a panther; the other emblema shows fish in the depths of the sea, a subject of which the Romans were particularly fond.

At the back of the tablinum is the first peristyle, leading to the *exedra*. Flanked by two Corinthian columns, the entrance to the exedra is covered with mosaics formed of tiny polychrome tesserae on which are represented the flora and fauna of the Nile valley, with snakes, plants, and aquatic animals inhabiting the river and its banks. But the masterpiece, which occupies almost the entire surface of the exedra, is a mosaic showing the victory of Alexander the Great over Darius at Issus. Made with tesserae ranging in color from white to yellow and red, from gray to brown, and from purple to black, this spectacular piece may be a mosaic version of a painting by Philoxenus of Eretria.

The Roman mosaicists also made small portable mosaics set on a support of baked clay or a slab of marble. These works, which are copies of Hellenistic and other original paintings, use tesserae as tiny as 1/32 in. (1 mm) square in order to resemble the brushstrokes of a painter.

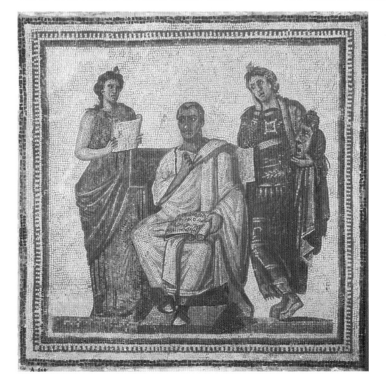

◀ *Virgil and the Muses*, 3rd century. Sousse, Tunisia.

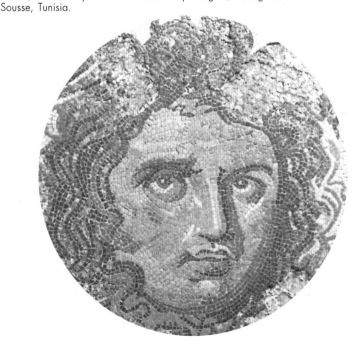

▼ *Medusa*. 2nd–3rd centuries. Museo Arqueológico, Tarragona.

Christian and Byzantine Art

Christian Art

With Christian art, mosaics moved from the floors onto the walls. Christian iconography appeared in mosaics in the middle of the fourth century in Santa Maria Maggiore and the church of Santa Prudenciana in Rome and in the mausoleum of Galla Placidia at Ravenna, where figures were represented on the walls but nonfigurative decorations filled the vaults and dome with subjects from the Old and New Testaments, the Passion of Jesus Christ, the Miracles, and the Parables. There are also animal, bird, and plant ornamentations.

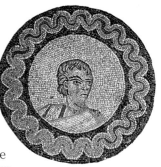

▼ Central medallion with a portrait of the emperor, 4th century. Aquileia cathedral.

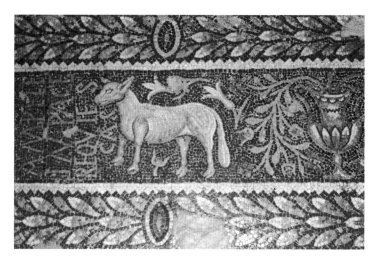

▲ Mosaic on the tomb of Ampellius, 5th century. Museo Arqueológico, Tarragona.

Byzantine Art

The most important Byzantine mosaics of the Justinian period are those in the churches in Ravenna. In San Vitale they show the Emperor Justinian and the Empress Theodora with their entourages. Another church decorated with mosaics is the basilica of Sant'Apollinare Nuovo.

Byzantine mosaics, which used glazed tesserae, were not smooth and polished but were placed so as to give a rough, irregular surface. New techniques were introduced, such as tesserae coated in silver, which were mixed with gold-covered tesserae to produce spectacular changing light effects. But above all, much care was taken in placing the pieces at different angles so that the light—whether daylight or the light from the candles that illuminated the churches at night—would reflect off them on to the viewer. These light effects gave the figures a surprising realism. For the faces and hands, colored stone tesserae were used, which were smaller in size that those employed for the hair and garments.

Some of the buildings in which the most important mosaic works can still be found are the basilica of St. Sophia in Istanbul (ninth and twelfth centuries), the cathedral in Monreale in Sicily (late twelfth century), and the church of Santa Maria in Torcello and St. Mark's basilica, both in Venice (eleventh to fifteenth centuries).

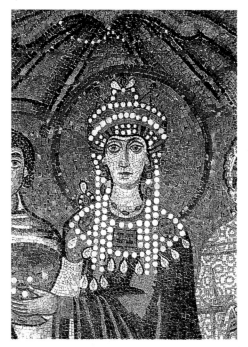

▼ The Empress Theodora (detail), 6th century. San Vitale, Ravenna.

▲ The Emperor Justinian (detail), 6th century. San Vitale, Ravenna.

◄ Floor in opus sectile in the center aisle (detail), 12th century. Basilica in Torcello, Venice.

During the seventh century there was a renaissance in mosaic art that spread from Constantinople both eastward and westward. In the east, mosaics—like mural paintings—covered the walls and ceilings of many mosques built during that century. But contrary to the paintings, which endured for several hundred years, the mosaics stopped being produced after a few decades.

These mosaics were the work of Byzantine artists loaned or sent by the emperor of Constantinople at the request of the caliph Walid ibn Add al-Malik to decorate the mosques in Mecca, Medina, and Damascus. The themes depicted in these figurative mosaics are landscapes with houses, palaces, and temples drawn in perspective; and stylized animals, trees, plants, and flowers. Geometrical designs (compositions with eight-point stars inscribed in a circle) formed part of the Byzantine aesthetic, but the human figures were removed in order to avoid conflict with the precepts of the Islamic religion. Phrases from the Koran written in Kufic letters were also produced.

The Great Mosque in Damascus is one of the most beautiful monuments not only because of its architecture but also for its wealth of mosaic decoration in gold tesserae. The outside walls of the seventh-century

▼ Arch on the right of the mihrab (detail), 10th century. Great Mosque, Cordoba.

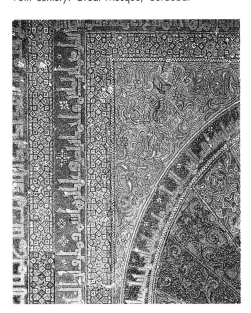

▶ Vase and acanthus volute (detail), 7th century. Dome of the Rock, Jerusalem.

Dome of the Rock in Jerusalem are covered in mosaic work. In the Great Mosque in Cordoba, mosaics were used during the mandate of the caliph Al-Hakam II (961–968) with representations of birds, lions, fish, and other animals, as well as decorations based purely on plant motifs in the mihrab. But it is in the geometrical ornamentation that the Moslem artists were at their best.

Gradually the decorative materials used in the buildings became less showy, due to their cost and to the speed with which the buildings were constructed. Consequently mosaics and marble were abandoned and came to be replaced by glazed ceramic tiles, plaster, and wood.

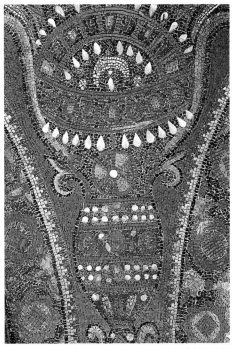

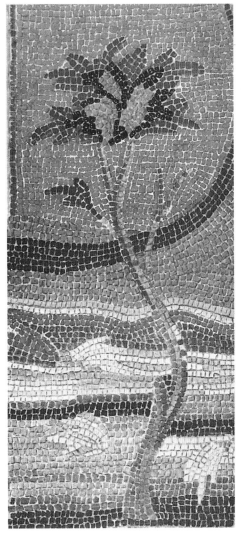

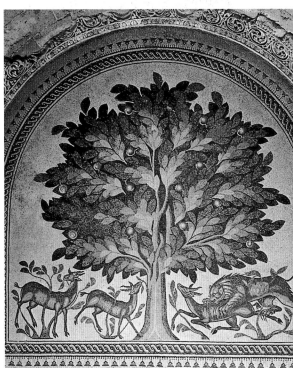

▲ Mosaic floor in the throne room (detail), 8th century. Jirbat al-Mafjar castle.

◀ Mosaic in the Great Mosque in Damascus (detail), 8th century.

Medieval Art

Medieval mosaic floors are a legacy from the ancient Roman floors. Two basic techniques were used: the opus sectile and the opus tessellatum, and it was very common to employ both types of work in the same floor.

Marble or hard limestone were used for the whites, blacks, and most other colors, but baked clay was used for the red. The irregular tesserae, with sides of 3/8 to 2 in. (1 to 5 cm), also vary considerably in thickness. The cement on which they were laid was usually of very poor quality and included gravel and even stones.

During this period, pebble floors were usual in churches that wanted a decorative floor but could not afford a more expensive material. Very often these mosaic floors extended throughout the church, except for the space decorated with opus tessellatum or opus sectile, which were reserved for the more important parts of the building.

The iconography consisted of biblical scenes from the Old Testament, to which were added mythological scenes, signs of the zodiac, literary symbols, and popular legends. Real and fantasy animals, inspired by bestiaries, invaded these floors. Pebble flooring was often used in private buildings, and decorative cobblestones were laid in the streets of medieval towns, along which we can still walk today, for it was a simple method of paving that continued until only a few decades ago, when concrete or asphalt became the norm.

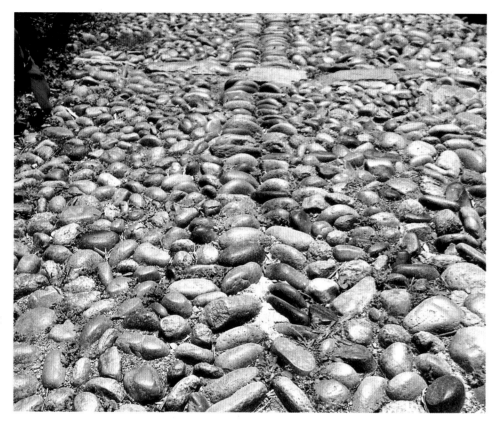

▲ Pebble mosaic. Medieval village of Tossa de Mar, Girona.

▼ Pebble mosaic. Medieval village of Tossa de Mar, Girona.

P re-Columbian artists produced extraordinary work in stone using serpentine, diorite, gabbro, and onyx, hard stones from which they made masks adorned with mosaics of turquoise, jade, coral, malachite, and red and white mother-of-pearl, and with nacre, shell, and obsidian for the eyes. The masks seem to have had a funerary and liturgical function and are found in various cultures such as the Teotihuacan, Maya, Aztec, Mochica, Toltec, Zapotec, and Mixtec, among others. Other mosaics were applied to articles of value for personal use, such as the circular ear discs decorated with warriors and mirrors.

The stones were cut with a flint to form facets and were stuck to the surface with a natural glue called *tzauhtli* and then burnished with fine sand to give them a bright luster.

On buildings in Mitla, in the Oaxaca valley, there is mosaic cladding on the walls. Small holes have been excavated in the stones on the outside walls and in the principal rooms into which tiny blocks of perfectly cut stones have been fitted, forming red encrusted geometrical patterns.

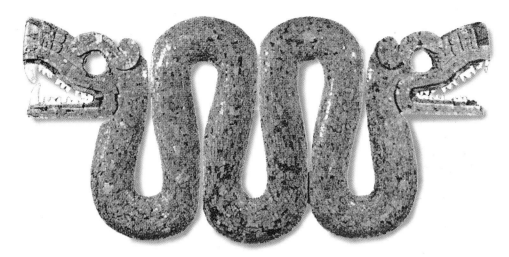

▲ Turquoise mosaic with shell teeth, representing a two-headed serpent, from the Aztec culture.

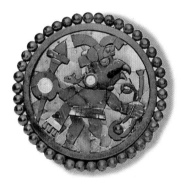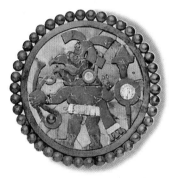

▲ Turquoise, shell, and gold ear discs decorated with bird-headed warriors carrying shields, lances, and slings, from the Mochica culture, 1st–12th centuries, 4 in. (10 cm) diameter.

◄ Mosaic mirror made of pinta, turquoise, and shell, from the Huari culture of Peru; 7th–10th centuries.

▼ Turquoise-encrusted ritual mask of cedar with shell teeth and eyes, from the Aztec culture, 6 in. (16 cm). British Museum, London.

▼ Shell-encrusted ceramic receptacle, representing the face of a warrior emerging from the jaws of a coyote, from the Toltec culture, 10th–12th centuries, 5 in. (12.5 cm). Tula, Hidalgo. Museo de Antropología, Mexico.

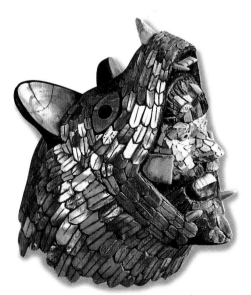

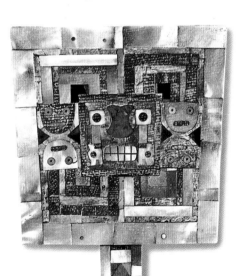

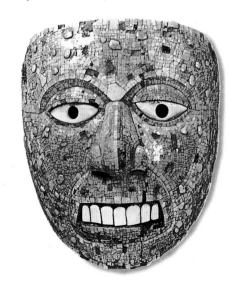

The Fourteenth to Nineteenth Centuries

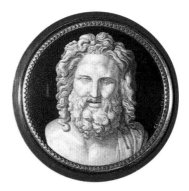

From the fourteenth century onward, mosaics gave way to painting and lost their status as an independent art form. A number of important painters produced cartoons for mosaics, and Giotto was the creator of one of the most well-known of these in St. Peter's in Rome.

In the fifteenth century, in the Florence of the Medicis, mosaics came to the forefront again and Domenico Ghirlandaio produced the *Annunciation* for the Duomo. In Venice, where the Florentine painters Paolo Ucello and Andrea del

▲ **Giacomo Rafaelli,** miniature, 18th century, 2 5/8 in. (6.7 cm) diameter. Private collection, Rome.

▲ Miniature, 19th century, 3 in. (7.6 cm) diameter. Museo Napoleonico, Rome.

▲ **Giacomo Rafaelli,** miniature, 19th century, 2 1/2 in. (6.2 cm) diameter. Private collection, Rome.

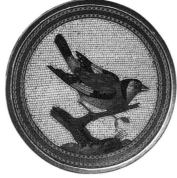

Castagno worked, a new school of mosaics was formed. In the sixteenth century, also in Venice, Titian designed cartoons for mosaic murals that were later produced. Seventeenth-century Rome became the center for the production of mosaics and the training of specialists in this art. This was largely due to the mosaic decoration of the basilica of St. Peter's.

In the eighteenth century, mosaics were appreciated for their durability in comparison with painting and for the brightness of the colors, which did not fade with the passing of time. There was a predilection for large-format mosaics, which were made with glass paste and were reproductions of paintings. These were so intricately worked that the fact they are actually mosaics is evident only upon close inspection. Because of their technical complexity they were much more difficult to produce than the painted miniatures. Miniature mosaics, made with tesserae measuring 1 x 1 mm, were widely used for decorating small everyday articles and also for decorating furniture.

◄ Miniature, 19th century, 1 3/4 × 1 1/4 in. (4.2 × 3.3 cm). L. Moroni collection, Rome.

In early nineteenth-century France, at the height of the Neoclassical period, an imperial school of mosaics was established where the principal activity was the imitation and restoration of antique models. Around the middle of the nineteenth century, Tzar Nicholas I of Russia set up a school of mosaics in Rome, which he then transferred to St. Petersburg, where a large number of paintings were reproduced.

▼ **Giacomo Rafaelli,** miniature, 18th century, 2 3/4 × 2 in. (7 × 5.2 cm). Private collection, Rome.

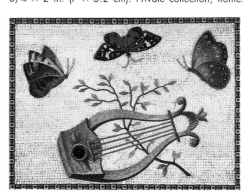

◄ **Nicola de Vecchis**, urn, 18th century, 20 1/4 in. high × 8 in. diameter (51.4 × 20.7 cm). Vatican Workshops. Los Angeles County Museum of Art.

I n the last quarter of the nineteenth century, original mosaics began to be produced, although they were of little artistic importance. But in 1900, the art of mosaics received an extraordinary stimulus as a result of the work of the brilliant Catalan architect Antoni Gaudí. These mosaics, most of which are nonfigurative, are laid like scales over the surfaces of walls, roofs, chimneys, and domes as well as the undulating benches in the Güell Park in Barcelona, or form medallions in the hypostyle and cover the dragon at the entrance to the park like a skin. They are made with fragments of ceramic tiles and broken pieces of glass and china, known in Catalan as *trencadís*, which are stuck together with mortar. Other buildings in Barcelona, including the church of the Sagrada Familia, are also partly covered in mosaics.

Other mosaics, such as those on the walls of the Sacré-Coeur in Paris (1912–22) and the 1920 mosaics on the front of the Palazzo Barbarigo on the Grand Canal in Venice, are examples of the renaissance of this art. This revival occurred at the same time as the appearance of the figure of the artist-mosaicist, who both designed and made his own mosaics.

Between the wars, the Italian painter Gino Severini produced numerous mosaics. Other important artists including Marc Chagall, Gustav Klimt, Oscar Kokoschka, and Georges Braque made cartoons to be executed as mosaics. Among the many well-known artists who worked in mosaics were Fernand Léger; Lucio Fontana, who covered some of his female statues with mosaics; and David Alfaro Sigueiros, the Mexican muralist and painter, who designed the mosaic for the University of Mexico. Others who produced mosaics for the same university include Juan O'Gorman, for the library; Eppens, for the Faculty of Medicine; and Diego Rivera and Rufino Tamayo.

Many other artists have carried on the tradition of mosaics, which add a personal, distinctive character to buildings, floors, and objects. The art of making mosaics is a slow and labor-intensive process, seemingly out of place in today's fast-moving, commercialized world. Yet it is an art form that continues to endure, and to boast many admirers and practitioners.

▲ Facade of the Palazzo Barbarigo (detail), 20th century. Venice.

▼ **Georges Braque**, *The Doves.*

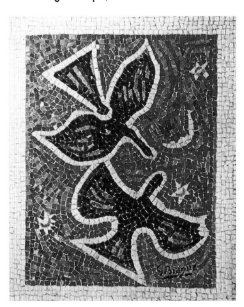

▼ **Fernand Léger**, detail of the facade of the Musée Léger in Biot, France.

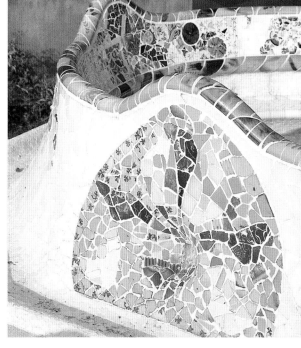

▲ **Antoni Gaudí**, detail of a serpentine bench in Güell Park, Barcelona.

▼ **David Alfaro Siqueiros**, mosaic for the rectory of the University of Mexico (detail), 1952–56.

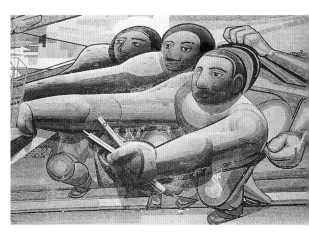

MATERIALS
AND TOOLS

From ancient times to the present day, mosaicists have worked with different materials in order to create their mosaics. Yet there has always been a common material: stone, from pebbles to marble and granite. The later discovery of glass paste broadened the range of chromatic potential for mosaic compositions, and semiprecious stones have also been used. Naturally, all these materials require tools for cutting them up: hammers and chisels, nippers and fretsaws—there is an entire range of different instruments that can be used for preparing virtually any kind of material.

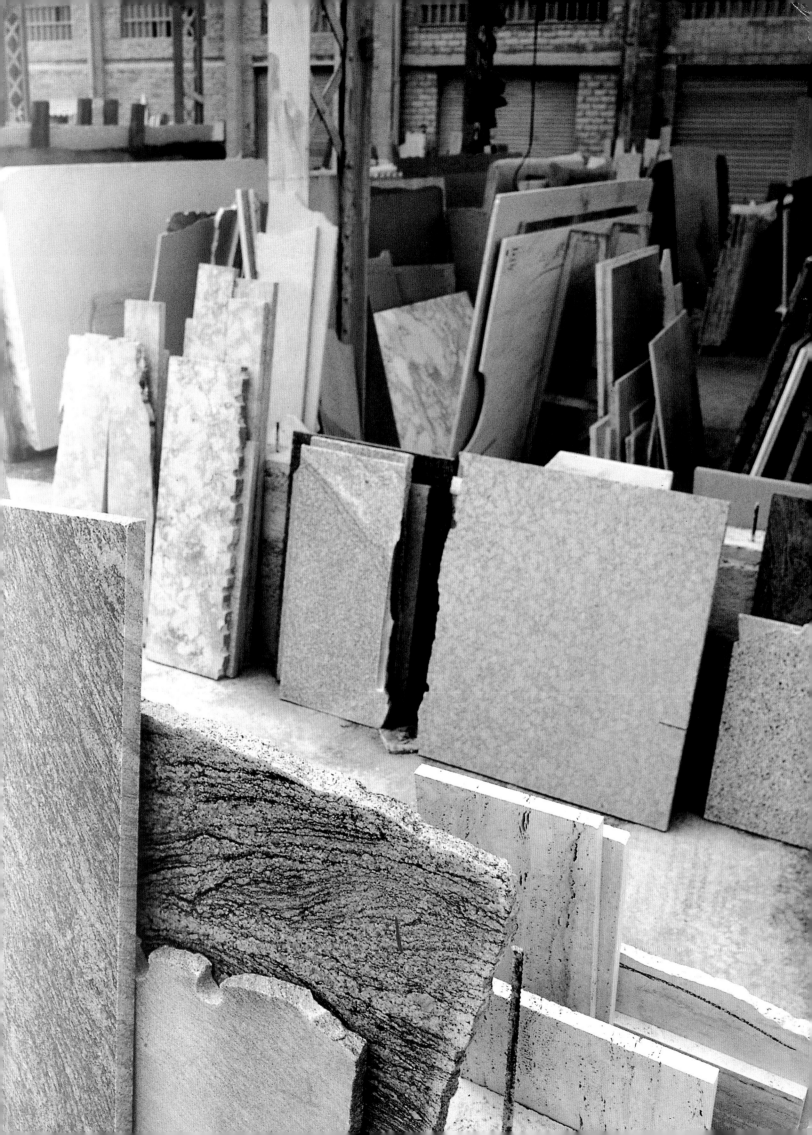

MATERIALS

When preparing tesserae, it is advisable to use materials that will not alter with the passage of time. These materials should be compact enough to allow them to be cut without their breaking up. It is not surprising, therefore, that the mosaicists of old used stone for their mosaics. This material—which forms the earth's crust and is subjected to the continuous action of geological agents—can be divided into three main groups: igneous rocks, sedimentary rocks, and metamorphic rocks, depending on their geological origins.

Igneous Rocks

Igneous rocks were formed by the cooling of the magma, or igneous material, and solidified later. When formed in the deepest levels of the earth's crust, these rocks cooled slowly and produced several varieties with a compact grain. Another variety is volcanic rock, which has reached the earth's surface. These are fine-grained rocks, such as basalt, and sometimes even have a glass-like appearance, such as obsidian. All these kinds of rocks are considered the hardest and therefore the most difficult to work with.

Granite

Granite is usually composed of quartz, feldspar, and mica. This composition can vary in proportion, although forms of granite that have a high quartz content are the hardest and most difficult to work with, as the crystals are not altered by atmospheric agents or acids. Usually light in color, granite can vary depending on its composition. Feldspars may have pink or reddish hues, while mica is generally dark, either greenish or grayish. Granite has a hardness of between 6 and 8 on the Mohs scale, so it is difficult to cut and therefore is little used in mosaic making. But when polished it is very shiny and resistant to damage.

Syenite

This rock belongs to the granite family and is formed by alkaline feldspar, plagioclastic rock, and hornblende. It can also contain biotite, augite, and even olivine. It varies in color, though it is generally light-hued. It can also range from pink and violet to greens and grays. Any reddish color is due to the pigmentation of feldspar hematites. It is grainy in texture and polishes very well. Because of its low quartz content it is softer than granite, and is relatively simply to cut.

▲ Granite

Diorite

Similar to granite, diorite is an intrusive rock, medium-grained and very hard. It is composed of alkaline feldspar and quartz, as well as hornblende and biotite. It is dark gray, though it can be black, depending on the proportion of hornblende. Diorites contain no more than 20 percent quartz. It is as highly resistant and hard-wearing as it is difficult to cut and polish.

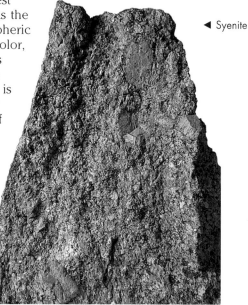

◄ Syenite

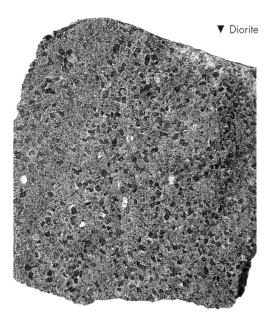

▼ Diorite

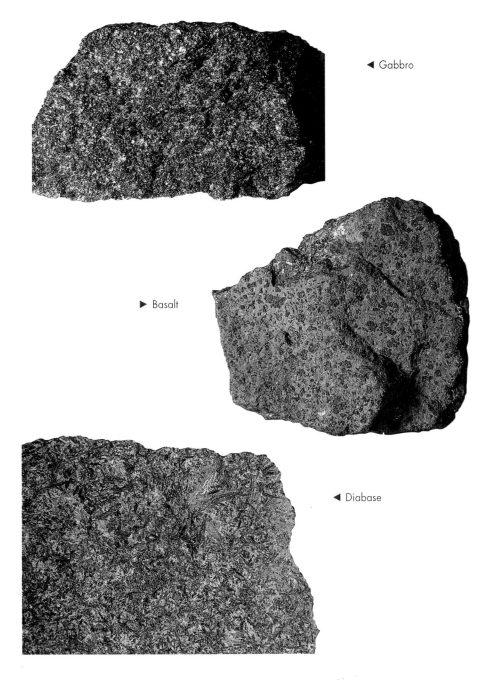

◄ Gabbro

► Basalt

◄ Diabase

▼ Porphyry

▼ Obsidian

Gabbro

Gabbro is a totally crystallized igneous rock composed of calcium and sodium feldspar, plagioclastic rock and quartz. It is generally gray in color, though it is often seen in whites and greens. It is very hard, but can be worked and polished.

Basalt

Of volcanic origin, basalt is compact and very hard, though easier to cut than granite. It produces a good polished surface. It is composed of plagioclastic rock, alkaline feldspar, and quartz, and ranges in color from black and gray to blue, green, and even reddish, occasionally with a metallic shine. From the point of view of volume, basalt is the most important extrusive rock on Earth.

Diabase

Diabase is a very hard, compact rock that is hard-wearing. It is very difficult to cut, but easy to polish. It varies from dark green to almost black.

Porphyry

Porphyry has feldspar crystals in its compact and dark red crystalline composition. It is a hard rock that is difficult both to cut and to polish.

Obsidian

Obsidian is a volcanic rock formed from melted lava that has solidified into a kind of glass. It is composed of quartz combined with iron, calcium, sodium, and potassium, with no crystals in its composition. It is hard and rather fragile but can be polished. It is very dark, sometimes black in color.

23

Sedimentary Rocks

Sedimentary rocks come from extrusive or metamorphic rocks that have been eroded by the weather. There are three stages in the formation of these rocks: the formation of the individual elements of the sedimentary material; the transport of this material, sometimes over great distances; and the actual sedimentation, that is, the accumulation of the mineral and organic particles into rock form. By the force of gravity, these particles come to rest and form deposits that are arranged in layers or strata. One layer of material is covered by another, which sometimes continue to form separate layers, while others become more compact and solidify into new rocks.

The two main types of sedimentary rock are sandstone and limestone.

Sandstone

This type of rock is composed of grains of sand with a high silica content, in addition to feldspar and mica. There are also other types in which the cohesive element is different, lending the rock a different nature. Silica sandstone is the most resistant due to its high silica content. Sandstone is usually earth-colored, such as ochres and a few grays. It has a porous appearance and usually cannot be polished.

Limestone

Limestone is formed from calcareous matter, that is, calcium carbonate ($CaCO_3$) in a proportion of over 75 percent. Some varieties of this rock look like marble due to the pattern of the grain and compact composition. Limestone is generally quite suitable for cutting and polishes extremely well. It varies in color from white to light gray, although any impurities will turn it a darker color.

Translucent Gypsum

This crystalline calcium carbonate, or limestone, is translucent and white. Some varieties are also yellow, reddish pink, brownish, gray, or black. It is a soft, easily cut rock and produces a perfect polish and finish, although it is not very hard-wearing. It has a hardness of 3 on the Mohs scale.

Travertine

Travertine is formed by the precipitation of calcium carbonate on plants in water containing carbon dioxide. It is solid, fine-grained, and porous, light in color, from yellowish to brown and even pink. Travertine is easy to cut and polish.

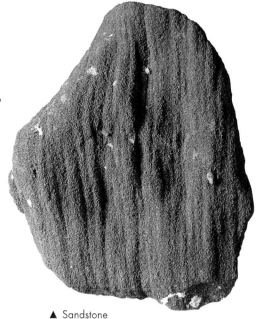

▲ Sandstone

▼ Limestone

▼ Translucent gypsum

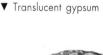

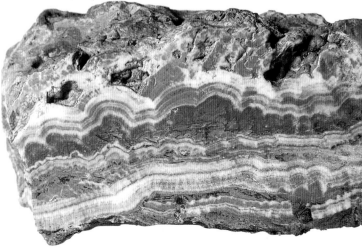

▼ Travertine

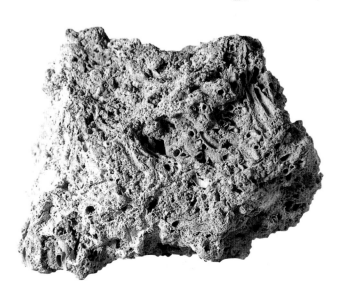

Metamorphic rocks are formed by the structural and mineralogical modification of existing extrusive and sedimentary rocks. Caused mainly by pressure, high temperatures, chemical processes, and recrystallization, these modifications together create a new type of rock. The most well-known metamorphic rocks are slate, marble, steatite, and serpentine.

Slate

Slate is a schistose rock formed from sedimentary rocks transformed from hardened clay that breaks up easily into sheets. The different elements, such as alumina, quartz, and mica, are often evident in a piece of slate. In color it ranges from bluish gray to green. It is easily worked, is impermeable and resistant to weather changes, and it polishes well.

Marble

Marble is basically composed of calcium carbonate ($CaCO_3$), together with other minerals such as silica, iron oxide, mica, hornblende, tourmaline, copper pyrite, chlorite, alumina, and iron pyrite. These impurities affect the hardness and the resistance of the marble, and also give it color. In general, marble is an extremely resistant stone, but can be cut well and takes a good polish. It is softer than granite but harder than most calcareous rocks. There are three main types of marble:

Calcite is 95 percent calcite crystals.

Dolomitic contains approximately 5 percent calcium carbonate and 46 percent magnesium carbonate ($MgCO_3$).

Mixed marble is formed from a combination of dolomite and calcite in different proportions.

The different coloring of marbles depends on the impurities contained in the calcium carbonate. It is unusual to find calcium carbonate in pure form. Marble

from Carrara, Italy, is 99.9 percent calcium carbonate, but this is an exceptional case; there are very few countries with deposits of white marble. Far more common is marble colored due to pigmentation that has modified its natural whiteness. Yellow marbles owe their color to limonite or iron hydroxide. Red marbles take their color from the presence of red hematites and there is a wide variety of this type of marble ranging from pink to red. Black marble has a high carbon content.

Steatite

Steatite is a dense, fine-grained talc rock that is hard and greasy to the touch. It is hydrated magnesium silicate, which can take a perfect polish and is rather similar to marble in appearance. It ranges from white to gray and from green to yellow; there is even a reddish variety. It has a hardness of 1 on the Mohs scale and can be easily cut, even with a knife, although it is highly fragile.

Serpentine

Serpentine is formed by the metamorphosis of olivine and by variations in its chemical composition. Composed of hydrated magnesium silicates ($2SiO_2$–$3MgO$-H_2O), it is green or reddish with specks. It is easy to work when soft, but becomes extremely hard over time and can take a perfect polish.

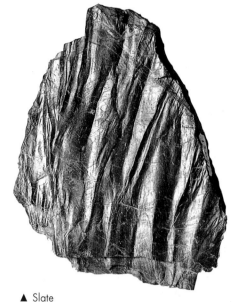

▲ Slate

▲ Marble

▼ Serpentine

◄ Steatite

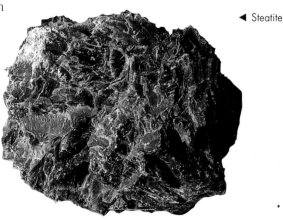

Stone Materials

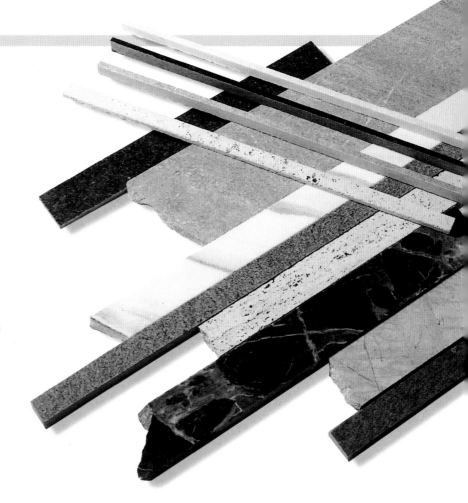

S tone was the first material mosaicists used, from the pebbled city streets to pavings made of mosaics. Stone was the ideal material for preparing the tesserae due to the wide variety of available types, hardness, variations in color, and resistance to damage.

Generally speaking, mosaicists used the natural stone found on or near the site of the mosaic itself, though when they required different colors, the stones would be brought from other areas, and they occasionally even used stone remains from buildings. Marble was the most commonly used stone, although tesserae were also made from granite, serpentine, porphyry, and basalt.

Finally, there are the semiprecious stones, with their extraordinary coloring. Stones such as malachite, obsidian, onyx, quartz, sodalite, jade, and agate were also employed for tesserae, although their greater expense meant they were used to a lesser degree.

▲▼ Strips and sheets cut into different lengths and widths: marble, travertine, and granite, polished and mechanically cut.

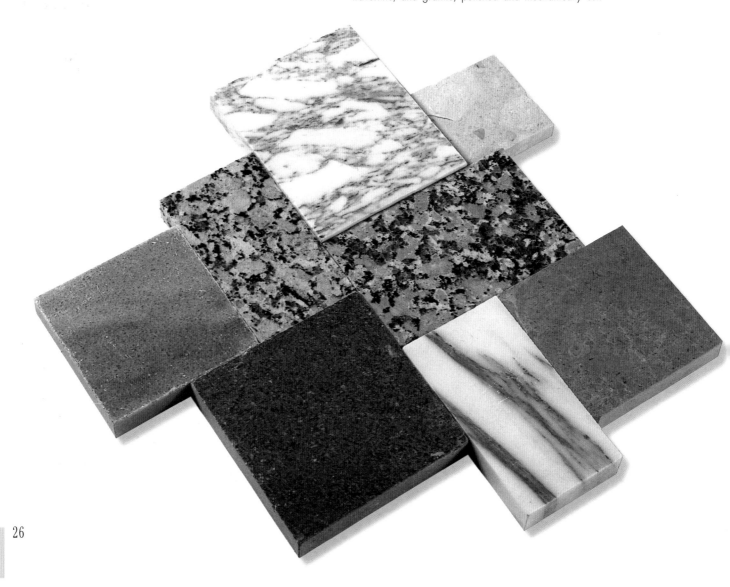

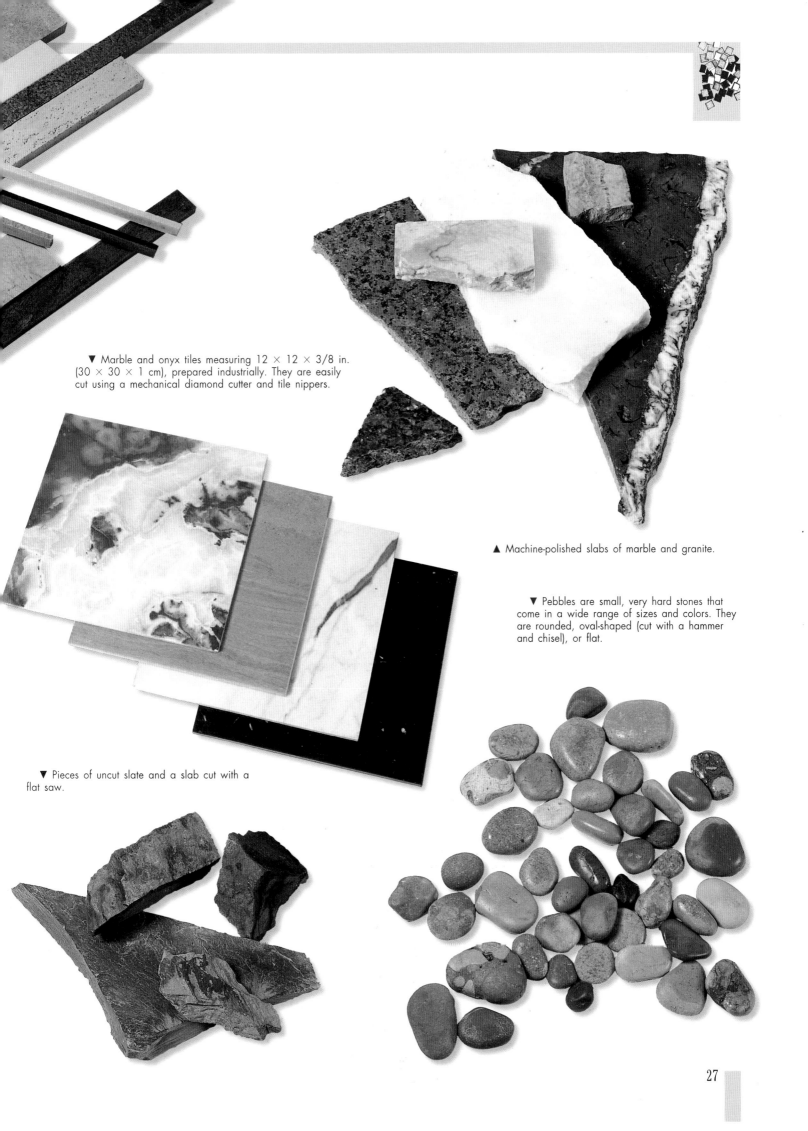

▼ Marble and onyx tiles measuring 12 × 12 × 3/8 in. (30 × 30 × 1 cm), prepared industrially. They are easily cut using a mechanical diamond cutter and tile nippers.

▲ Machine-polished slabs of marble and granite.

▼ Pebbles are small, very hard stones that come in a wide range of sizes and colors. They are rounded, oval-shaped (cut with a hammer and chisel), or flat.

▼ Pieces of uncut slate and a slab cut with a flat saw.

27

Glass Paste

Another material used for preparing tesserae is glass paste. Also called "smalti," these pieces of colored glass contain such components as silica, lime, soda and potash, alumina, magnesia, lead oxide, boric acid, and phosphoric acid, which act to vitrify, fuse, and stabilize the smalti. Metal oxides such as cobalt, copper, chrome, uranium, nickel, iron, silver, and manganese dioxide are used to render the glass opaque and to color it. The materials are reduced to powder and mixed, and then placed in a furnace at temperatures of up to 2700 or 2800°F (1500 or 1600°C). While still in a fluid, viscous state, the material is formed into sheets and then placed in an annealing oven to cool slowly. The cold sheets can then be cut up into tesserae.

◄ Smalti, or glass paste tesserae, from Murano, in Venice, Italy.

▼ Small plaquettes of colored glass measuring about 1/16 to 1/8 in. (3 to 4 mm), cut with a glass-cutter's tool.

▲ ▶ Panels of glass paste tesserae in a standard 15 × 15 in. (40 × 40 cm) format. The paper support is easily peeled off when wet. Above, loose tesserae made from the same material; each measures 3/4 × 3/4 × 1/8 in. (2 × 2 × .4 cm).

Ceramics and Semiprecious Stones

Ceramic Materials

Tesserae are often prepared from enameled ceramic tiles. Their wonderful coloring, the ease with which they can be cut, and their very low price in comparison to marble or smalti make them a popular choice for mosaicists.

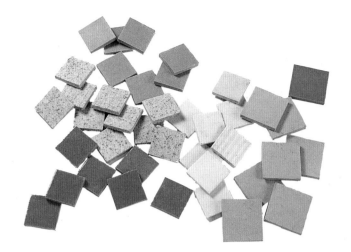

◄ Ceramic tesserae of colored stoneware, fired at 2280 to 2350°F (1250 to 1280°C), can be perfectly cut using nippers and a tile cutter. They have a matte color as they are not enameled.

▼ Enameled ceramic tiles come in a wide variety of shapes and colors and are easy to cut, both with a cutter and with tile nippers.

◄ Baked ceramic pastes, which can be colored, have been fired at 1650 to 2280°F (900 to 1250°C). The coloring is due to the natural oxides and also to the firing temperature. They can be cut using a tile cutter, nippers, or a power saw if they are very thick.

► Assorted semiprecious stones are sold in specialty stores. Seen here are lapis lazuli, agate, jasper, quartz, malachite, sodalite, howlite, turkenite, and amethyst, among others.

Semiprecious Stones

Other materials, such as semiprecious stones (including agates, jade, onyx, and lapis lazuli), pose added problems such as their high cost and the need for more sophisticated cutting means. However, the results obtained with these materials are outstanding.

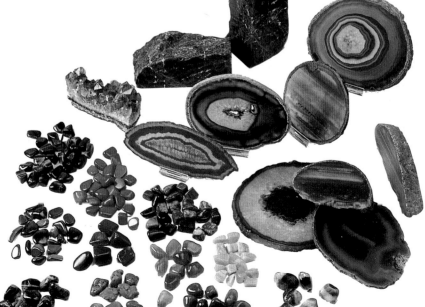

◄ Assorted semiprecious stones are sold in specialty stores. Seen here are lapis lazuli, agate, jasper, quartz, malachite, sodalite, howlite, turkenite, and amethyst, among others.

TOOLS

The mosaicist's main tools are the hands, but since the materials used are necessarily quite hard, other mechanical means are required. Although the portion of the work carried out using just the hands seems more appealing, remember that cutting up tesserae takes a large part of the time put into creating a mosaic, so machine tools are important both for saving time and for obtaining perfect cuts. The time saved can then be better employed in the artistic process.

Types of tools

A mosaicist's most important pieces of equipment have always been the hammer, chisel, nippers, and small anvils, especially for cutting up stone tesserae. For glass paste tesserae, a diamond wheel or glass-cutter's tool like a tile cutter is necessary.

The following pages describe various tools, both hand and machine, which should be more than sufficient for any professional mosaicist's studio. Knowing how to choose and use the right tool for the material in question is basic to good mosaic making.

Tool Definitions

Anvil

An anvil is a metal tool with a triangular-shaped cutting section and a cylindrical shank set into a trunk. Stones, strips, or slabs of marble, thick glass paste, or other materials are placed on the anvil to be cut into tesserae. When using an anvil it is advisable to use a wooden box as shown in the photograph to collect any shards.

◄ The wooden tray mounted on the trunk acts as a container for the stones and cut tesserae. It also collects any shards produced during the cutting.

▼ View of an anvil; the cutting edge varies depending on whether you are cutting thin strips or slabs.

▼ Hammers with cutting edges, and mallets. The two hammers on the left are used with the anvil. The stone, slab, or pebble is cut into two by striking it with the hammer.

► Anvil mounted on a trunk of wood, 35 in. (90 cm) tall. The wood dampens the vibrations caused by the blows with the mallet.

Hammers

Hammers are available with either double cutting edges or a single edge for cutting or breaking up the stones to prepare the tesserae. They are used in combination with an anvil.

Mallets

Mallets are used for striking chisels. They should always be used for breaking up rocks and round pebbles. They weigh between 1 and 2 1/2 lbs. (500 g to 1 kg). The harder the rock, the heavier the mallet should be.

Cutter

As its name implies, a cutter is a mallet with a cutting edge; the other side is square and heavy. It is used for splitting slabs of marble or stone.

Chisels

Chisels are used in combination with a hammer and/or mallet, for breaking up rocks. This must be done on a hard surface, using firm blows.

Nippers

Nippers are used for breaking up small stones and cutting and shaping tesserae. They must have sharp cutting edges, as well as long handles to allow for more leverage. They can take different forms, such as tongs with a spring to keep them open. Flat nippers have flat edges and are very useful for holding tiles that have been scored as well as strips of marble, or strips or sheets of glass paste.

Electric cutting disc

A tungsten carbide or diamond disc is used to cut pieces of marble or other hard, stony materials, as well as for polishing them. It requires careful handling, and gloves and goggles should be worn at all times. It generates a lot of powder, so it is best used in the open air.

Electric cutter

Used for cutting up ceramic tiles, marble, granite, and other materials, this has a built-in diamond cutting disc and is water-cooled. It is a highly versatile and handy tool to have.

Goggles and protective mask

Goggles and a mask should always be worn when cutting tesserae, especially when using an electric disc cutter and when cutting stone on the anvil. They afford protection from the powdery dust and from any shards that might fly up when cutting.

▲ Cutting mallet

▼ Different types of nippers: pincers (A), flat nippers (B), and (C) tongs

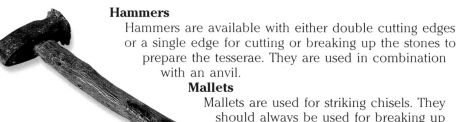

A

B

C

▼ Chisels

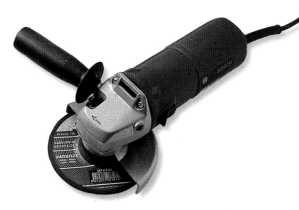

▲ Cutting disc

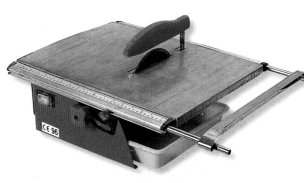

▲ Electric cutter

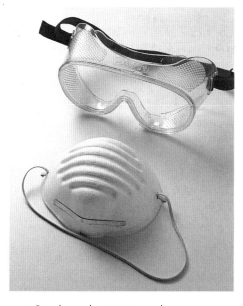

▲ Goggles and protective mask

Face protector
Made of plastic, the face protector is very useful when using an electric disc cutter.

Gloves
Leather gloves are used with electric disc cutter, mallet, chisel, and anvil. Rubber or latex gloves are worn when applying glues and epoxy adhesives, or when preparing mortar.

Tile cutter and tile splitter
As its name implies, the tile cutter is used for cutting and breaking up tiles into tesserae. It uses a small hard metal disc set into an arm that slides between two fixed fences.

The tile splitter, used together with the cutter, is quite useful for very hard tiles. This simple piece of equipment consists of a clamp that holds the tile over a set point and a lever that, when pulled down, applies pressure and snaps the tile along the scored line.

Hand cutter
The hand cutter has a small diamond disc for cutting glass paste and glass sheet tesserae.

Tweezers
Similar to nippers, metal tweezers are used for holding and laying small tesserae when making the mosaic.

Grinding stone
This special stone is used to sharpen objects and to file down the edges of cut tesserae.

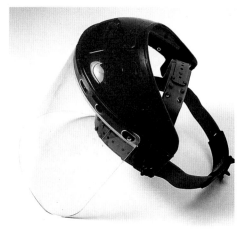

▲ Face protector

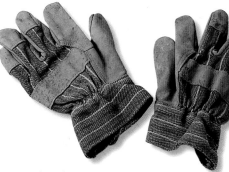

▲ Leather gloves

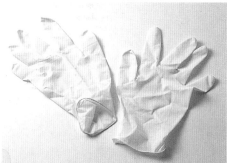

▲ Latex gloves

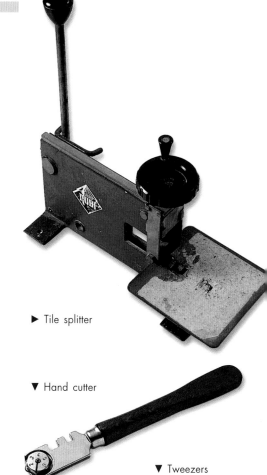

▶ Tile splitter

▼ Hand cutter

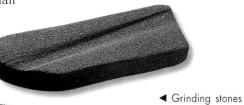

▼ Tweezers

◀ Grinding stones

▶ Trowels

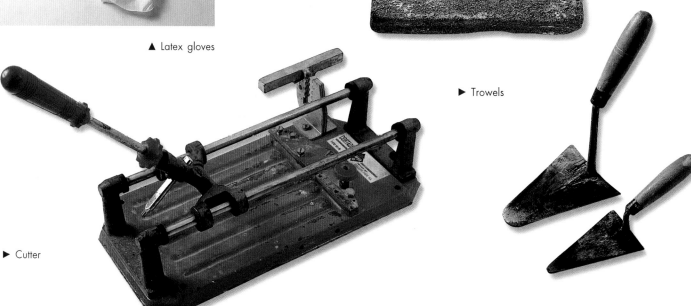

▶ Cutter

▲ Trough

Trowel
The trowel is used for mixing mortar and sand and spreading it over the back of the mosaic.

Small trowel
The small trowel is used for applying mortar in small amounts and for forcing it into the joins. It is also used for preparing adhesive cement in the trough.

Trough
Usually made of wood, plastic, or rubber, the trough is the vessel in which the mortar is mixed and prepared.

Scraper
The scraper is for filling in the joints between the tesserae with putty, on flat surfaces.

L-Square
The L-square is a metal, wood, or plastic instrument with two "arms" joined at a right angle; one arm is marked off in centimeters or inches.

Spirit level
The spirit level is used to check whether a line or plane is horizontal and to determine the difference in height between two points.

Brush, paintbrush, flat brush, and sponge
These implements are used to clean away remains of grout and mortar from the mosaic.

Matt knife and scissors
The matt knife and scissors are used to cut out designs and patterns on which to lay the mosaic. The knife can also be laid flat to scrape away the remains of any glue stuck to the surface of the tesserae.

Tape measure
A tape measure is necessary for measuring and for calculating proportions.

Plant mister
A plant mister is handy for dampening the surface of the mosaic during laying, as well as for wetting the clay and sand.

▼ Scrapers

▲ Various brushes

▼ L-square

▲ Tape measure

▼ Spirit level

► Matt knife and scissors

► Plant mister

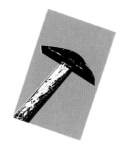

CUTTING TECHNIQUES

K nowing how to choose the right tool to break up a particular mosaic material is crucial. The desired shape and the hardness of the material must both be taken into account.

Nowadays there are power tools to cut almost any mosaic material, no matter hard it is. It is important to learn to handle these instruments, but it is also important to learn how to obtain almost perfect tesserae using only a hammer and an anvil. The hammer should deliver a single, firm blow to produce a straight cut with clean edges. Striking the stone several times will bring poor results; the slab will have chipped edges and the cut will be irregular. As with any other activity, practice is necessary

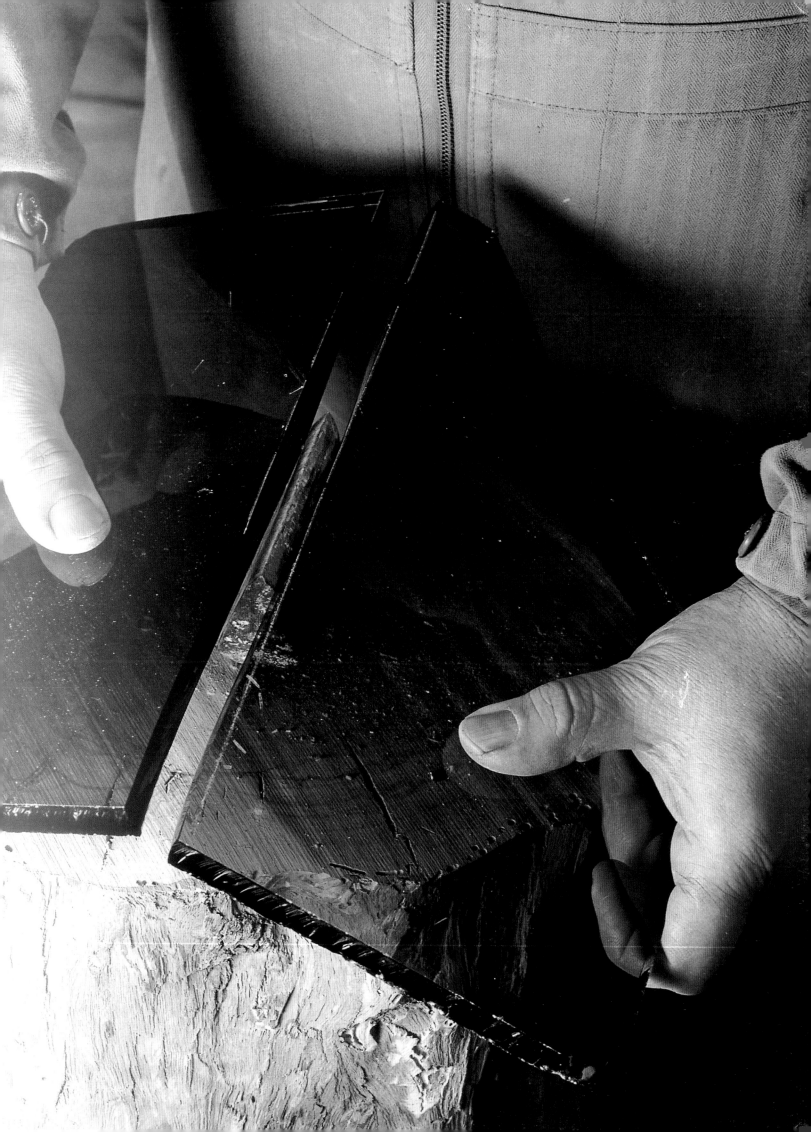

CUTTING VARIOUS MATERIALS

This section explains how to cut different materials—slabs of marble, slate, pebbles, and granite; ceramic tiles, glass paste, and glass—as well as how to cut using a power tool. We can start with the cutting mallet to break up a marble slab, cut it on the anvil, and finally use the nippers; we could also cut this slab using a power cutter. The final result is the same: tesserae.

Marble Slabs

Marble slabs for mosaics are sold ready prepared in specialty workshops in thicknesses of about 3/4 to 1 in. (2 to 3 cm), although most mosaicists generally use thinner slabs, between 3/8 and 3/4 in. (1 to 2 cm).

The process illustrated in the photographs shows how to split a marble slab 1 in. (3 cm) thick without any mechanical aid, just a mallet, chisels, and cutting mallet.

We could have the piece precut on the machine in the marble workshop, but that is not the purpose of this exercise, which shows a simple technique for cutting a marble slab and then breaking it up into tesserae. As you can see from the photographs, I changed the marble during the photo session, but I could have continued with the first piece with the same results.

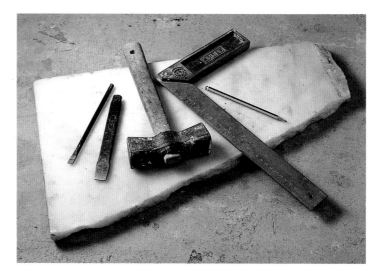

◀ 1. This is the piece of white marble I am going to cut. I prepare the chisels, mallet, L-square, and pencil.

▼ 3. I use the mallet and chisel to "score" along the marked line.

▼ 2. I draw a pencil line on the upper and lower part of the slab, with the aid of the L-square.

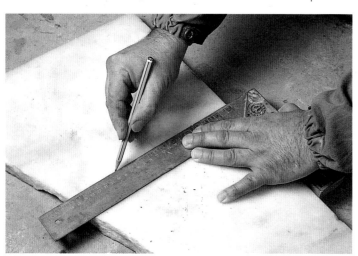

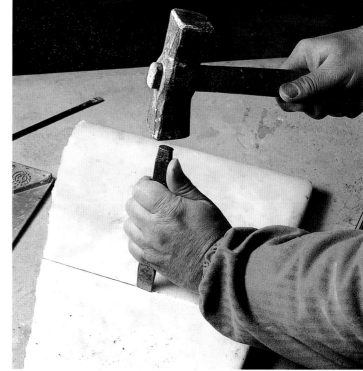

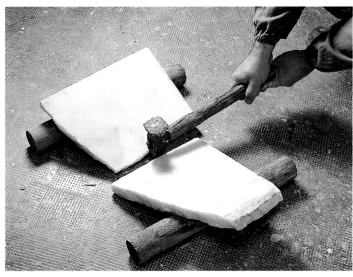

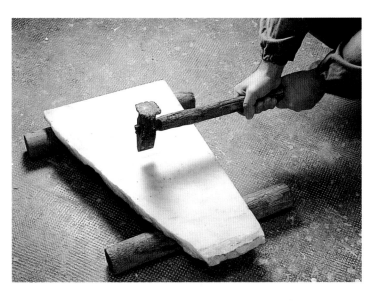

▲ 4. I place the slab of marble on two wooden rollers with the cutting line parallel to them. I take the hammer firmly and place it on the line, practicing the striking movement several times without actually hitting the marble, to check that the cut is true.

▲ 5. I raise the hammer and bring it down strongly and sharply. The marble slab splits exactly along the chiseled line. You can see the clean cut in the photograph.

▶ 6. Now I begin to cut a strip of marble using a hammer and anvil. I hold the marble firmly in my left hand and place it on the chisel head of the anvil, using my index finger as a kind of stop underneath against the chisel head. I place the hammer on the line to be cut.

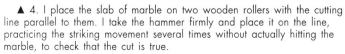

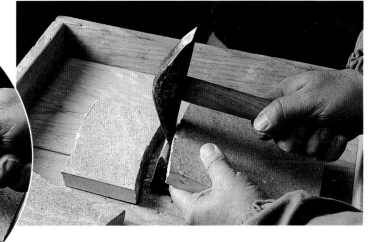

▼ 8. I repeat the process with one of the cut strips.

▲ 7. I bring the hammer down sharply and split the marble.

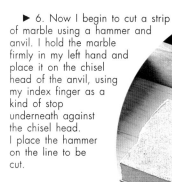

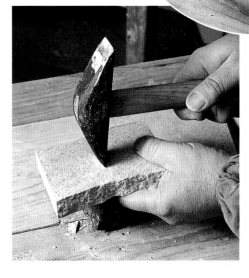

▶ 9. Here the hammer is about to strike another, smaller piece. Notice that the position of the hand has changed: I am holding the marble plaquette between the thumb and index finger. This is now the position for cutting all the tesserae.

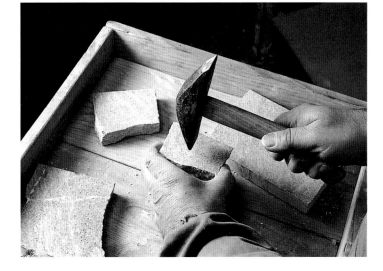

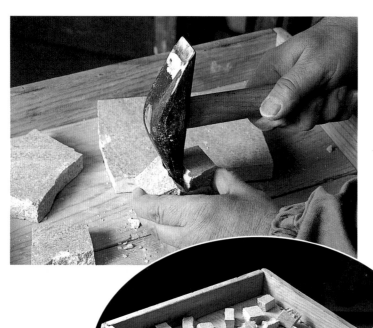

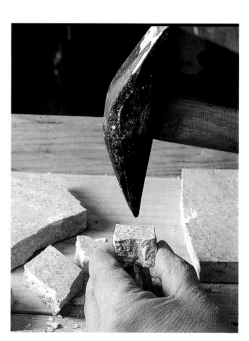

◄ 10. I now break up the plaquettes into smaller and smaller pieces.

► 11. I can obtain two tesserae from this small piece of slab.

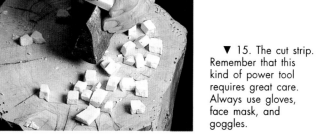

► 12. The wooden tray holds the cut tesserae.

◄ 13. I use the chisel and hammer to prepare smaller tesserae from white marble.

▼ 14. To cut this strip of black marble with an electric cutting disc, I place the strip on a piece of wood and clamp it to the table, inserting another piece of wood to protect it from being scratched by the clamp. The strip must be held perfectly tight. I run the disc gently along the marked line, with a forward and backward motion. I run over the cut again, as many times as necessary until the strip is cut through. You should not attempt to slice straight through the marble in one pass.

▼ 15. The cut strip. Remember that this kind of power tool requires great care. Always use gloves, face mask, and goggles.

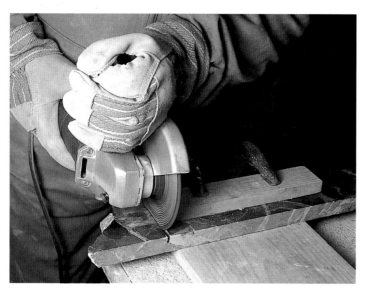

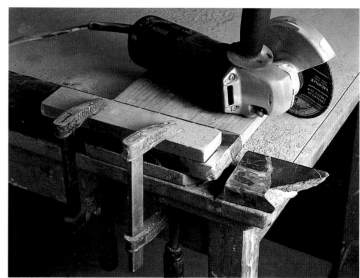

Slate is a type of stone that belongs to the group of metamorphic rocks. It can be considered a "soft" rock since it is easy to cut, as long as this is done in the direction of its strata, or layers.

A mallet and chisel are used to split the slabs, which are then shaped using nippers. Slate can be cut easily with an electric cutter, provided it is held firmly, although it does splinter slightly in the cutting area due to the vibrations of the machine. A diamond disc cutter will yield a perfect cut. Slate is sold in slabs a minimum of 3/8 in. (1 cm) thick, and perfectly square.

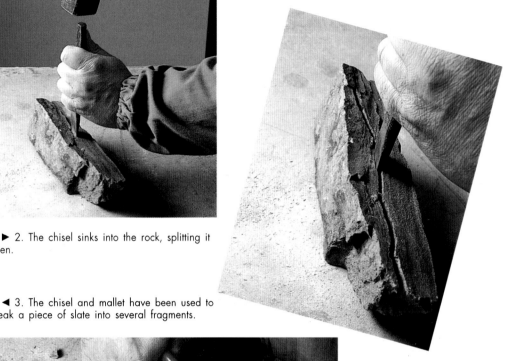

◄ 1. Slate is easy to cut provided you follow its natural strata. Place the piece of slate on its edge and choose the desired thickness. Prepare the chisel and mallet and hit medium hard.

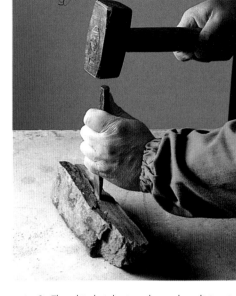

► 2. The chisel sinks into the rock, splitting it open.

◄ 3. The chisel and mallet have been used to break a piece of slate into several fragments.

◄ 4. I use tongs to prepare the tesserae.

◄ 5. Here I am using an electric cutting disc to cut a piece of slate. The procedure is the same as that for cutting marble in step 14 on the opposite page.

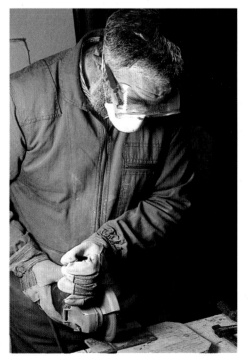

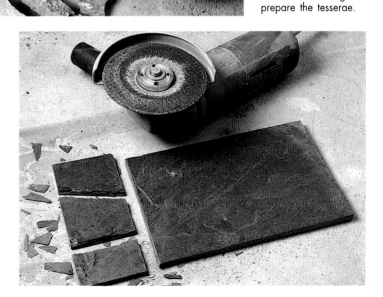

► 6. Three fragments have been cut from the slate with the electric cutting disc.

Pebbles and Granite Tesseras

I f pebbles need to be split, the easiest way is use the anvil. Since they are round or oval, they must be held firmly on the anvil before they are struck. Blows should be accurate and strong in order to split them on the first attempt. As the photographs show, a particular shape of pebble can be cut up differently to produce a variety of tesserae shapes, which can be used either face up or face down.

Flat pebbles can easily be cut with nippers. The cut should begin across the edges, not the middle, which would require too much strength.

Because granite is one of the hardest rocks, it should be cut into strips mechanically to obtain tesserae 3/8 in. (1 cm) thick. Again, nippers can be used for this, but they should be applied to the center, not the edge of the strip. Electric disc cutters are not recommended due to the vibrations they cause. A standing electric cutter can be used, however, for a more precise cut.

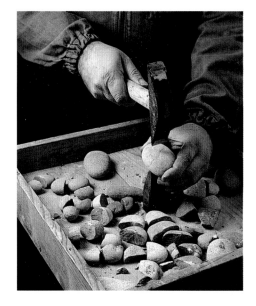

▲ 1. Round or thick pebbles should be cut using the hammer and anvil. The system is the same as before, except that the pebble should be held tightly, using the middle or ring finger against the anvil as a stop to prevent the stone from slipping.

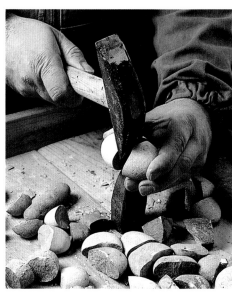

▲ 2. Notice the position of the hand holding this freshly cut pebble.

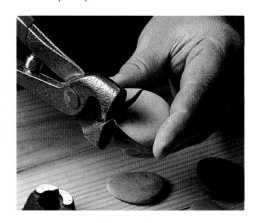

▲ 5. Biting strongly with the nippers cuts clean through the pebble.

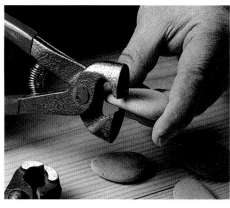

◄ 3. Pebbles can be cut into tesserae of various shapes.

▲ 4. Flat pebbles can easily be broken with the nippers. Notice how the nippers are used to break off a piece from the edge, never the center.

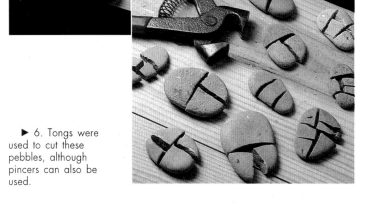

▶ 6. Tongs were used to cut these pebbles, although pincers can also be used.

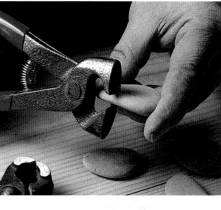

▶ 7. These tesserae were cut from strips of granite using pincers. Granite is extremely hard, but if it is first cut into strips in a specialty workshop, it can be more easily cut with the nippers.

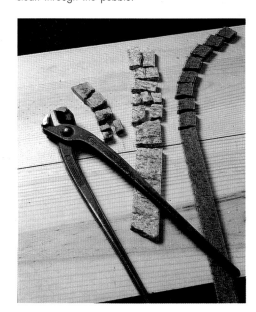

lass paste is sold in rectangular slabs ranging in thickness from 1/32 to 3/4 in. (1 to 20 mm). Although it is easy to cut, it requires more care than some other types of material. Before trying to cut or split it, it should be scored on both sides using a diamond cutter and then struck against the anvil along the cutting line. This operation is then repeated until the fragments are too small to continue using both hands. Then a hammer is used until the tesserae are of the desired size. A slab as thick as 3/4 in. (2 cm) will not yield very small tesserae. Take great care with glass shards and always use safety goggles or a face mask when cutting.

◄ 1. Slabs of glass paste are easy to cut but they should first be scored using a glass-maker's hand cutter.

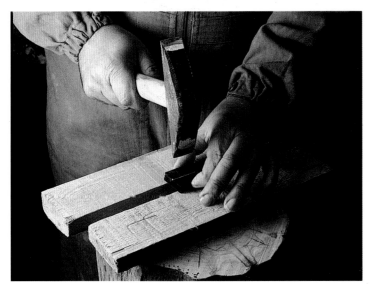

◄ ▲ 2. Grip the slab with both hands and bang it sharply against the anvil.

▼ 3. I place two pieces of wood on the log and bring the hammer down on the plaquette resting on the anvil.

▼ 4. The tesserae were prepared with these tools.

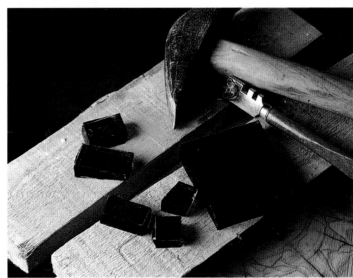

Plate Glass

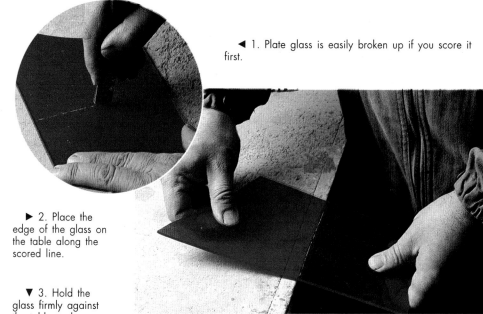

◀ 1. Plate glass is easily broken up if you score it first.

Sheets of glass come in a very wide range of colors and are easy to find in specialty stores and glass workshops, which frequently have a lot of off-cuts that are too small to sell separately for stained-glass work but are very handy for the mosaicist.

Cutting this material is simple once you have mastered the use of the diamond cutter. The procedure is the same as for glass paste, except that sheet glass is not as thick, so simply scoring and striking it is usually enough to break it up. Plate glass allows us to produce more-irregular shapes of tesserae because we can score virtually any shape we want with the diamond cutter.

▶ 2. Place the edge of the glass on the table along the scored line.

▼ 3. Hold the glass firmly against the table and press down with the other hand. The glass should split easily.

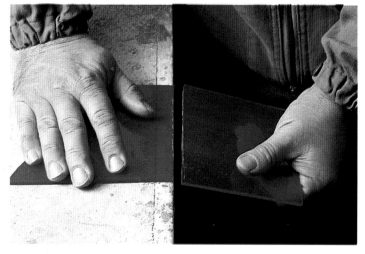

▼ 4. Strips of glass must be cut up to make tesserae. This is best accomplished with flat nippers.

▼ 5. You can also score thinner strips with the diamond cutter.

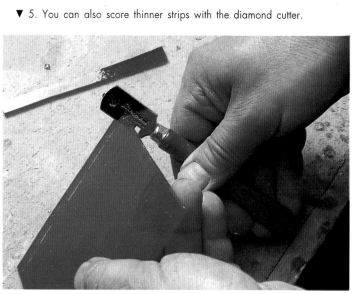

▼ 6. Slabs have been cut into strips, and then into tesserae.

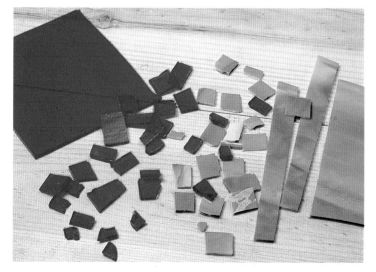

The use of ceramic tesserae is relatively modern. This is strange because they appear almost to have been made expressly for this type of artistic creation. There are ample reasons for using them: their extraordinary range of colors and low price; their simplicity of use and hard-wearing nature; and the fact that many types of adhesive or mortar can be used.

The pastes used for making ceramic tiles are fired at either low or high temperature (from about 1650 to 2400°F [900 to 1300°C]); the first type is easy to cut, while the second requires a tile cutter as well as an electric cutter. The resulting tesserae, laid as if they were an opus incertum, have been used to create extraordinary works such as those of the Catalan architect Antoni Gaudí at the beginning of the twentieth century.

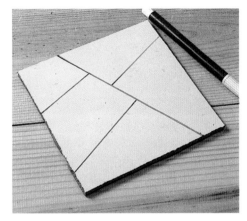

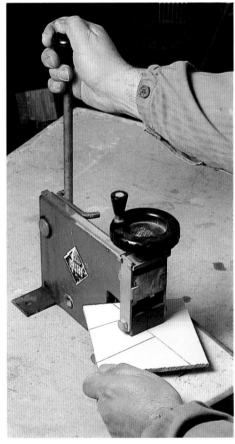

▼ 4. Pull down the lever to cut cleanly through the tile.

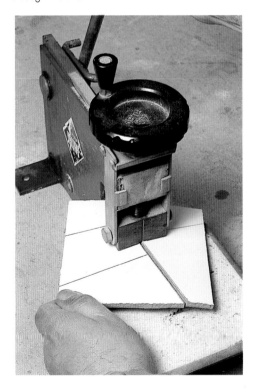

▶ 5. Repeat this operation until the tile is broken up.

◀ 1. Ceramic tiles are very easy to cut with a tile cutter. Draw the cutting lines on the tile with a felt marker pen.

▼ 2. Place the tile on the cutter, position the wheel on the main line, and slide it along.

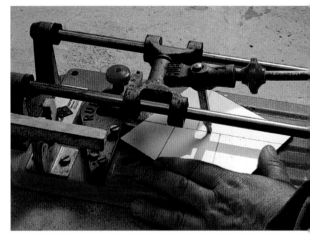

◀ 3. Use the tile splitter to break up the tile.

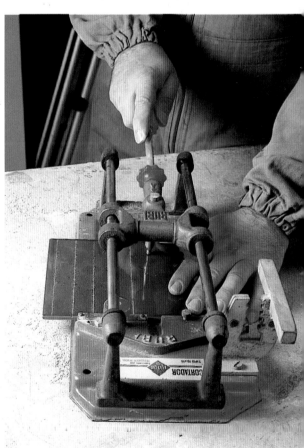

▲ 6. It is easy to prepare tesserae with the tile cutter alone. Score vertically, forming a right angle with the measured guide on the upper part.

▼▶ 7. Turn the tile around to cut horizontally.

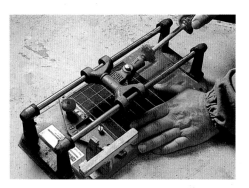

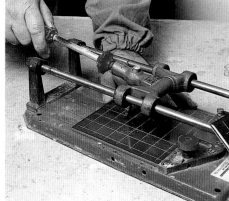

▼ 8. The scored tiles are ready to be transformed into tesserae.

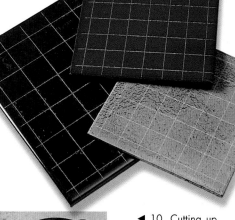

◀ 9. Break the tiles into strips.

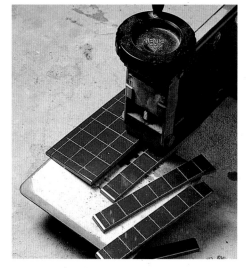

◀ 10. Cutting up the strips yields the tesserae.

▼ 11. To obtain a circle, semicircle, or oval of tile, use the cutter. Draw the desired shape on the tile and draw a geometric shape around it.

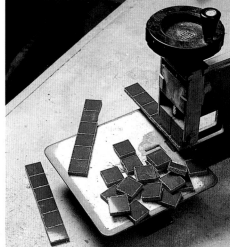

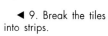

▼ 12. Use the cutter to remove most of the waste material.

▼ 13. Use nippers to nibble down to the outer circle.

▼ 14. Round the tile down to the desired shape with a grindstone.

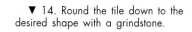

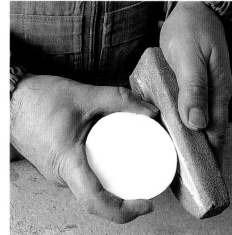

Certain specialized industries handle, prepare, and cut slabs of stony material such as marble, travertine, granite. These industries require a lot of space due to the huge quantity of material they stock and their large-scale machinery, which is programmed to carry out automatically the heaviest, most repetitive work. Large blocks of stone, brought directly from the quarry, are cut into slabs of different thicknesses and conveyed by powerful cranes. But specialized workers are needed for manual jobs or those requiring special attention, as well as for small projects that cannot be handled by large machines.

The mosaicist who uses this type of material must look to a special workshop such as this before starting to work. No other supplier has such an amount and range of material on display. Strips and pieces of stone can quickly be transformed into tesserae for use in mosaics.

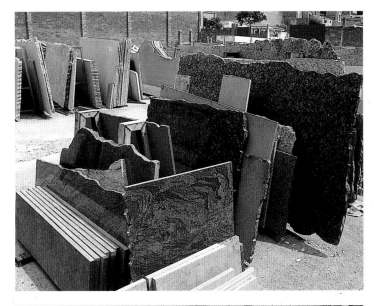

◄ Slabs of marble and granite are stored in an industrial workshop.

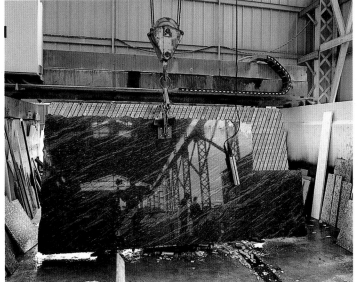

◄ A powerful crane is used to move a polished slab to the cutting machine.

▼ This water-cooled manual polishing machine is used for marble, granite, or any other small stony material. It swivels in all directions, and the abrasive disc can be changed depending on the type of polish desired.

▼ Automatic cutting machines such as this are preprogrammed and work virtually unaided. They are water-cooled to keep the saws from overheating and to the prevent the generation of powder that would result from dry cutting.

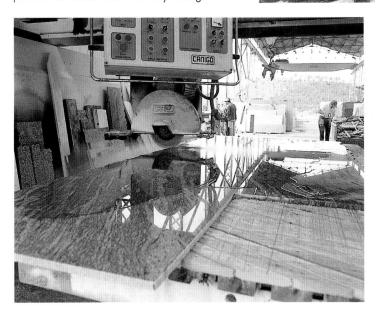

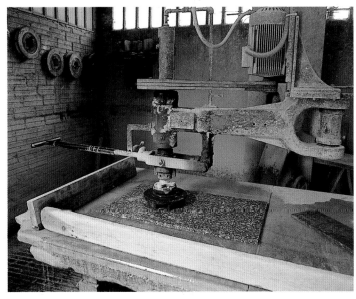

LAYING SYSTEMS

T he creation of mosaics requires a good theoretical and practical knowledge of the subject, which takes some practice. The modern-day mosaicist carries out all the processes alone, but this was not the case in Roman times, when everything was carried out by a team. In the Roman mosaic workshop, called the *officinal*, a specific task was assigned to each worker. The orderly Romans regulated the name of the workers and their functions in the preparation and laying of the mosaic. Thus, the *pictor imaginarius* was the artist who drew the design for the mosaic. The *pictor parietarius* transferred the design to the wall or floor. The *palidarius* prepared the tesserae themselves by cutting up slabs of marble. The *tesselator* or *tessellarius* laid the stone pavement and set the tesserae in accordance with the drawing. The *calcis coctor* was in charge of preparing the lime. The *musivarius* was the artist who created wall mosaics using glass paste.

This chapter explains some of these systems. Before we begin to lay the tesserae, we must first decide on a design, and for this we need a preliminary sketch to guide us. Explained on the following pages are the two main systems that were used for developing these works. The rest of the chapter explores the different kinds of bases, adhesives, mortars, and frames, as well as a summary, in table form, of all this information.

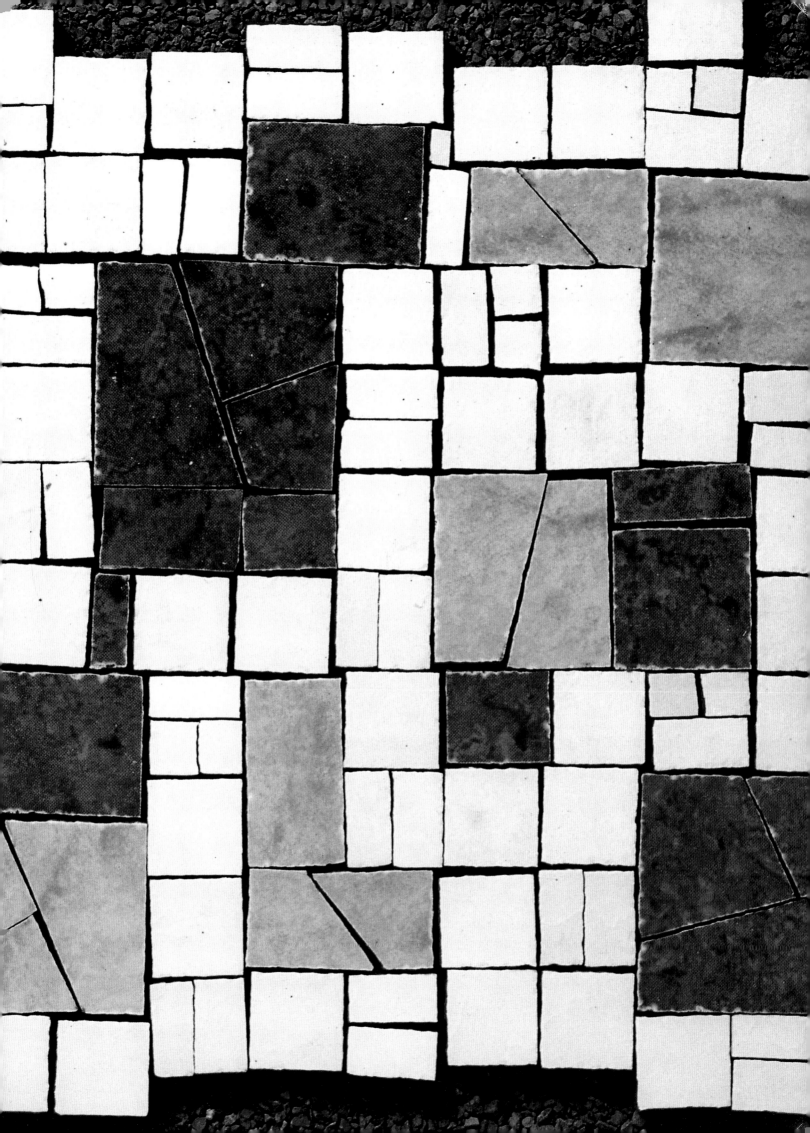

The Preliminary Sketch

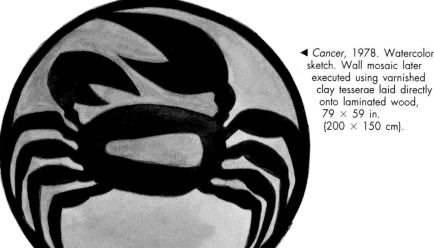

◄ *Cancer*, 1978. Watercolor sketch. Wall mosaic later executed using varnished clay tesserae laid directly onto laminated wood, 79 × 59 in. (200 × 150 cm).

Many artforms require a preliminary sketch before actual work can begin, and mosaic work is no exception. This sketch, which is usually smaller scale than the actual mosaic, acts as a reference point during the mosaic's development. Bear in mind that it is difficult to reproduce the sketch exactly when working on the mosaic because the different colors that can be obtained with watercolor, gouache, oils, or other paints will not precisely match the colors of the mosaic material. So we should focus on masses of color rather than subtle changes in hue.

Some mosaicists are able to start their mosaic with just a rough colored outline. Others, however, need not merely an outline but a full sketch detailing all the elements in the composition and the colors for the final work. Use whichever system works for you; just remember that however elaborate a sketch may be, when laying the actual mosaic you should always feel free to adapt your initial project as the work develops.

Mosaic work is not excessively complicated but it does require a long time as well as some degree of expense, so it is important to have a clear idea of what you want to do before beginning. Some artists feel that carefully plotting out a design ahead of time may sacrifice spontaneity, but I believe that if the

▼ *Tree*, 1978. Watercolor sketch for a wall ceramic, 79 × 39 in. (200 × 100 cm).

▼ *Bird*, 1978. Colored pencil sketch.

▼ *Bird*, 1978. Mosaic, 13 × 14 in. (34 × 36 cm). Ceramic tile tesserae laid directly on a bed of mortar.

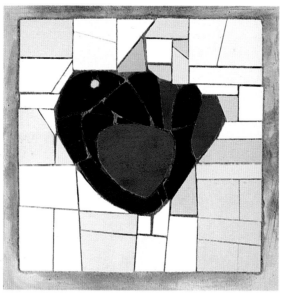

idea itself is original and spontaneous, this will be apparent in the finished work.

In my experience, both as a professional mosaicist and teacher, I found that finding solutions to potential problems beforehand helps us to work more calmly and ultimately saves time and unnecessary effort. But this should not prevent us from making changes as necessary if we discover they are appropriate.

Once the sketch is complete, it must be enlarged to actual working size. This can be done by imposing a grid over the sketch and redrawing it to scale, or by enlarging it on the photocopier. Then the enlargement must be transferred to the base. There are several methods for this: carbon paper, templates, scored lines, stencils, or even a slide

projector. Experiment to discover which method works best for you.

On these pages are a number of sketches drawn over a period of years, some accompanied by a photograph of the finished work. Note that chromatic changes have been made, but dramatic formal differences have not occurred.

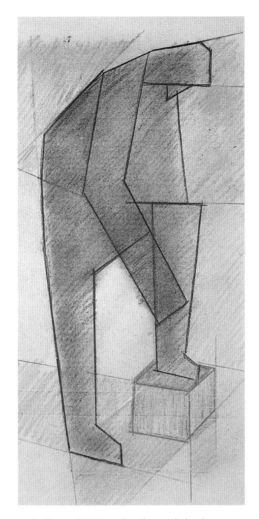

▲ *Figure*, 1979. Colored pencil sketch.

▼ *Still Life*, 1980. Colored pencil sketch.

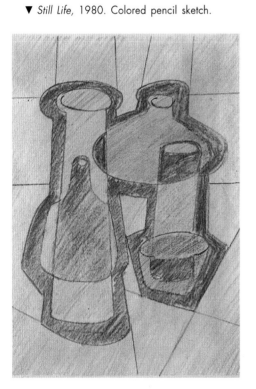

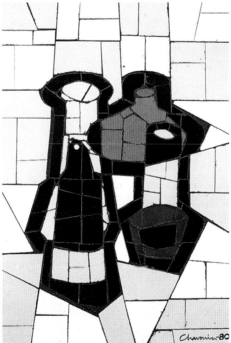

▲ *Figure*, 1979. Mosaic,
27 1/2 × 9 3/4 in. (70 × 24.5 cm).
Ceramic tile tesserae laid directly on a base of fiber cement.

◄ *Still Life*, 1980. Mosaic, 20 × 14 in.
(50 × 35 cm). Ceramic tile tesserae laid directly on a base of fiber cement.

◄ ▲ ▼ Various watercolor sketches for wall mosaics, 1980; mosaics later executed in ceramics, 53 × 41 in. and 53 × 31 in. (135 × 105 cm and 135 × 78 cm).

▶ *Wood* (detail), 1981. Wall mosaic, 16 1/2 × 10 ft. (500 × 300 cm); detail, 20 × 20 in. (50 × 50 cm). Ceramic tile tesserae laid directly on laminated wood.

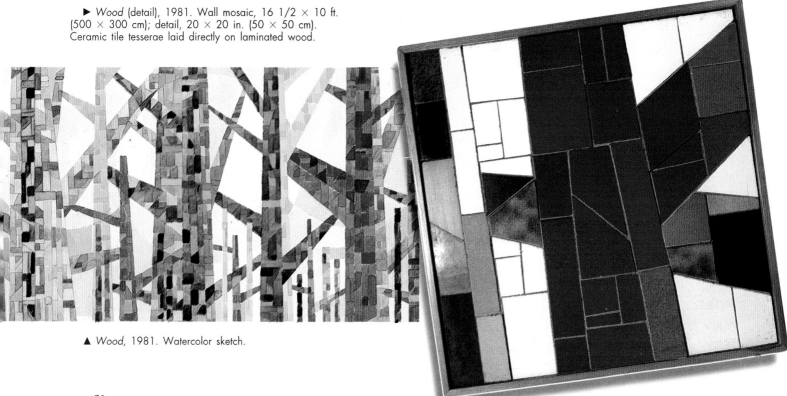

▲ *Wood*, 1981. Watercolor sketch.

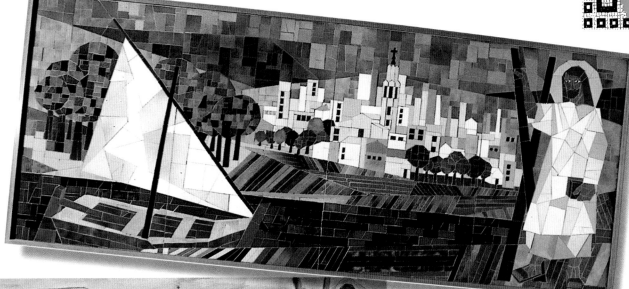

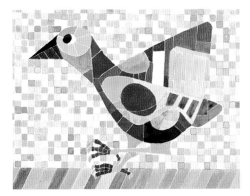

▲ *Saint Andrew,* 1981. Watercolor sketch.

◄ *Bird,* 1982. Watercolor sketch.

▼ *Bird* (detail), 1982. Wall mosaic, 13 × 10 ft. (400 × 300 cm); detail, 23 × 19 in. (58 × 49 cm). Ceramic tile tesserae indirectly laid on a bed of mortar using the direct system.

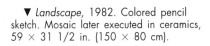

▲ *Saint Andrew,* 1981. Wall mosaic, 13 ft. × 59 in. (400 × 150 cm). Ceramic tile tesserae laid directly on chipboard.

▼ *Landscape,* 1982. Colored pencil sketch. Mosaic later executed in ceramics, 59 × 31 1/2 in. (150 × 80 cm).

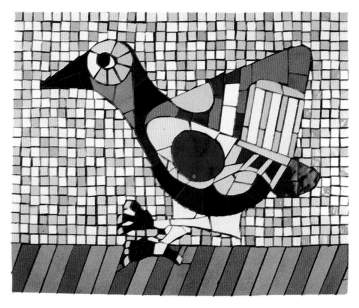

◄ *Tree*, 1983.
Watercolor sketch.
Project later executed in
ceramics, 13 × 13 ft.
(400 × 400 cm).

▲ *Ashtray*, 1985. Watercolor sketch.

◄ *Ashtray*, 1992. Mosaic,
8 × 8 × 1 5/8 in. (21 × 21 × 4 cm).
Ceramic tile tesserae laid directly onto a
tile.

▼ *Mirror*, 1987. Watercolor sketch.

◄ *Mirror*, 1986. Watercolor sketch.

▼ *Mirror*, 1992. Mosaic,
24 3/4 × 17 3/4 in. (63 × 45 cm).
Ceramic tile tesserae laid directly onto
a wood base.

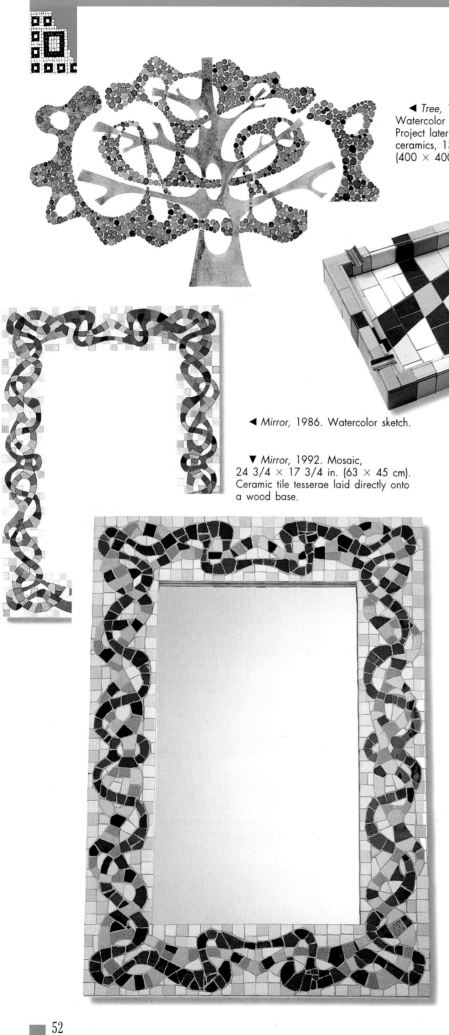

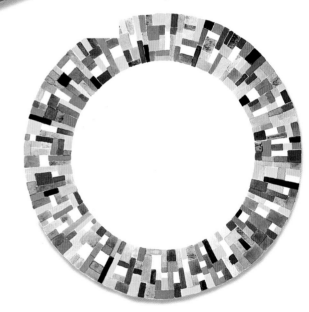

▼ *Mirror*, 1993. Mosaic, 21 in. (54 cm) diameter.
Ceramic tile tesserae laid directly onto a wood base.

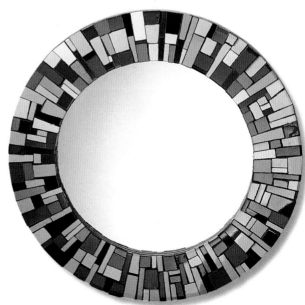

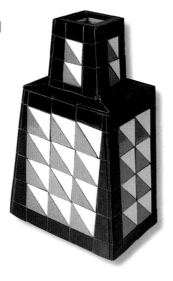

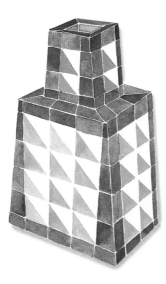

◄ *Vase*, 1993. Mosaic, 7 1/2 × 4 3/4 × 12 in. (19 × 12 × 31 cm). Ceramic tile tesserae laid directly onto a shaped and baked ceramic vase.

▼ *Table*, 1992. Watercolor sketch.

◄ *Vase*, 1990. Watercolor sketch.

▼ *Table*, 1994. Mosaic, 27 1/2 × 12 in. (70 × 30 cm). Glass paste tesserae measuring 3/4 × 3/4 in. (2 × 2 cm) laid directly onto a base of laminated wood.

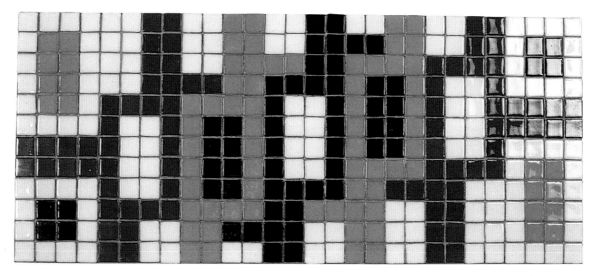

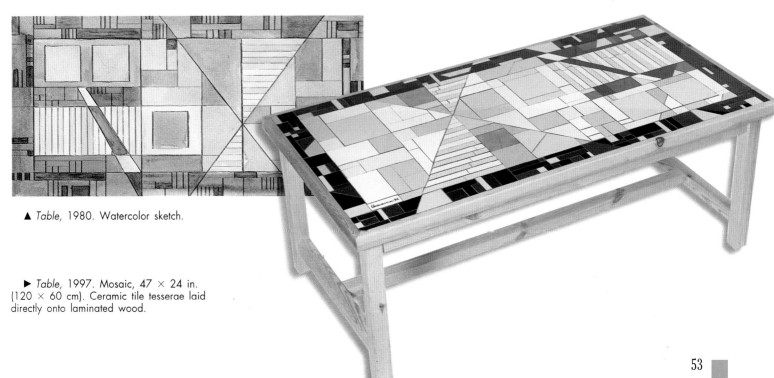

▲ *Table*, 1980. Watercolor sketch.

► *Table*, 1997. Mosaic, 47 × 24 in. (120 × 60 cm). Ceramic tile tesserae laid directly onto laminated wood.

LAYING TECHNIQUES

Opus is the Latin term for work or task; *opus musivum*, therefore, refers to working in mosaic. There are three basic systems for mosaic pavements: *opus tessellatum, opus sectile,* and *opus vermiculatum.* There are also other systems that use combinations or variations of these three.

Preparation

Pliny the Elder explained how his contemporaries prepared the ground before laying a mosaic. Following his instructions, I have prepared the model seen here.

First, they smoothed the earth and laid a bed of pebbles and rocks arranged tightly together. This layer, the *statumen,* was about 3 to 5 in. (8 to 12 cm) thick. On top of this they laid rough mortar, *rudus,* comprising three parts gravel and fragments of terra-cotta and one part lime, about 10 in. (25 cm) deep. Then came the *nucleus,* made from three parts sand mixed with smashed tiles and bricks, and one part lime. The design was scored into this top layer and then the mosaic was set into a mortar of fine sand and lime. This produced thick, consistent, and solid pavement, with all the layers firmly bonded together.

◀ **Joaquim Chavarria**, cross-section model of a Roman pavement as described by Pliny the Elder, 1997, 12 × 12 × 9 1/2 in. (31 × 31 × 24 cm).

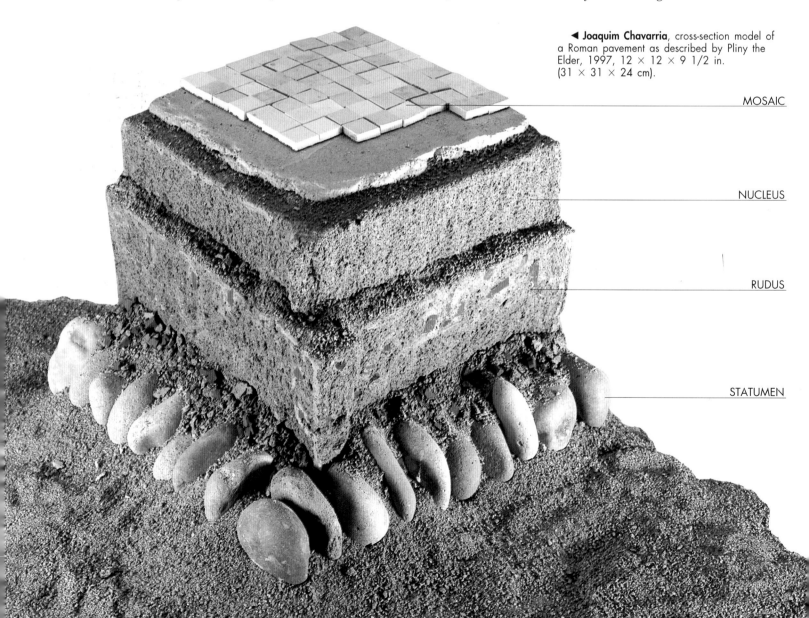

MOSAIC

NUCLEUS

RUDUS

STATUMEN

As mentioned above, the Romans employed three basic systems, or opus, for laying mosaics: tessellatum, sectile, and vermiculatum.

Opus tesselatum used cubed tesserae measuring approximately 3/16 to 1 1/8 in. (.5 to 3 cm), in black and white.

Opus sectile used stone slabs rather than tesserae. Generally of marble, in varying sizes and irregular shapes, the slabs were accurately cut up and used to form pavements with a rich coloring.

Opus vermiculatum, whose name apparently derives from the Latin word *vermis* (worm), is the most detailed of the three. These tesserae are often extremely small, under 3/16 in. (.5 cm), allowing highly detailed motifs to be drawn and laid. In this technique the crevices between the tesserae are hidden to produce subtle shadings of color that are impossible to achieve with larger pieces.

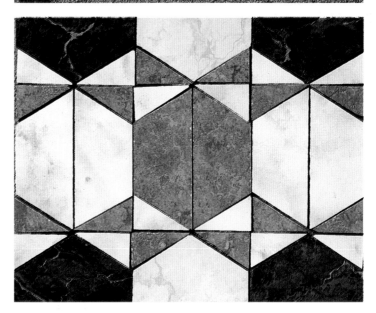

◄ **Opus tesselatum** uses cube-shaped tesserae, all the same size but different colors. Motifs are represented by laying black tesserae against a white background, while the outline is white on black. This method is used for composing geometric designs.

▼ **Opus incertum** uses irregularly shaped slabs of stone, usually small in size and slightly smoothed down. They were sometimes laid in horizontal lines, though generally they were laid without following any particular order, hence the name, which means "uncertain."

► **Opus sectile** is more a form of embedding than a true mosaic system. Slabs of marble or other stone, called *crustae*, form geometric patterns. Later animal and floral motifs were introduced, indicating the high level of mastery this system attained.

▼ **Opus vermiculatum** is the system most suitable for creating figures and scenes and is usually combined with opus tessellatum. Each tessera is perfectly adapted to the outline of the drawing, allowing almost any kind of design to be created.

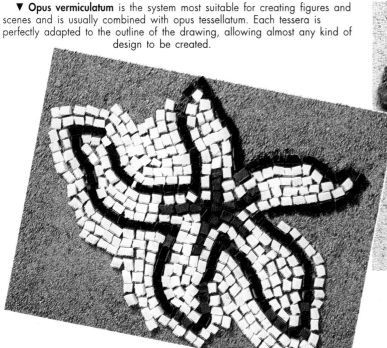

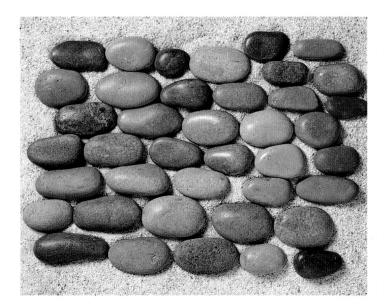

◀ **Opus lapilli,** possibly the earliest example of mosaic pavement, is a system in which the pavements were made using pebbles bound by compacted earth or a mixture of lime and sand.

▶ **Opus musivum** is the name given to wall mosaics, which used only glass paste tesserae, transparent and/or opaque. The artist who carried out this kind of mosaic was a known as a *musivarius*. This method reached technical perfection during the Byzantine period.

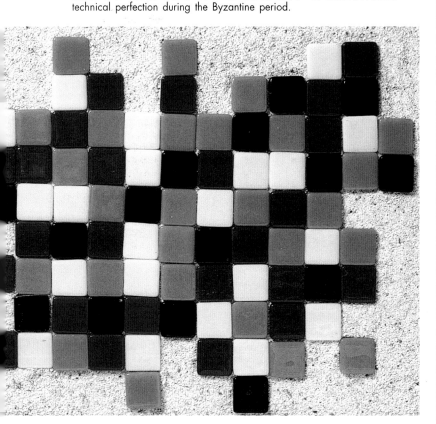

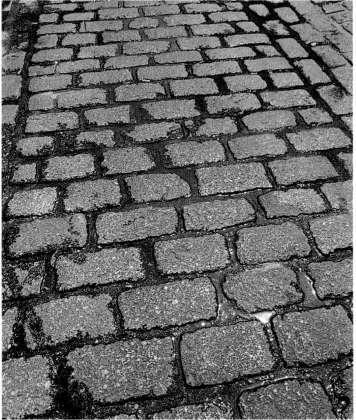

▲▶ **Opus quadratum** clearly has its origins in architecture in which stone was hewn into blocks in the form of a parallelepiped. Formed by parallelepipeds of stone arranged in regular, parallel rows, which lends a checkered appearance. It was employed for paving ancient streets, using granite cobbles, dry-bedded and bound by sand.

▲ **Opus reticulatum,** another basic construction technique, features tesserae in oblique rows, formed by stone pyramids whose quadrangular base is visible on the wall.

► **Opus segmentatum** derives from a type of pavement made with spare bricks, interspersed with shiny stones. The next step in its evolution was a mosaic formed of equal-sized tesserae combined with other tesserae of the same color, but larger.

▼ **Opus signinum,** which takes its name from the city of Signia, consists of different-colored tesserae placed slightly apart in simple geometric patterns on a smooth pavement base, prepared with powdered brick and lime.

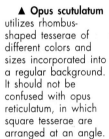

▲ **Opus scutulatum** utilizes rhombus-shaped tesserae of different colors and sizes incorporated into a regular background. It should not be confused with opus reticulatum, in which square tesserae are arranged at an angle.

▼ **Opus spicatum,** derived from method of brick laying, features tesserae laid in rows in a herringbone pattern. Pebble pavements with this design can still be seen in the streets of certain cities dating back to the Middle Ages.

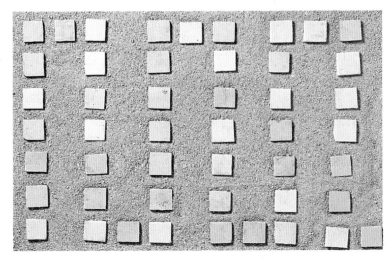

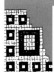

Direct Method

Probably the easiest and certainly the oldest technique of laying mosaic, the direct method consists of placing the tesserae directly onto the base, which has been first coated with glue or mortar. This method can be used for any type of work, both small- and large-scale projects. It is practical for pavements and large wall mosaics, provided they are mounted on laminated wood, fiber cement, or even marble frames, as was done by the mosaicists of old when creating *emblema*. Very large surfaces are impractical, however, since the excess weight might detach the mosaic from the adhesive cement.

Laying the tesserae one by one enables you to see how the mosaic is progressing and to control it throughout the entire process. The step-by-step demonstration shown here uses the direct system on a piece of fiberglass mesh. A full-size sketch was made on paper, then the fiberglass mesh was placed over the drawing to enable it to be transferred. After the design is traced onto the mesh, the sketch is removed and replaced by a sheet of waxed paper to keep the glue from sticking to the worksurface.

The tesserae are stuck to the mesh using a drop of neoprene glue. Use as little adhesive as possible so that the entire surface of the tesserae is not covered and will adhere to the mortar. The tesserae can be rearranged until the glue hardens.

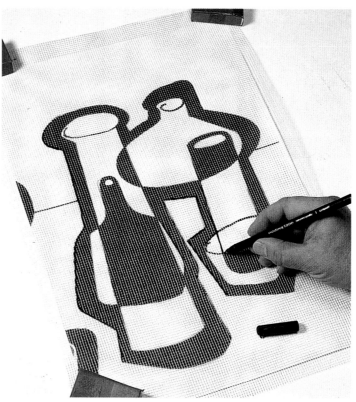

◀ 1. Place the fiberglass mesh over the actual-size drawing. Anchor the paper with weights and draw over the design with a felt-tip pen.

▼ 3. A few drops on the back of the tesserae is sufficient for them to adhere well to the mesh. Use rubber or latex gloves to protect your hands from the glue.

▼ 2. Remove the drawing and place two sheets of waxed paper under the mesh to keep the glue from sticking to the worksurface.

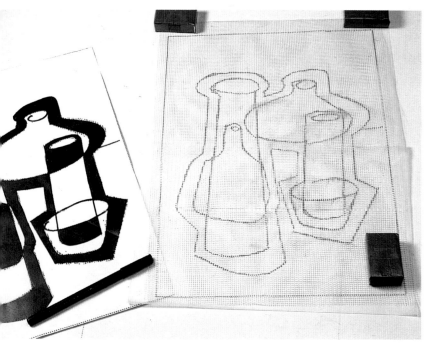

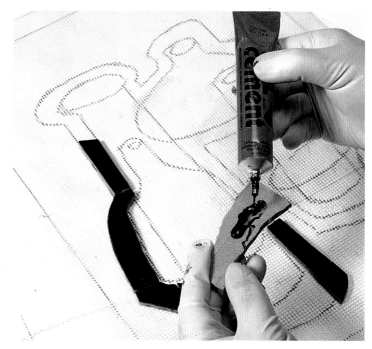

The indirect method is subdivided into two techniques: direct and reverse. Each depends on the material used. In the direct version, any type of material commonly used for mosaics can be used, but the reverse technique will work only with tesserae that are the same color on both sides.

Direct Laying

In this process, tesserae are laid on a provisional base—such as dry sand, soft clay, or plasticine—that enables them to be attached without any adhesive. The tesserae are carefully embedded in these materials until the entire surface is completed. It is important that the tesserae be set at the same level: to level them, tap gently with a flat piece of wood.

Once the process of laying the tesserae is complete, the mosaic is covered with water-soluble glue and brown paper and pressed down with a brush for a perfect join. If the surface is relatively large (over 10 x 10 in. [25 x 25 cm]), it is advisable to apply a second coat of glue and brown paper to ensure that the base will withstand the weight of the mosaic.

If the surface of the mosaic is not entirely flat, as is the case with tiles and pebbles, it is preferable to use tarlatan (starched muslin) as a base as it will adapt perfectly to the small undulations of the tesserae.

Once the base has dried completely, it can be turned over. Any remains of the base material are carefully removed and it is then ready for the mortar to be poured over it.

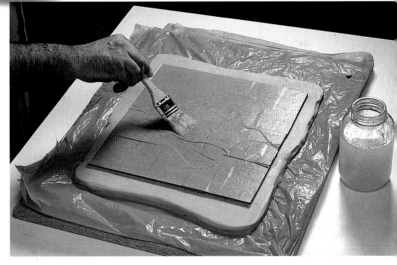

◄ 1. The tesserae are all cut before beginning the process. Prepare a plasticine base (soft clay or dry sand works equally well); this one measures about 15 ×15 in. (38 × 38 cm). Lay out the tesserae and gently press them into the plasticine.

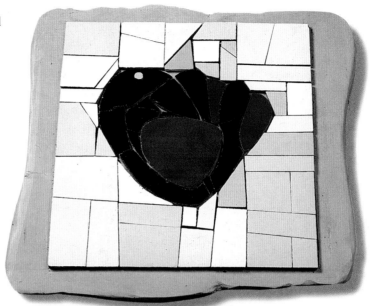

► 2. Cut out two sheets of brown paper the same size as the mosaic; in this case 12 × 12 in. (30 × 30 cm). Apply water-soluble glue to the entire surface of the mosaic and lay one of the sheets of paper on top, smoothing it down with your hand. Apply a coat of glue to the surface of this sheet and place the second sheet over it. (This second sheet helps ensure that the paper will support the weight of the mosaic.) Let the glue dry.

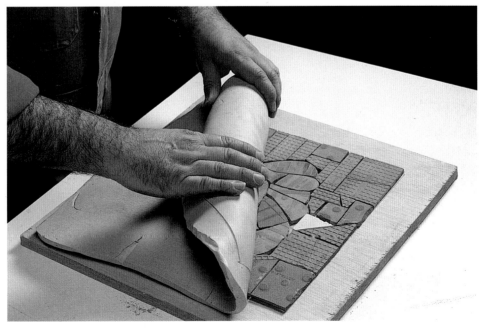

► 3. When the glue is completely hard, turn the mosaic over and place it on a wooden board. Carefully lift up the plasticine base, making sure no tesserae come unstuck. If that happens, reglue and reposition it. Clean away any remains of plasticine. The mosaic is now ready for the mortar.

Reverse Laying

This technique requires the use of tesserae that are the same color on each side, such as marble, glass, smalti, glass paste, and colored ceramic. The mosaic is laid in reverse from its final appearance, but because the process reverses the image twice, the finished mosaic will have the same orientation as the original drawing.

The motif is first drawn on paper, and then transferred with a piece of carbon paper and a piece of brown kraft paper. The tracing process reverses the image onto the other piece of paper. The tesserae are then laid on this reverse drawing. Part of the paper is glued with water-soluble glue and the tesserae are then laid with a little extra glue. This process is repeated until the mosaic is finished. A variation of this system, used especially for small tesserae, is to hold then with tweezers and apply glue to the base.

▶ 1. In addition to the finsished drawing, this method requires pencil, kraft paper, carbon paper, and weights.

▼ 2. Place the carbon paper face up, then the kraft paper the glossy side down on the carbon, and finally the drawing on top of that. Weight down the corners so the paper will not move and trace over the lines with a hard lead pencil.

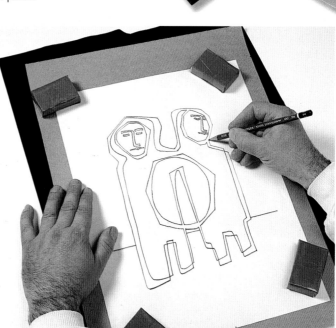

▼ 4. Lay out the tesserae on the kraft paper. (The tesserae must be the same color on both sides; in this case, white marble and black granite.) Apply glue to one side of the tesserae and lay it on the paper. When the entire surface of the paper has been covered with tesserae, allow it to dry before applying the mortar. Remember that the finished mosaic will have the same orientation as the original.

▼ 3. The process produces a mirror image of the original motif on the kraft paper.

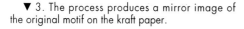

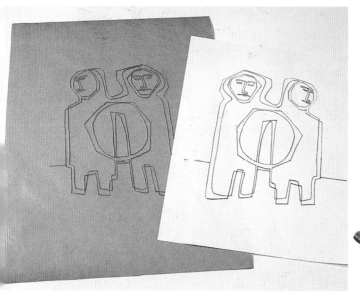

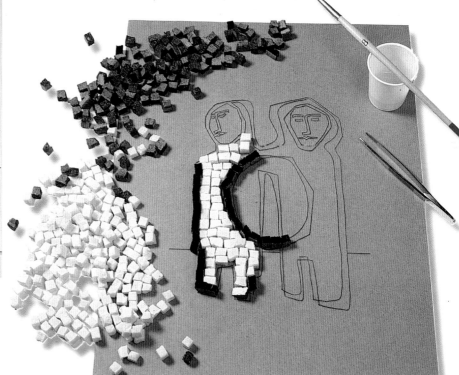

Although this is not a common technique, mosaics can be set directly onto a wall, as long as the correct method is used. The method requires adhesive cement of the kind used for laying wall and floor tiles. Always follow the manufacturer's instructions for using the cement.

If the wall is covered with a layer of mortar or plaster, this must first be removed from the area where the mosaic is to be laid, until the brick is exposed. This step is important because adhesive cement is very strong once it sets and could detach part of the wall covering if it is not anchored to something perfectly solid.

When creating a mosaic fragmented into slabs of cement, a bricklayer must be called in to lay them, using either mortar or adhesive cement plus special supports nailed into the wall if a heavy mosaic is to be laid. Always begin from the floor and work upward, after preparing the base for the mosaic and making sure it is level and true.

Different systems can be used for making the mosaic. The fiberglass mesh system (explained on page 58) is one choice. The main motifs are prepared on the mesh, then the background is laid directly on the wall. This system is commonly used by mosaicists who prepare the mosaic in their studio and then transfer it to the site where it is to be laid.

If using the direct method, which is very slow, after preparing the wall the drawing is transferred on to it with a stencil to check the final position of the tesserae. The stencil does not have to be detailed, just the main shapes are needed, leaving some room for maneuvering when laying the

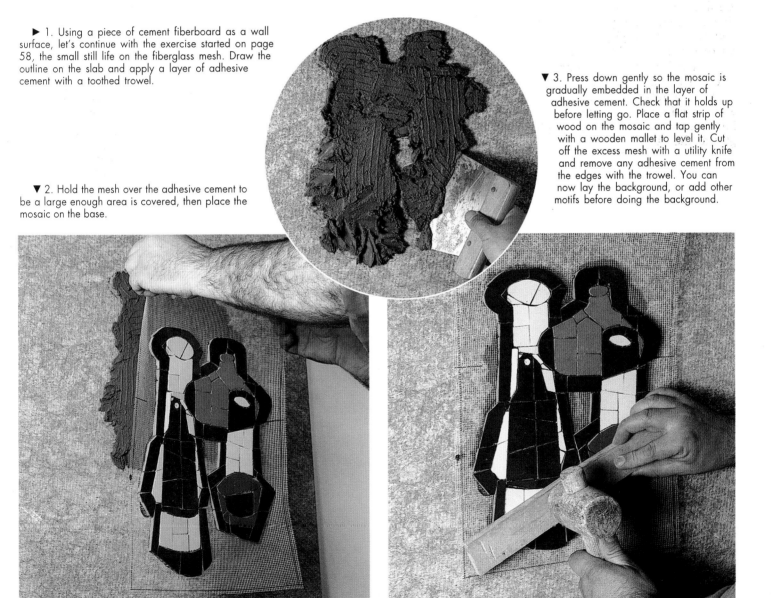

► 1. Using a piece of cement fiberboard as a wall surface, let's continue with the exercise started on page 58, the small still life on the fiberglass mesh. Draw the outline on the slab and apply a layer of adhesive cement with a toothed trowel.

▼ 2. Hold the mesh over the adhesive cement to be a large enough area is covered, then place the mosaic on the base.

▼ 3. Press down gently so the mosaic is gradually embedded in the layer of adhesive cement. Check that it holds up before letting go. Place a flat strip of wood on the mosaic and tap gently with a wooden mallet to level it. Cut off the excess mesh with a utility knife and remove any adhesive cement from the edges with the trowel. You can now lay the background, or add other motifs before doing the background.

tesserae. Then the already-prepared mosaic is placed on the floor or a table to keep it within easy reach.

Begin by placing the first tesserae on the dry, clean wall, applying a little adhesive cement on the back and pressing down gently with the hand or tapping gently with a rubber hammer. Remove the cement squeeze-out with a spatula, scraper, or small trowel. Continue laying the tesserae the same way, taking care not to jostle the ones already laid.

Since this is a slow process, the adhesive cement will start to dry while the tesserae are still being laid. If you must take a break and continue later, clean the exposed edges of the tesserae first while the adhesive cement is still wet.

▼ 3. I continue with the tesserae that form the leg, arm, and body, and finally I finish the other leg and the support the figure is leaning on. The background is laid in the same way.

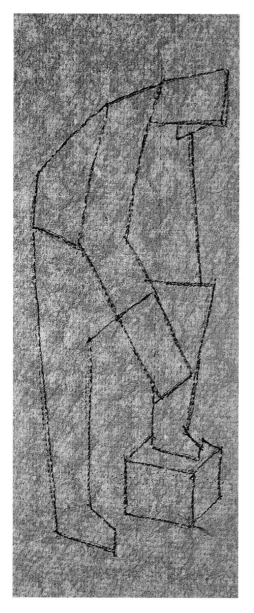

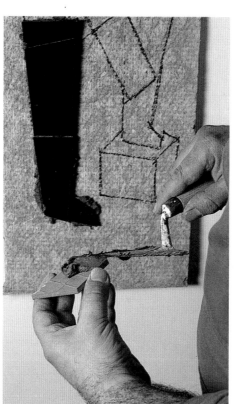

◄ 1. Again, a piece of cement fiberboard has been used as a wall surface. Transfer the drawing onto the surface and it is ready for the tesserae to be laid.

▲ 2. The mosaic to be laid on the wall has already been prepared, as has the adhesive cement. (The tesserae in this example are made from ceramic tiles.) I begin with the tesserae for the right foot (left of photograph), putting a drop of adhesive cement on it and sticking it to the slab by pressing down gently. Any remaining adhesive cement can be used for other pieces.

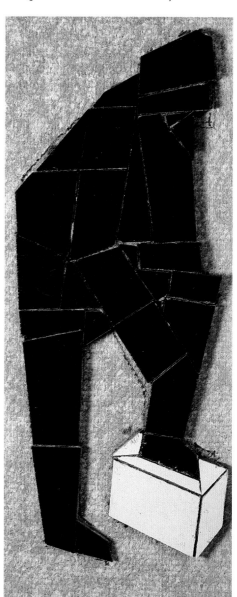

Comparison Chart of Laying Systems

LAYING SYSTEM	DEFINITIVE BASE	PROVISIONAL BASE	GLUES	MATERIALS	SURFACE	SITE
DIRECT	Laminated wood board		White glue, epoxy	Tiles, GPT, SCP, smalti, SM	Flat or slight relief due to tesserae of different thickness	Indoors
	Cement fiberboard		Epoxy, adhesive cement	Tiles, GPT, SCP, smalti, SM	Flat or slight relief due to tesserae of different thickness or being placed on edge	Indoors/ Outdoors
	Concrete (wall); Brick (wall)		Adhesive cement	Tiles, GPT, SCP, smalti, SM	Flat or slight relief	Indoors/ Outdoors
	Concrete (wall sculpture)		Adhesive cement	Tiles, GPT, SCP, smalti, SM	Tesserae adapt to surface of sculpture	Indoors/ Outdoors
	Tiles (terra-cotta)		Adhesive cement, epoxy, and white glue	Tiles, GPT, SCP, smalti	Flat or slight relief	Indoors/ Outdoors
	Sculpture (terra-cotta)		Adhesive cement	SM	Tesserae adapt to surface of sculpture	Indoors/ Outdoors
	Marble and stony materials		Epoxy, adhesive cement	Tiles, GPT, SCP, smalti, SM	Flat and/or relief	Indoors/ Outdoors
		Fiberglass mesh (built into the wall)	Neoprene (later placed on wall or floor with added mortar or adhesive cement)	Tiles, GPT, SCP, smalti, SM (watch out for weight)	Flat and/or slight relief	Indoors/ Outdoors
INDIRECT (Direct)	Slab of reinforced concrete	Clay, plasticine, sand		Tiles, GPT, SCP, smalti, SM, pebbles	Relief possible when base material is modeled	Indoors/ Outdoors
INDIRECT (Reverse)	Slab of reinforced concrete	Brown paper, tarlatan	Water-soluble glue, wallpaper adhesive, rabbit-skin glue	GPT, SCP, smalti, SM	Flat	Indoors/ Outdoors

SM . Stony materials
SCP. Stoneware ceramic paste
GPT . Glass paste tesserae
Epoxy Adhesive using two ingredients (resin and catalyst)

BASES

Mosaics can be laid on walls or on floors, as long as the surface is properly prepared for laying the tesserae. The mosaicist must be able to decide which method is most appropriate for each type of work. Direct laying, for example, requires that the tesserae be applied directly to the wall or base (such as wood or cement fiberboard), while the indirect method entails the use of tartalan or brown paper. Thus there are two types of bases: definitive and provisional bases. Definitive bases are used in the direct method, and provisional bases are used for the indirect method.

Types of Bases and Appropriate Materials

Examples of definitive bases are wood, cement fiberboard, slabs of marble or cut stone, terra-cotta tiles. Each one must be worked in accordance with a particular technique, and with the glues or other adhesives best suited to that particular material.

Wooden boards are not recommended because even when they are perfectly dry, they still have a tendency to warp. Laminated wooden boards, however, do provide a good base for mosaics because, apart from being lightweight, the criss-cross arrangement of the boards prevents twisting. The tesserae are attached to the board with white glue and a double-ingredient adhesive. Mortar, concrete, and adhesive cement should not be used on laminated wood. Mosaics laid on laminated boards should not be left outdoors, since dampness may cause the wood to twist, thus detaching the tesserae.

Other base materials such as cement fiberboard, marble, and terra-cotta tiles can be used with double-ingredient adhesives, mortar, and adhesive cement. The fiberglass mesh can also be used with this system of laying; the tesserae are glued with neoprene, although this kind of mosaic should later be laid on a definitive base.

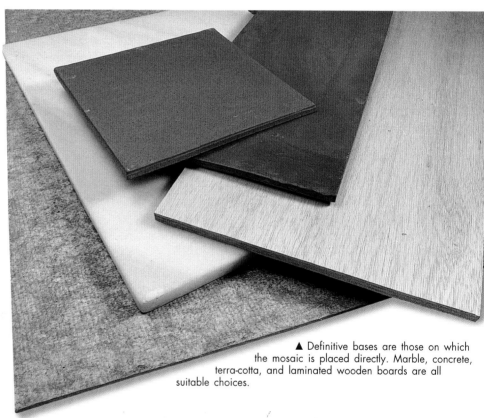

▲ Definitive bases are those on which the mosaic is placed directly. Marble, concrete, terra-cotta, and laminated wooden boards are all suitable choices.

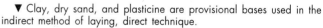

▼ Clay, dry sand, and plasticine are provisional bases used in the indirect method of laying, direct technique.

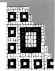

Provisional Bases

The indirect method requires a provisional base for laying the tesserae. This base can be made from clay, sand, or plasticine. If clay is used, it should be dampened before laying the mosaic to keep it from hardening, and it should be covered with a damp cloth and a sheet of plastic during any interruptions while working.

Plasticine does not require dampening because its greasy consistency keeps it in perfect condition for a long time, provided it is stored tightly closed in a warm place when not in use.

Sand is also an excellent provisional base, especially when damp and compacted.

Three other bases that can also be used to transfer the mosaic are the fiberglass mesh, for the direct method, and brown paper and tarlatan, for the indirect method.

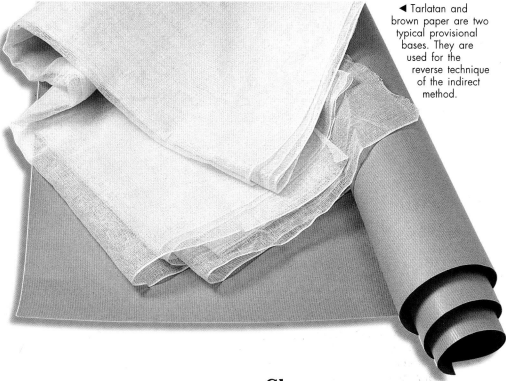

◄ Tarlatan and brown paper are two typical provisional bases. They are used for the reverse technique of the indirect method.

▼ The fiberglass mesh is a provisional base that can also be use to transfer the mosaic. It is used in the direct laying method and remains as part of the wall or pavement, together with the mosaic.

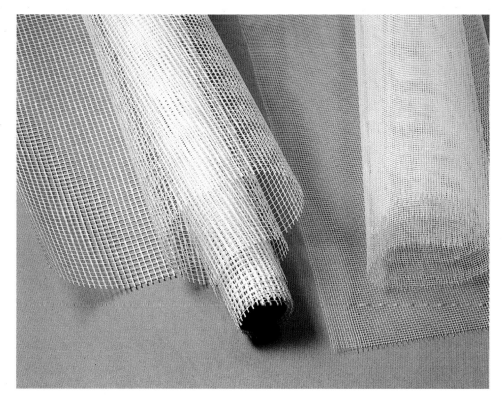

Glues

The term *glue* refers to all those materials used for adhering the tesserae to the base, whether definitively or provisionally. The glues we will use during our exercises are white carpenter's glue, double-ingredient glue, neoprene glue, wallpaper adhesive, rabbit-skin glue, mortar, and concrete.

White carpenter's glue is ideal for mosaics on porous surfaces, laminated wood, or terra-cotta bricks that will be kept indoors.

Neoprene glue is used for sticking the tesserae to a fiberglass mesh, and wallpaper adhesive and rabbit-skin glue (both water-soluble), to tarlatan and brown paper.

▼ Neoprene glue is used to adhere tesserae to fiberglass mesh. It is relatively slow drying, which means the pieces can be moved if necessary.

► Rabbit-skin glue and wallpaper adhesive are water-soluble and can be used for tartalan and brown paper. White carpenter's glue is used in the direct method on laminated wood. Epoxy resin, formed by combining two ingredients (resin and catalyst) can be used on any surface.

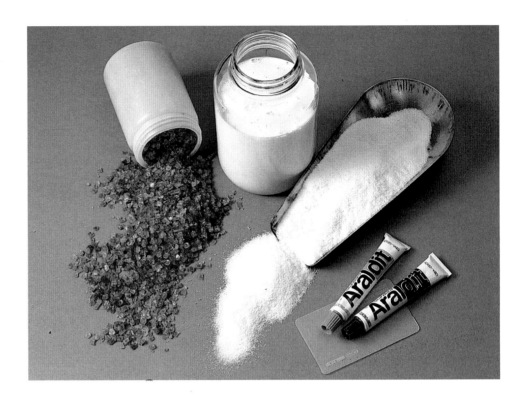

Double-ingredient glues (epoxies), prepared from resins, consist of an adhesive and a hardener that are combined when ready to use. Follow the manufacturer's instructions when using these glues. This kind of adhesive can be used for indoor or outdoor mosaics, laid on slabs of cement fiberboard, marble, and terra-cotta bases.

Note that many adhesives—especially white glue—must be applied on horizontal surfaces and are not suited to use on vertical surfaces. Although fast-drying adhesives can be used, the nuisance of having to continually prepare small amounts to apply them straight away becomes impractical.

Mortar and Concrete

Mortar and concrete are prepared in the same way, although the components may vary. We will use them in the indirect laying method.

To prepare them, place the correct proportions of sand, gravel, and cement in a trough and stir with a trowel to form a uniform mix. Add water, stirring with the trowel to form a creamy mass. Apply the mortar or concrete to the back of the mosaic with the trowel, forming a layer about 3/8 to 5/8 in. (1 to 1.5 cm) thick, shaking it gently to remove the air from the mass and to help it penetrate the cracks between the tesserae. Place a piece of chicken wire on this first layer (it should be slightly smaller than the surface of the mosaic) and immediately top this up with mortar or concrete, smoothing it and

shaking it again. Allow it to set for one hour, then key the surface with a punch or other sharp object. This will give tooth to the surface, thus helping the mosaic to adhere to the wall when another layer of adhesive cement is applied.

Remember that a mosaic covered with mortar or concrete should be left to rest for at least 72 hours. During this time, place a damp cloth over the entire surface and then place a sheet of plastic over the cloth. The cloth should be regularly dampened so that the mortar or concrete remains moist.

▼ Mortar is generally prepared with Portland cement, white cement, lime, sand, and powdered marble. Adhesive cement is sold ready to use and needs only to be mixed with water; wait ten minutes before use.

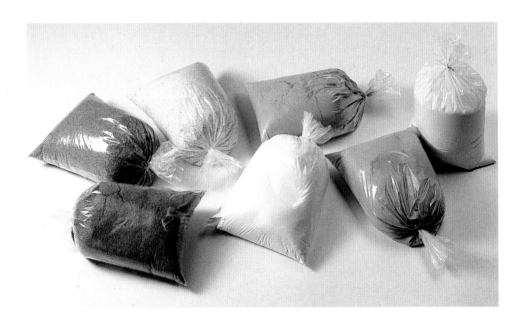

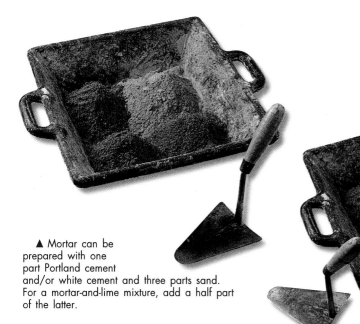

▲ Mortar can be prepared with one part Portland cement and/or white cement and three parts sand. For a mortar-and-lime mixture, add a half part of the latter.

▶ To ensure that the mosaic is strong enough when using the indirect system of laying (for both the direct and reverse techniques), reinforcement is necessary.

both the base and the back of the tesserae are clean and free of the residue of any other products. Always make sure that glue containers are properly closed and sealed after use so that they do not harden. To prevent a dry film from forming on a container of glue, especially when it will not be in use for a long period of time, add about 1/16 in. (2 to 3 mm) of water so that it just covers the surface.

It is also important to choose the right base. In general, mosaics to be placed outdoors on a wall should be attached using mortar or adhesive cement. If the mosaic is not to be embedded in the wall, it is preferable to use a slab of cement fiberboard. This will allow you to attach the mosaic to the wall and remove it later if desired.

▼ Remember to take great care when cutting and preparing tesserae, especially when working with power tools, adhesives, and mortar.

Reinforcement

Reinforcement is essential when filling a frame with mortar or concrete. It is preferable to use welded steel grilles, like those used in construction work. The strands should not be more than 1/8 in. (4 mm) in diameter, since the concrete layer is not very thick.

If these are not available, they can be approximated using wire and a drop of adhesive. Another solution is to place several thin bars on top of the mortar or concrete and gently embed them, then place more bars at right angles and cover them with mortar or concrete so that they do not move. Still another option is 3/8 in. (1 cm) steel netting, which

will remain perfectly flat and stable when inserted into the mortar or concrete.

General Working Tips

It is helpful to store the various tools and materials on shelves. When preparing tesserae, don't bother to save the smallest fragments; since mosaic work involves producing many such fragments, it is easier to cut and prepare one only when you actually need it.

Be sure to choose the most suitable adhesive for each project, and always follow the manufacturer's instructions for use. Before applying any type of glue, make certain that the surfaces of

STEP-BY-STEP PROJECTS

U ntil now, we have examined the mosaic-making process from a theoretical point of view. Now is the time to put this information into practice. What follows, therefore, is a series of functional and artistic projects utilizing various techniques, materials, bases, and binders, in addition to an assortment of tools. This will provide a detailed view of the procedure from the beginning of a work to its completion.

These projects should be considered starting points for your learning experience, not simply examples to copy. The pieces vary greatly, and each one has been conceived and designed with the most suitable processes and materials for each kind of work. Each project starts with an introduction to the technique, followed by an illustrated step-by-step explanation showing the entire process in detail.

I hope and trust that with continued practice and the use of your imagination, you will come to find your own personal way of creating mosaics.

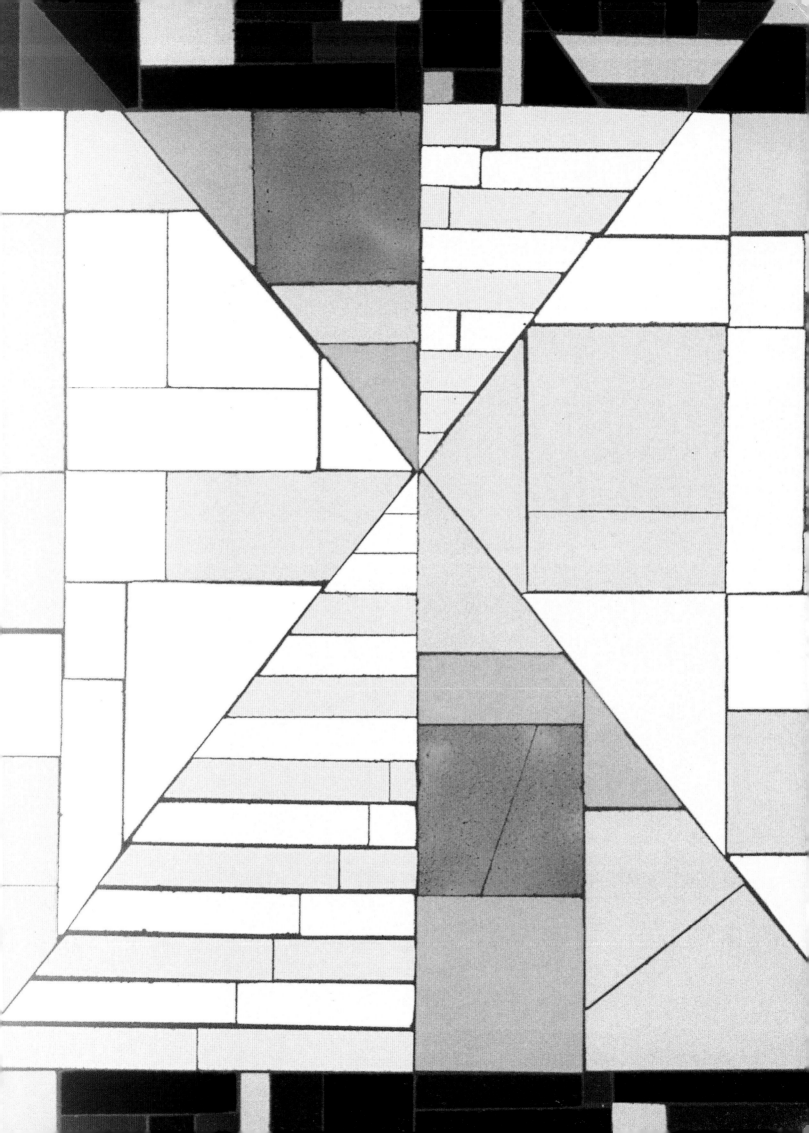

Tabletop Using the Direct Method

The mosaic for this table is very straightforward and relatively simple since it uses the direct method. If the materials are cut with the right tools, as shown here, even for someone with a minimum of experience, this mosaic should present no problem. As a more advanced project, it could also be made using the indirect method, direct technique.

Because this mosaic is for a tabletop, the pattern was designed with this use in mind; in other words, it appears similar from various angles, an overall design without secondary patterns. The finished tabletop must be completely flat and smooth, so ceramic tiles of the same thickness are a good choice. As an adhesive, use adhesive cement or epoxy. (If using tiles or tesserae of different thicknesses, use a slab of cement fiberboard and adhesive cement to allow for leveling the tesserae.)

Remember that this table is not suited for outdoor use because dampness could warp the wood and cause the tesserae to peel off. If you want to make a table suitable for the outdoors, use a slab of cement fiberboard with the same system of laying.

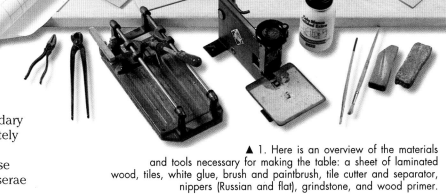

▲ 1. Here is an overview of the materials and tools necessary for making the table: a sheet of laminated wood, tiles, white glue, brush and paintbrush, tile cutter and separator, nippers (Russian and flat), grindstone, and wood primer.

◀ 2. In addition to an actual-size drawing of the mosaic, you'll need carbon paper, a set of squares, rulers, a hard lead pencil, scotch tape, and weights.

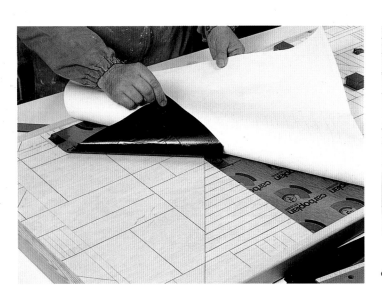

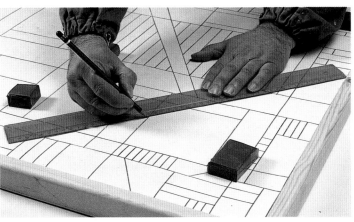

◀ ▲ 3 and 4. Place the carbon paper face down on the wood with the drawing face up on top, and trace over the whole design.

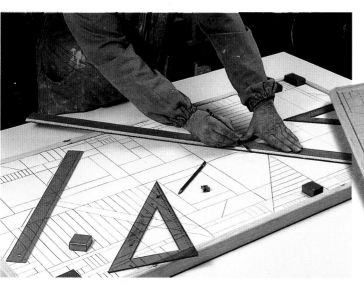

◀ 5. Be sure that the drawing is completely visible on the wood.

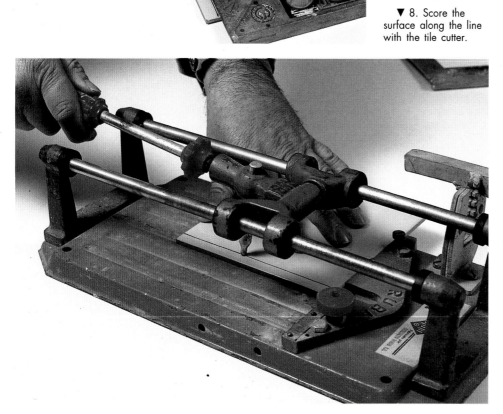

▼ 6. Once the design transfer is complete, the position of the tesserae is clearly marked.

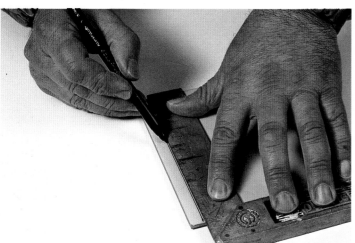

◀ 7. Using an L-square and a felt pen, mark the area of the tile to be cut.

▼ 9. Use the tile separator to snap off the strip.

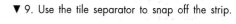

▼ 8. Score the surface along the line with the tile cutter.

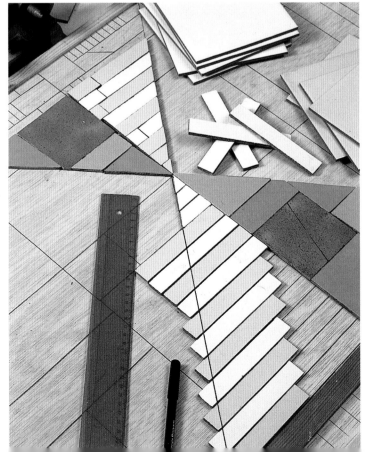

◀ 10. With the grindstone, polish and smooth the edges of the tile.

▼ 11. Place the tile on the drawing and mark another cutting line with the ruler.

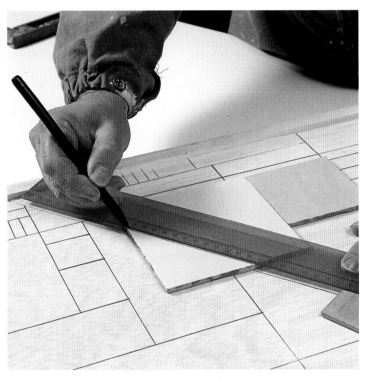

◀ 12. Begin to position the blue tesserae following the diagonal and vertical lines. They are not yet glued.

◀ 13. Continue with the yellow tesserae, cutting the necessary strips.

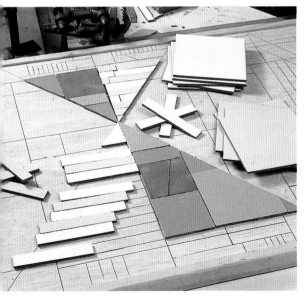

▶ 14. Place the strips on the design and mark the diagonal cutting line with the felt pen.

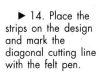

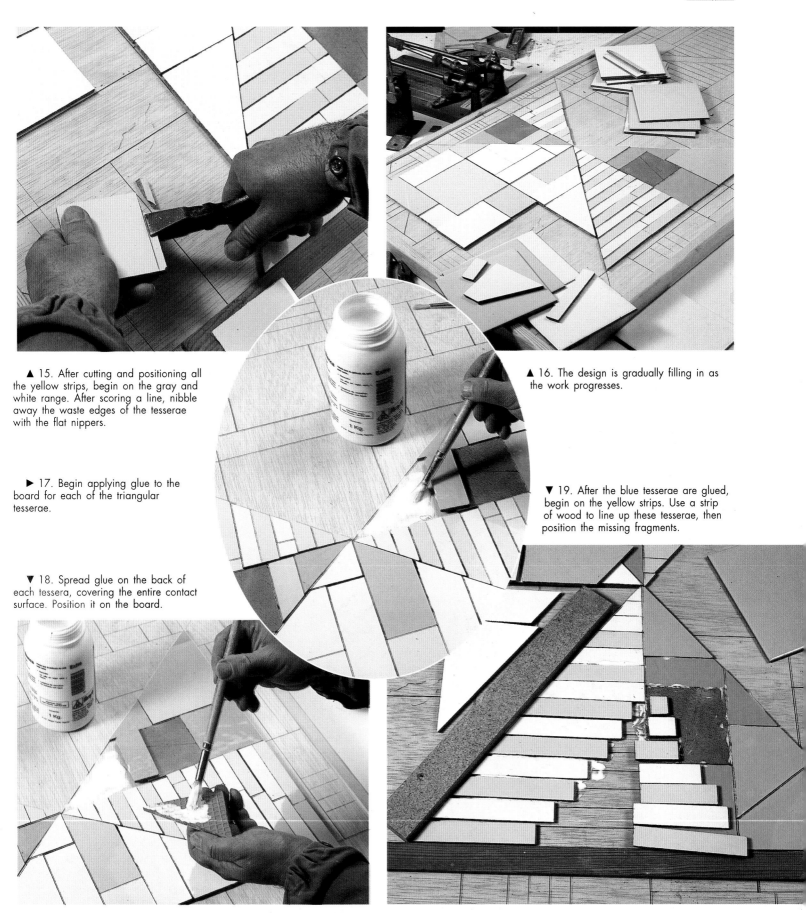

▲ 15. After cutting and positioning all the yellow strips, begin on the gray and white range. After scoring a line, nibble away the waste edges of the tesserae with the flat nippers.

▲ 16. The design is gradually filling in as the work progresses.

► 17. Begin applying glue to the board for each of the triangular tesserae.

▼ 19. After the blue tesserae are glued, begin on the yellow strips. Use a strip of wood to line up these tesserae, then position the missing fragments.

▼ 18. Spread glue on the back of each tessera, covering the entire contact surface. Position it on the board.

▲ 20. In this finished part of the mosaic, note the excess glue between the tesserae. This should be left to dry before trying to remove it.

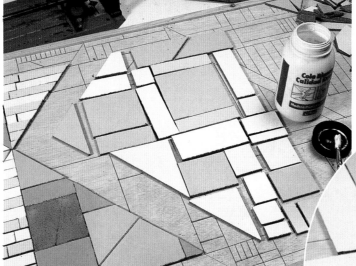

▲ 21. Repeat the process, covering a new area of the board with tesserae.

◄ 22. In preparation for gluing, it is helpful to separate the tesserae a bit.

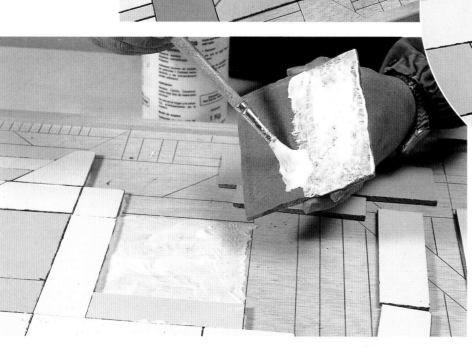

▲ 23. The freshly glued tesserae can still be moved, using a knife blade or flat-tipped tool. Flat toothpicks can also be used to position the tesserae properly.

◄ 24. Once the glue has been spread on the board, glue the back of the tessera.

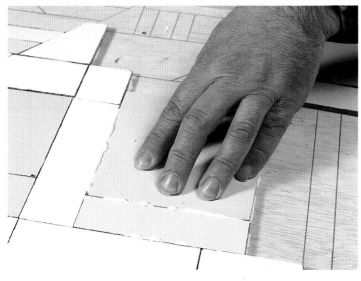

◄ 25. Press the tessera down so it sticks firmly. The excess glue will squeeze out beneath.

► 26. Remove the small irregularities of a cut edge with pincers.

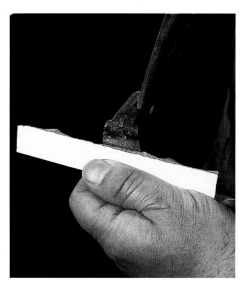

▲ 27. Continue placing the tesserae on the board, following the drawing.

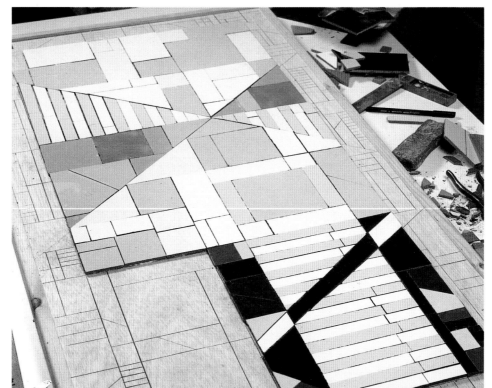

▲ 28. The entire yellow rectangle is ready for gluing. As before, the tesserae on the diagonal have been aligned with a small strip of wood.

◄ 29. The mosaic progresses as the green tesserae are added.

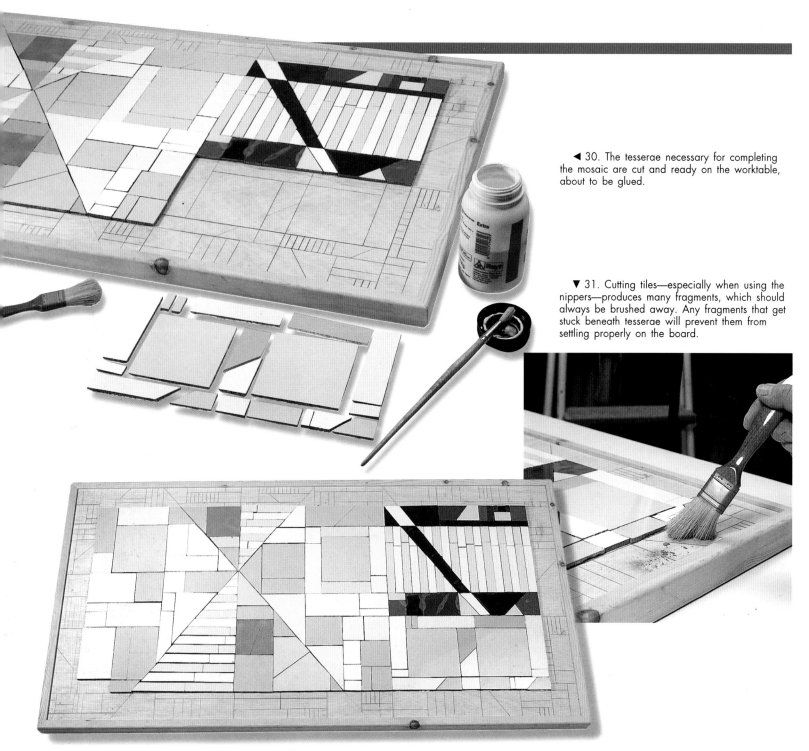

◄ 30. The tesserae necessary for completing the mosaic are cut and ready on the worktable, about to be glued.

▼ 31. Cutting tiles—especially when using the nippers—produces many fragments, which should always be brushed away. Any fragments that get stuck beneath tesserae will prevent them from settling properly on the board.

▲ 32. At this point the mosaic is nearly finished, except for the border.

► 33. Various shades of blue tiles are cut and positioned to form the border.

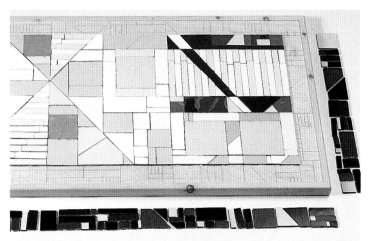

◄ 34. After the border tesserae are cut for several sides, move them to the worktable so they are ready to be laid.

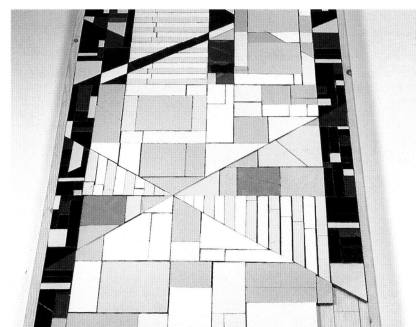

▲ 35. Begin to lay the tesserae for the border. Note the excess glue in the crevices. Be sure to press down hard to keep all the tesserae level.

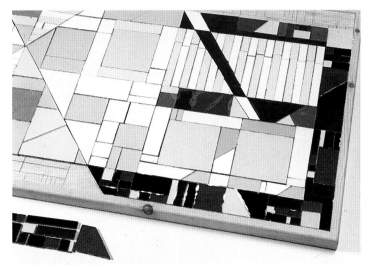

▲ 36. With three-quarters of the border finished, all that remains to be laid is the final side of the border.

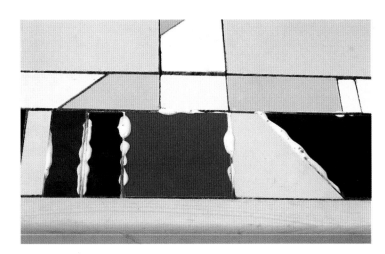

▲ 37. Allow the excess glue between the tesserae to dry.

► 38. Using the blade of the utility knife, remove the hardened glue.

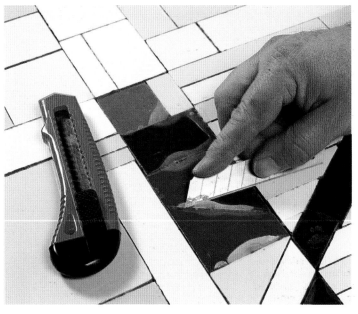

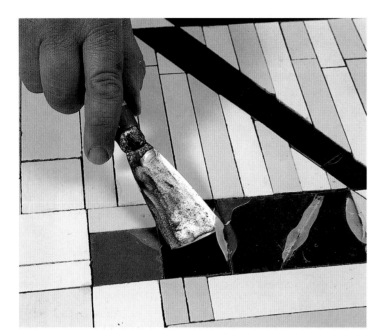

◄ 39. Hardened glue can also be removed with a sharp-edged scraper.

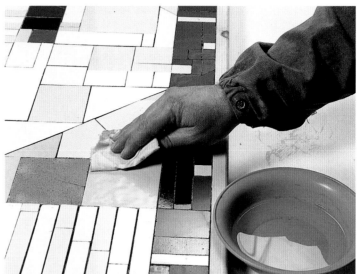

▲ 40. Clean the surface of the mosaic with a damp cloth.

▲ 41. The finished mosaic awaits grouting.

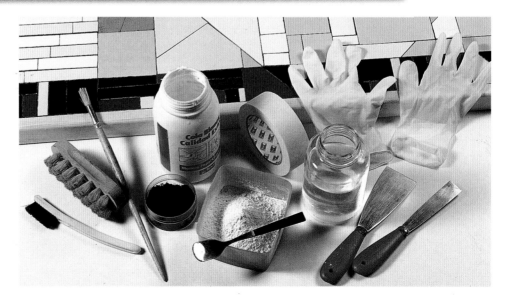

► 42. To seal the crevices between the tesserae, you'll need a fine brush, a hard bristle brush, a small brush, black powdered pigment, white glue, powdered grout, wide masking tape, water, scrapers, and rubber gloves.

▶ 43. Mix the powdered grout with the black pigment until the color is even. Add water until it forms a thick paste. Let it sit for 20 minutes before using it.

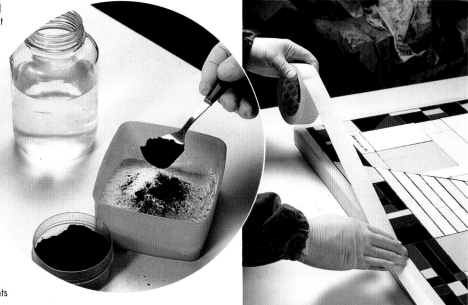

◀ 44. Cover the wooden border of the table with the masking tape, pressing the tape down over the edge.

▼ 45. Using the scraper, apply grout over all the joints between the tesserae.

▼ 46. Grout can also be applied with a brush.

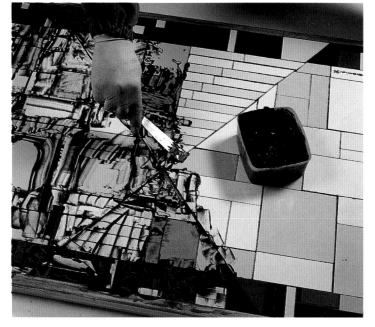

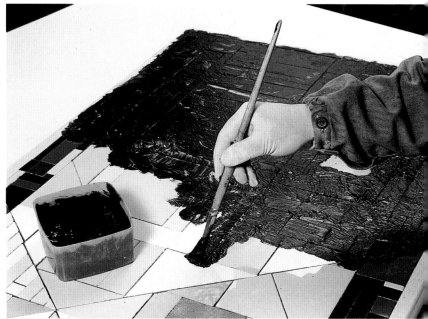

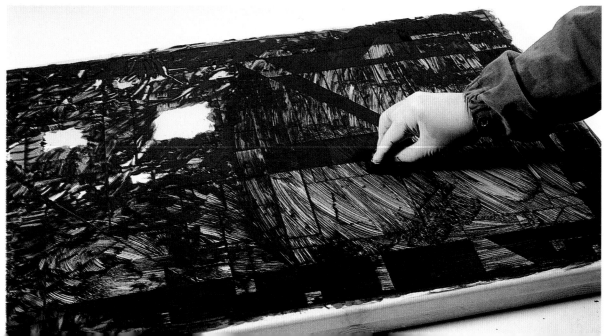

◀ 47. Allow the grout to dry for 30 minutes, then clean the surface of the mosaic with a damp cloth.

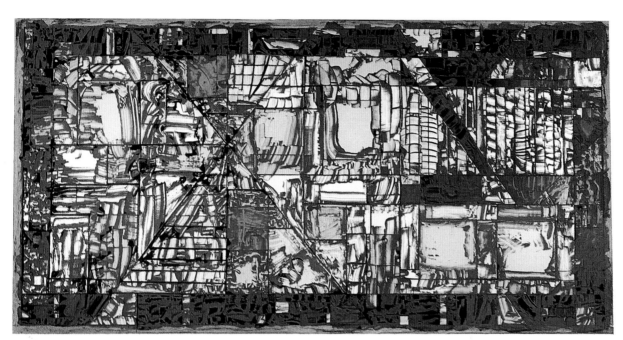

◀ 48. Even after wiping off the surface, there will still be excess grout.

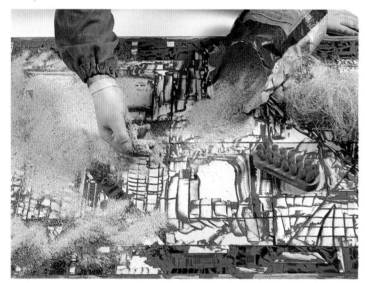

◀ 49. You can keep working with the damp cloth, but you may find it easier at this stage to sprinkle on fine sawdust and rub it over the surface with a hard brush.

▲ 50. Continue rubbing off the sawdust, removing the excess grout from the tesserae.

◀ 51. A final sprinkle of clean sawdust helps remove the last traces of extra grout.

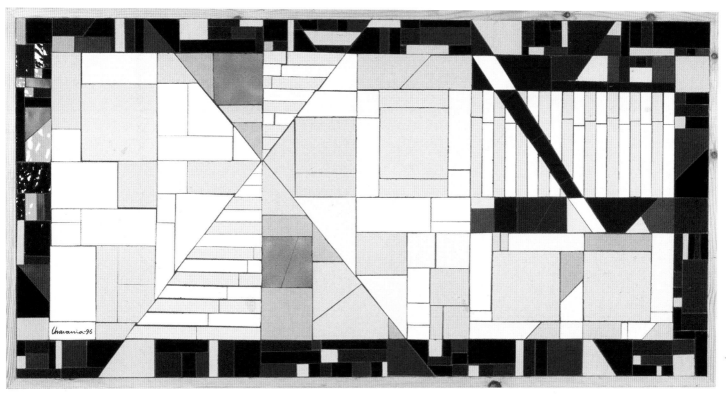

▲ 52. The finished mosaic could also be mounted on a wall rather than a table.

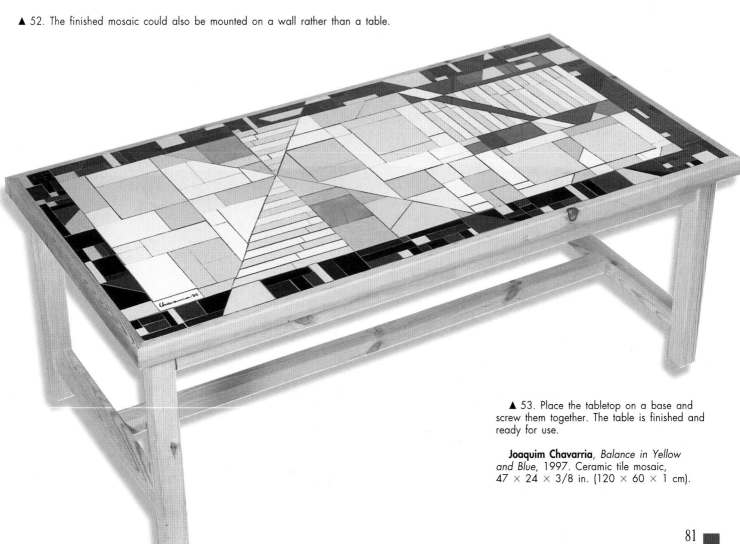

▲ 53. Place the tabletop on a base and screw them together. The table is finished and ready for use.

Joaquim Chavarria, *Balance in Yellow and Blue*, 1997. Ceramic tile mosaic, 47 × 24 × 3/8 in. (120 × 60 × 1 cm).

Wall Mosaic Using the Direct Method

One method for making a wall mosaic is to use slabs of cement fiberboard as a base. Any of the commonly used tesserae can be laid on this surface, using adhesive cement or epoxy.

Slabs of cement fiberboard are very appropriate for outdoor mosaics, since they are unaffected by weather changes. When they are used as a base for indoor mosaics, white carpenter's glue can also be used. Because some of the tesserae in this project are a little larger than those commonly used in mosaics, I have chosen epoxy because it is so strong.

This wall mosaic in relief (maximum depth about 1 5/8 in. [4 cm]) is made from strips and small plaquettes of marble, travertine, granite, and stoneware. The first three materials were machine cut in specialty workshops, but while composing the mosaic I cut additional tesserae from these strips using the diamond cutter and the hammer and anvil. As mentioned earlier, you must exercise great care when using power tools; always wear gloves, face mask or safety goggles, and dust mask, and, if possible, work in the open air.

Prepare only small quantities of epoxy at a time, since it begins to set the moment the two elements are combined. It can usually be used up to one hour after mixing. (Follow the manufacturer's directions.) Once the project is glued, allow it to dry for at least 12 hours; the epoxy reaches maximum adherence after three days. This drying time is shorter in warm weather, which speeds up the process. Do not use epoxy in temperatures below freezing.

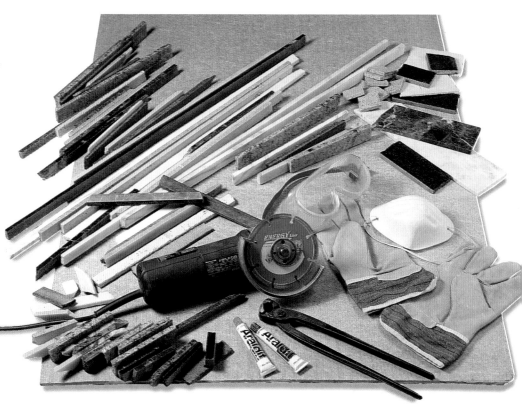

▲ 1. In addition to the cement fiberboard base, you'll need a range of tools and material. Your work will proceed more smoothly if the process is organized.

▼ 2. Transfer the design to the base using carbon paper, or, if you're brave enough, draw directly on the slab.

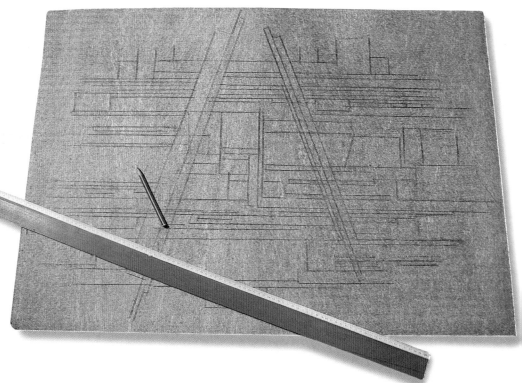

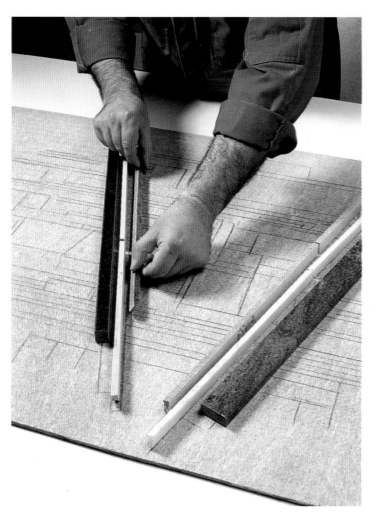

◀ 3. Position the first strips on the base.

▼ 4. Prepare the epoxy, mixing equal parts of resin and hardener, and apply it to the back of one of the granite strips.

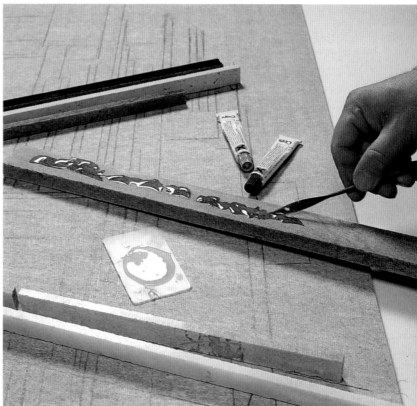

▼ 5. Place the strip in its exact position. Try to get it placed correctly the first time; although it is possible to readjust it, the epoxy is so sticky that it is best to avoid dirtying surrounding areas of the base.

▼ 6. Cut one of the marble strips with the pincers. Using the right amount of pressure, thicknesses of up to 3/8 in. (1 cm) can be cut this way.

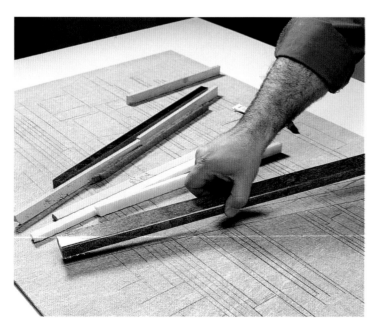

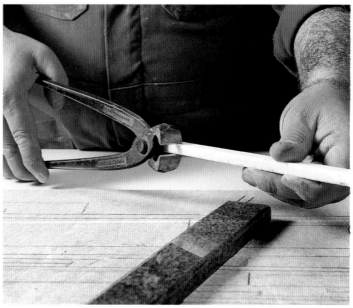

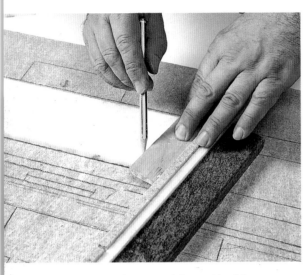

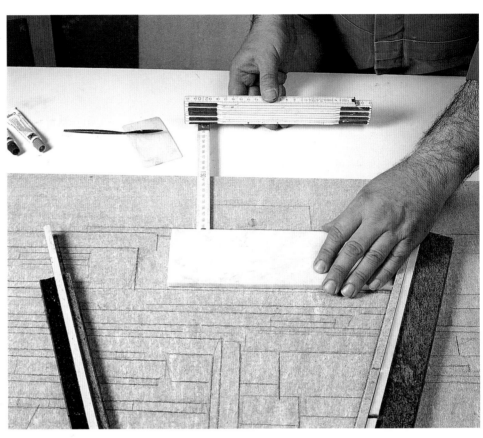

▲ 7. Place one of the marble slabs next to the strips to form a slanting line. Using a strip of wood parallel to the stone, mark a cutting line. Cut along this line with the electric cutting disc.

▶ 8. After checking the measurements, position the cut marble slab.

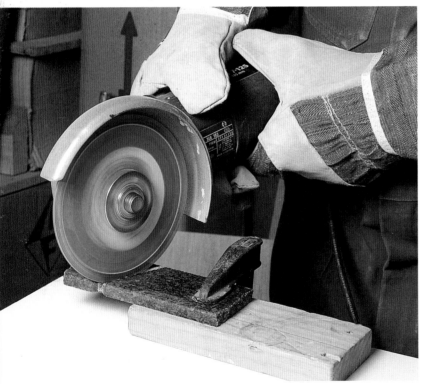

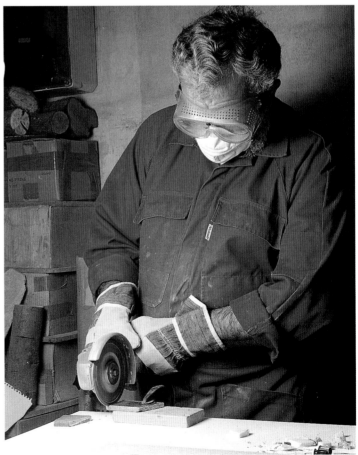

▲ 9. Cut a small plaquette of black marble. Note the slanted cutting line and that the slab is clamped to the table.

▶ 10. Run the edge of the diamond disc over the cut edge to remove any roughness.

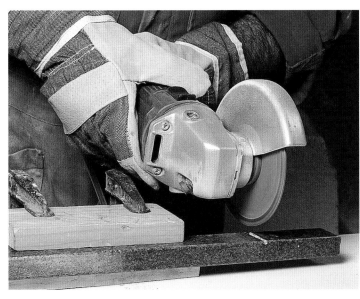

◀ ▼ 11 and 12. Continue cutting strips with the machine. Longer strips need to be gripped more firmly, using two clamps and wood scraps to absorb the vibration.

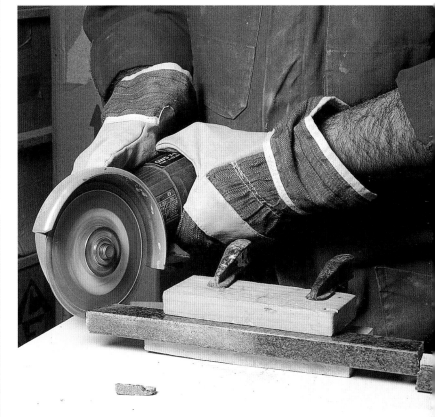

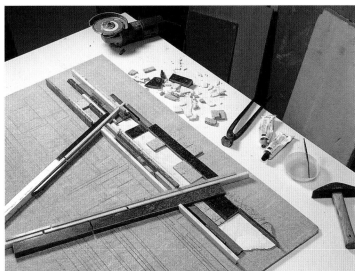

◀ 13. In this project you must be very careful to keep the strips and horizontal tesserae parallel. Note that gluing is the final stage; at this point the pieces are simply laid in place.

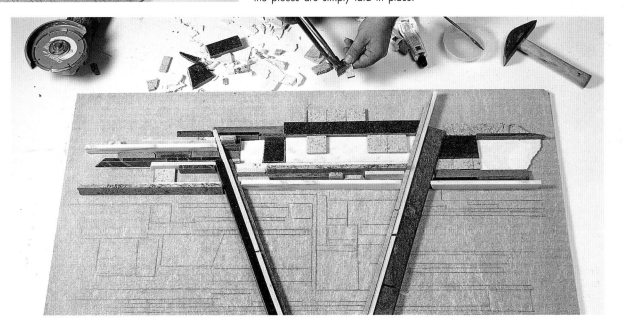

▶ 14. Using the Russian nippers, break off an oblique section of a tessera so that it fits perfectly into one of the slanted strips.

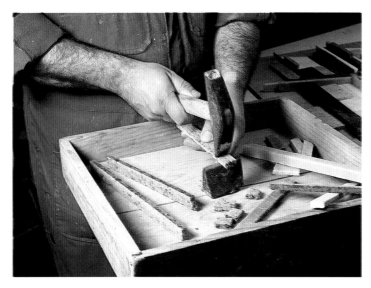

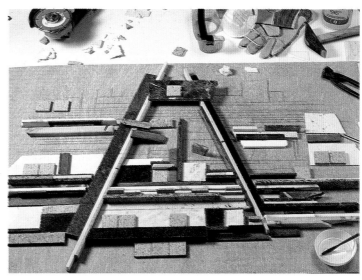

▲ 15. Cut a strip into several tesserae using the hammer and anvil. Continue positioning the tesserae on the base, then glue them on when a section is complete.

▲ 16. To clean off any remaining adhesive, use alcohol immediately after gluing the tesserae. Or you can scrape off the excess with a utility knife after letting the adhesive harden for an hour. Do not try to remove it at any other times. If the adhesive is not fully hardened, it is impossible to remove with the knife. If it has hardened for more than an hour, removal attempts may tear up part of the base or the tesserae themselves.

◄ 17. Use a set square and marker to draw the lines for cutting the marble slabs. Cut them with the electric cutter, making an oblique cut along one edge so the tesserae will fit within the interior of the converging strips.

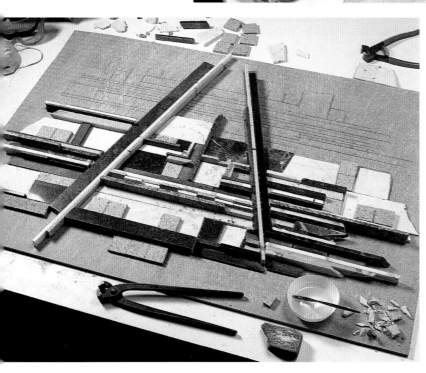

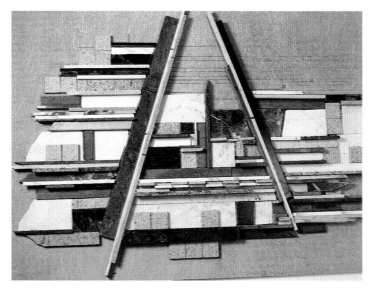

◄ ▲ 18 and 19. Depending on the thickness of the material, both the Russian and the Japanese nippers may prove useful. A polisher can also be used for marble and stoneware, but not for granite.

▶ 20. Continue laying and gluing the mosaic in sections.

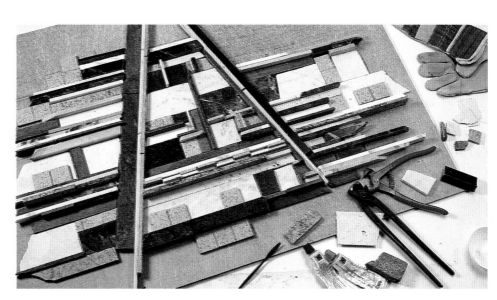

▼ 21. Compare the finished mosaic to the drawing on page 82. Notice that the slanting strips on the right have been lengthened to balance the volumes; a few other minor adjustments have been made as well.

Joaquim Chavarria. *Via Vitae*, 1996. Marble, travertine, granite, and stoneware, 39 × 27 1/2 × 1 5/8 in. (100 × 70 × 4 cm).

Pebbled Paving Tile Using the Indirect Method, Direct Technique

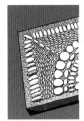

The pebble—an extremely common natural material—was perhaps the first material to be used for mosaic pavements. This project uses the indirect laying method, direct technique, which is a fairly simple approach for this type of work. It could also be done by direct laying; in that case it would have to be prepared on site so the pebbles can be positioned in the mortar while it is still wet.

Prepare water-soluble glue according to the manufacturer's instructions. The mortar is prepared as explained on page 66. Once complete, the piece must be kept damp and left for 72 hours before handling.

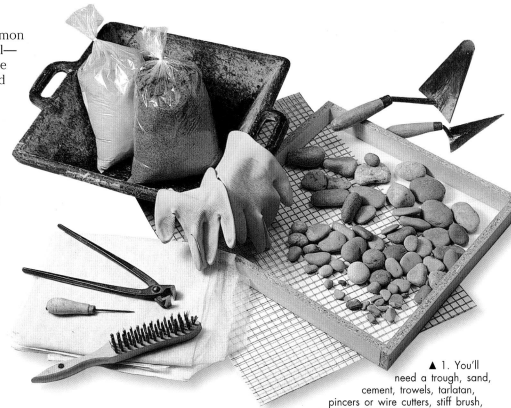

▲ 1. You'll need a trough, sand, cement, trowels, tarlatan, pincers or wire cutters, stiff brush, wooden frame, pebbles, wire netting, and gloves. You'll also need several sheets of plastic, a board to work on, extra strips of wood, hammer, cardboard, metal pick, rubber syringe, scissors, utility knife, and plant mister.

▼ 2. A melamine-coated frame was used for this project, but an ordinary wooden frame would work as long as it is first covered with plastic packing tape to render it waterproof.

▼ 3. Cover the board with the sheet of plastic and place the wooden frame on top. Fill the frame with sand.

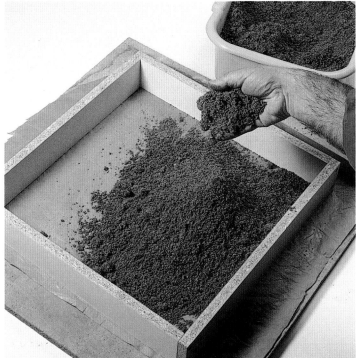

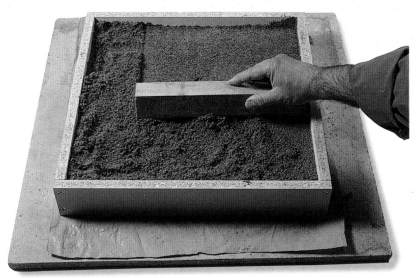

▶ 4. Smooth the surface of the sand with the strip of wood, compressing it into the frame.

▼ 5. Place 3/8 in. (1 cm) strips of wood on the sand all around the frame.

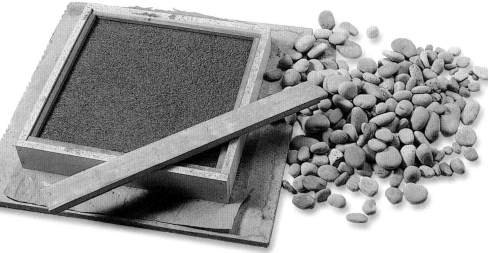

▼ 6. Begin to arrange the long pebbles neatly, just touching the wooden strips.

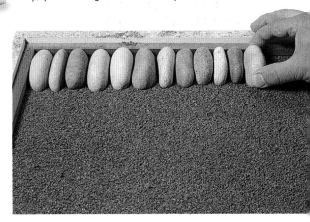

▼ 7. Use a longer strip of wood to check the height of the pebbles. Tap with the hammer to level them.

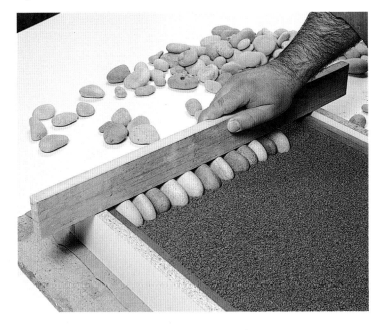

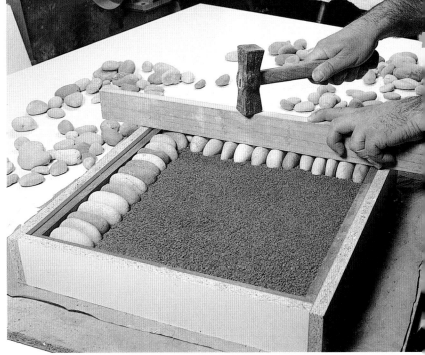

▶ 8. Place another row of pebbles along the next side of the frame and tap them with the wood and hammer to level them.

89

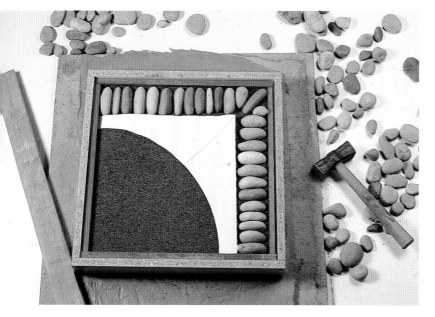

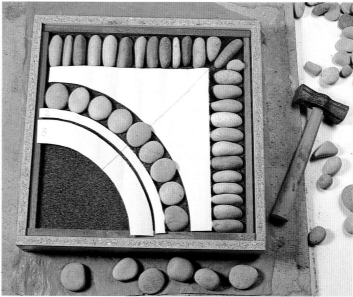

▲ 9. Prepare cardboard templates to help with the arrangement of the pebbles.

▲ 10. Fill in the next row with circular flat pebbles, forming a quarter circle.

▶ 11. Form the next quarter circle with smaller pebbles laid on edge.

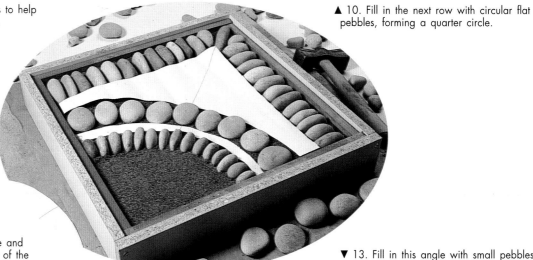

▼ 12. For the third quarter circle, use smaller circular flat pebbles. With very small pebbles standing on edge, form a right angle and dividing line running from the corner of the frame.

▼ 13. Fill in this angle with small pebbles, leveling them with the others.

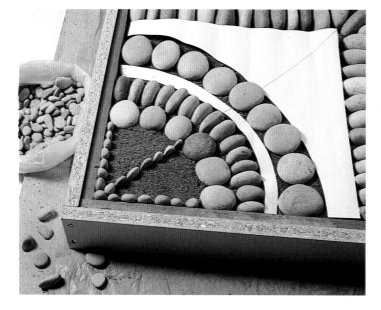

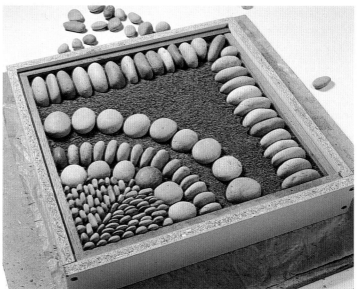

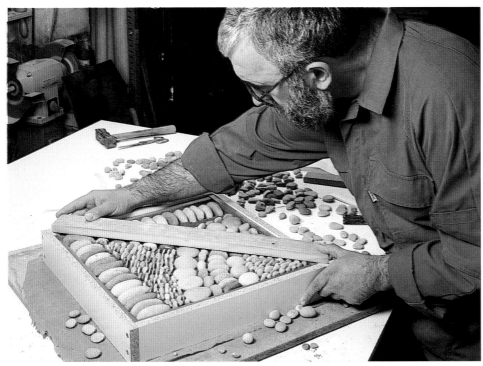

◄ 14. After filling in most of the mosaic, use the strip of wood to check the alignment of the pebbles forming the diagonal line.

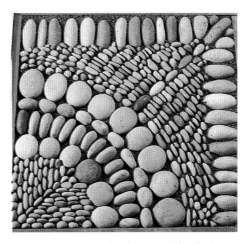

▲ 15. When the frame is completely full of pebbles, be sure they are all level and well embedded in the sand.

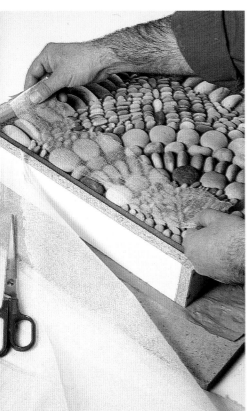

◄ 16. Cut strips of tarlatan and check their length over the pebbles.

▶ 17. Prepare the water-soluble glue and it apply with a brush so that it penetrates through the mesh and between the pebbles.

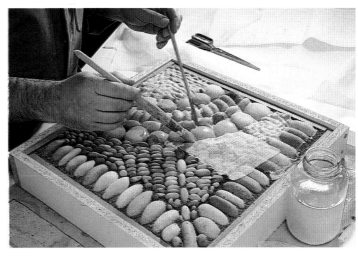

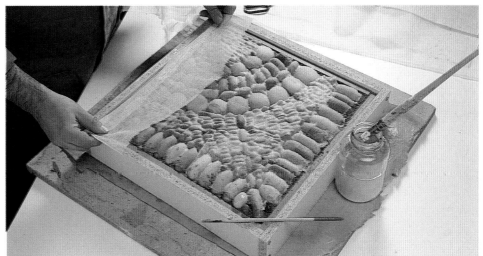

▶ 18. Continue gluing on the strips, placing alternate layers at right angles to each other to add strength. Three layers of tarlatan have been used here since the pebbles are quite heavy.

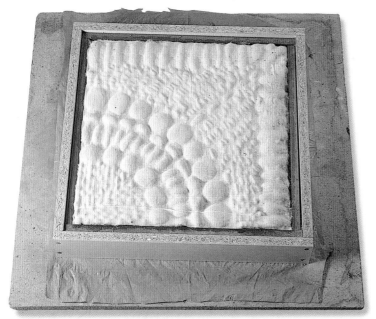

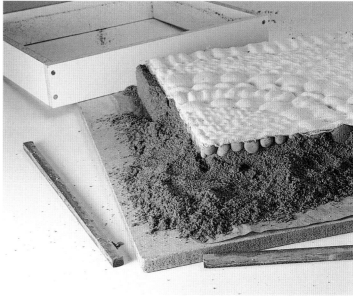

▲ 19. Let the covering dry completely.

▲ 20. Once the tarlatan has dried, remove the wooden strips and then the frame.

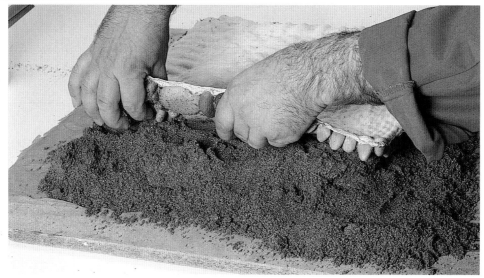

► ▼ 21 and 22. Gently lift up the sheet of pebbles and place it face up. If the gluing has been done properly, all the pebbles should be well adhered to the cloth.

▼ 23. Use the small trowel and flat brush to remove the sand carefully.

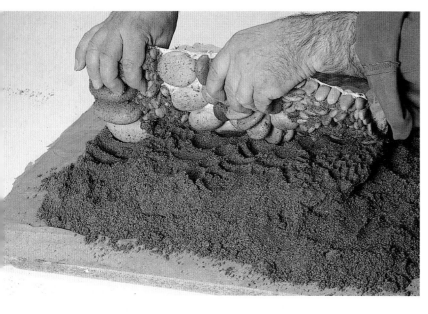

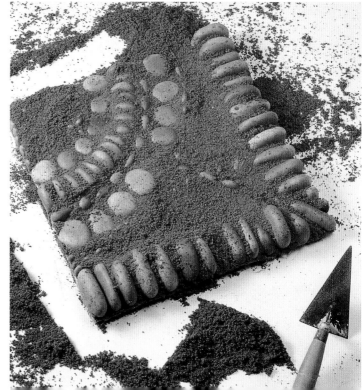

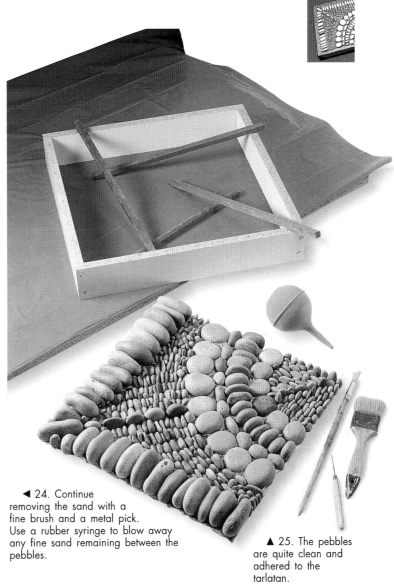

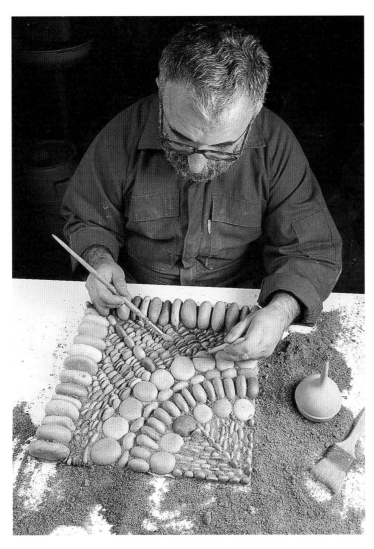

◀ 24. Continue removing the sand with a fine brush and a metal pick. Use a rubber syringe to blow away any fine sand remaining between the pebbles.

▲ 25. The pebbles are quite clean and adhered to the tarlatan.

▼ 26. Cover any edges of the frame that are not melamine-coated with packing tape to waterproof them.

▼ 27. Cover the board with a new sheet of plastic. Place the frame on this and set the pebbles inside. Reinsert the thin strips of wood used at the beginning. Apply liquid soap to them and the walls of the frame so that the mortar will come away more easily.

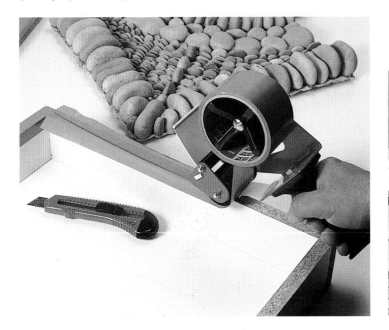

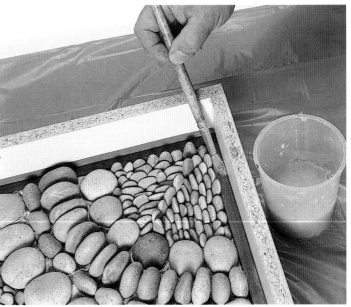

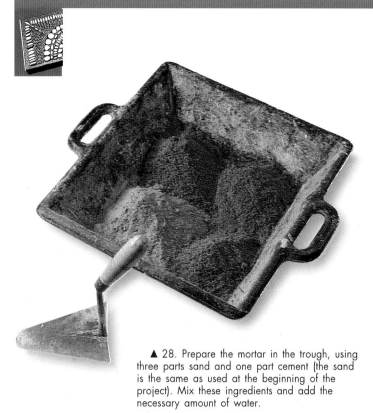

▲ 28. Prepare the mortar in the trough, using three parts sand and one part cement (the sand is the same as used at the beginning of the project). Mix these ingredients and add the necessary amount of water.

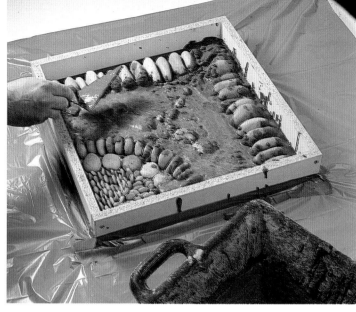

▲ 29. First apply a bed of fairly runny mortar so that it will penetrate into the joints between the pebbles, then cover the pebbles with mortar.

◄ 30. Position the wire netting on the frame to measure the size and cut off the excess with pincers or wire cutters.

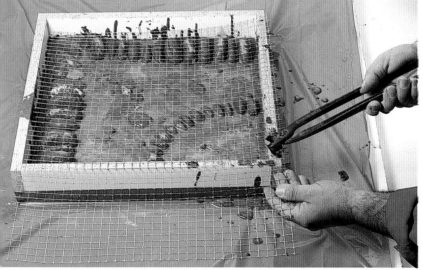

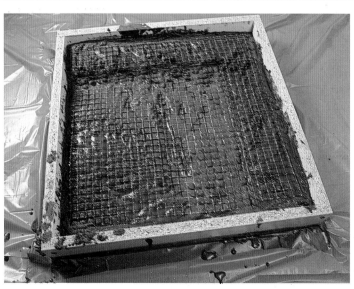

◄ 31. Since the larger pebbles form an angle, it is a good idea to prepare the wire netting in the same shape, forming two planes to strengthen the mosaic.

▲ 32. With the trowel, carefully press the wire netting into the mortar and fill up the rest of the frame.

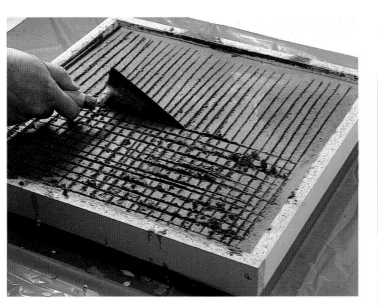

◀ 33. Let the mortar partially dry and then key the surface with the small trowel.

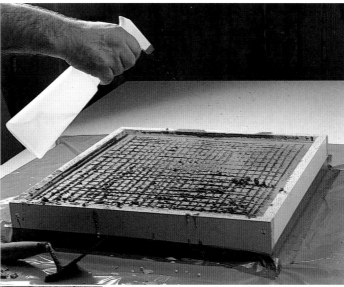

▲ 34. Dampen the surface with the plant mister. The damper the mortar is, the better it sets.

◀ 35. Cover the entire surface of the tile with a damp cloth and cover this with a sheet of plastic so that it will not dry out.

◀ 36. Let it sit for three days, regularly dampening the mortar during this time, then remove the cloth and turn the mosaic over.

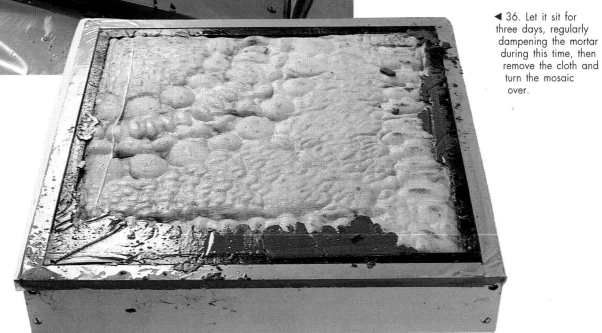

► 37. Remove the screws holding together the frame, which should come away easily because of the soap brushed on in step 27. Also remove the strips of wood that were inserted around the frame, and take off the tarlatan.

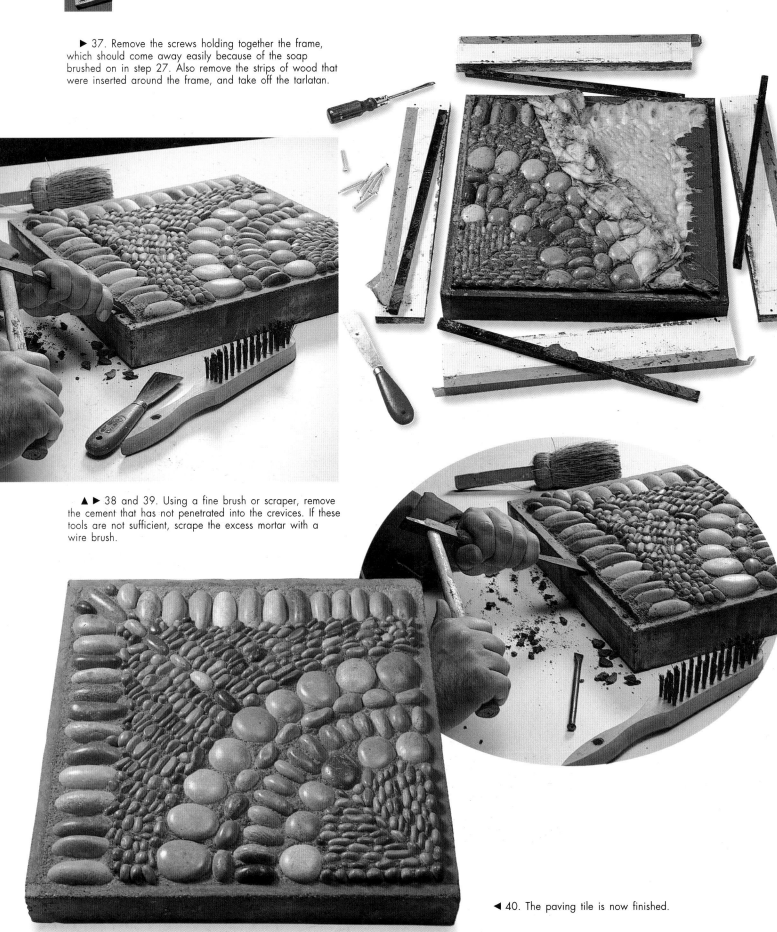

▲ ► 38 and 39. Using a fine brush or scraper, remove the cement that has not penetrated into the crevices. If these tools are not sufficient, scrape the excess mortar with a wire brush.

◄ 40. The paving tile is now finished.

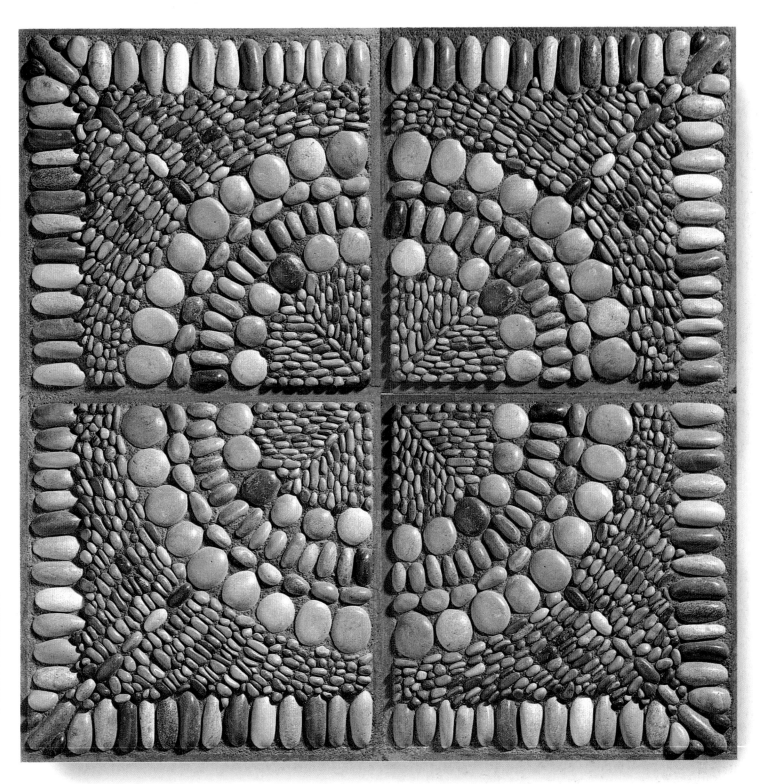

▲ 41. Four paving tiles together make a striking design.

Joaquim Chavarria. *Lapilli,* 1996. Pebble mosaic,
16 × 16 × 2 3/8 in. (40 × 40 × 6 cm).

▼ 21. Whole tesserae were used for the clothing area around the neck. A few pieces had to be cut down, such as the triangular and trapezium shapes along the edge of the shoulders. Before beginning the next stage, let the mosaic dry.

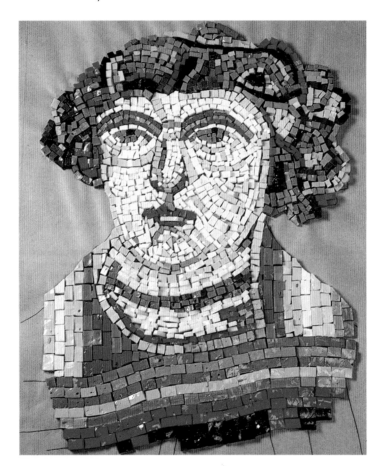

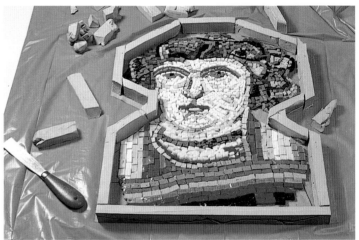

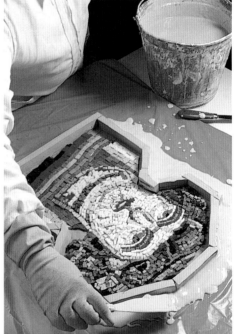

▲ 22. Place the mosaic on a sheet of plastic and prepare strips of clay or plasticine, 1 1/8 × 3/4 in. (3 × 2 cm). Position these around the mosaic to form a kind of framework. Remember that the area within this framework will be filled with mortar.

◀ 23. Add brown earth to the plaster so it will be distinguishable from the white mortar. Using a scraper, spread it around the outside of the clay frame. It is best to wear rubber gloves for this.

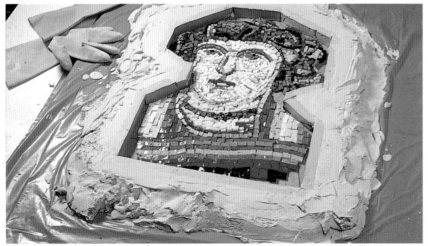

▲ 24. Build up the plaster around the outside of the framework up to the height of the frame, smoothing down and leveling the plaster before it starts to set.

▶ 25. When the plaster has set and cooled, remove the strips of clay, taking care not to damage the mosaic or the plaster frame. Brush liquid soap on the inside and upper part of this framework to prevent the mortar from sticking later. This process should be done without interruption so that the plaster is still damp.

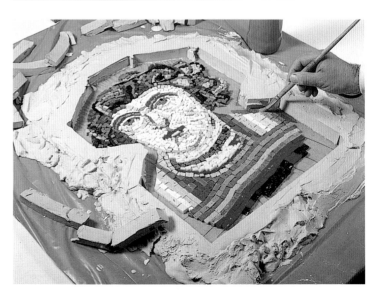

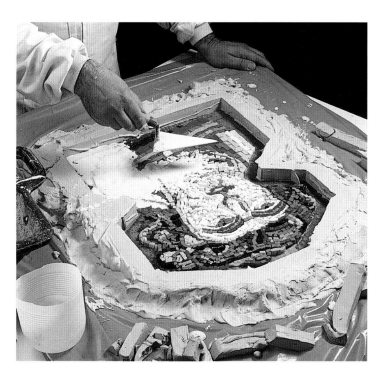

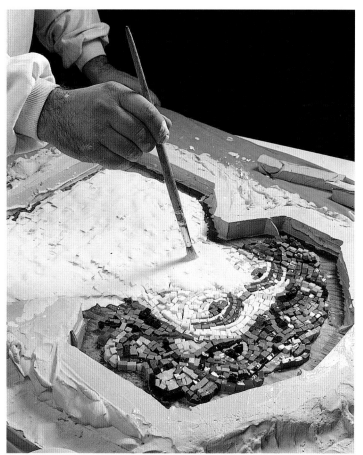

▲ 26. Prepare a runny mix of white cement. Begin applying it with a small trowel; it must penetrate the cracks between the tesserae to form a solid block when it sets.

▶ 27. Carefully press the cement between the tesserae with the brush and completely cover the mosaic.

▼ 28. For reinforcement, cut wire netting to size so that it fits inside the frame. Place it directly on top of the white cement covering the tesserae.

▼ 29. Prepare the mortar with one part white cement, three parts powdered marble, and water. Fill the entire frame, making sure it penetrates well by tapping the table or gently shaking it to remove any air. This way the mortar will settle and form a compact mass.

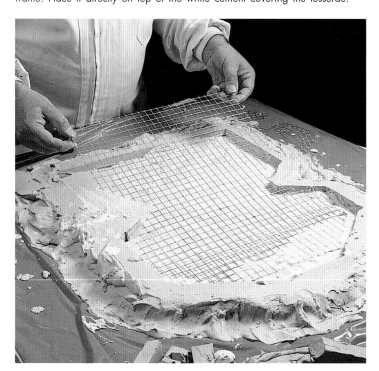

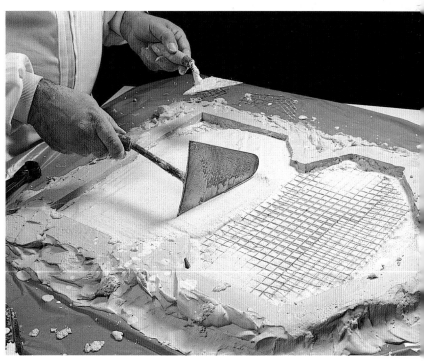

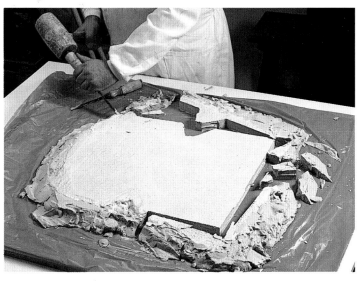

◄ 30. Let the mosaic dry for a few hours until it is hard to the touch. Cover it with a damp cloth to keep it moist and leave it for 72 hours, covered with a sheet of plastic.

▲ 31. After this time, use a chisel and wooden mallet to break away the plaster frame, which should crumble easily.

◄ 32. When the mosaic is held up, you can see the features through the paper base.

◄ 33. Place the mosaic on a water-resistant surface (melamine-coated board was used here). The paper should peel off easily because the dampness of the cement dissolves the glue that adhered the tesserae to the paper. The wrinkles in the mortar are caused by the paper. If you want to avoid this, cut the excess paper away before framing the mosaic.

▶ 34. Clean away any remaining glue with a sponge and water. Clean out joints with a metal pick to remove any cement covering the tesserae.

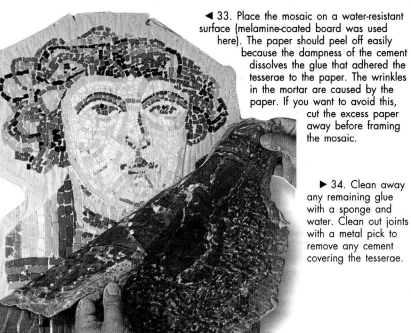

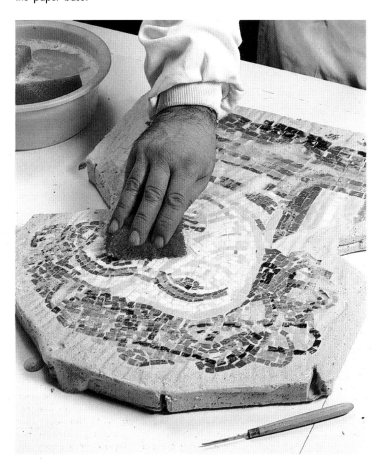

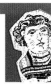

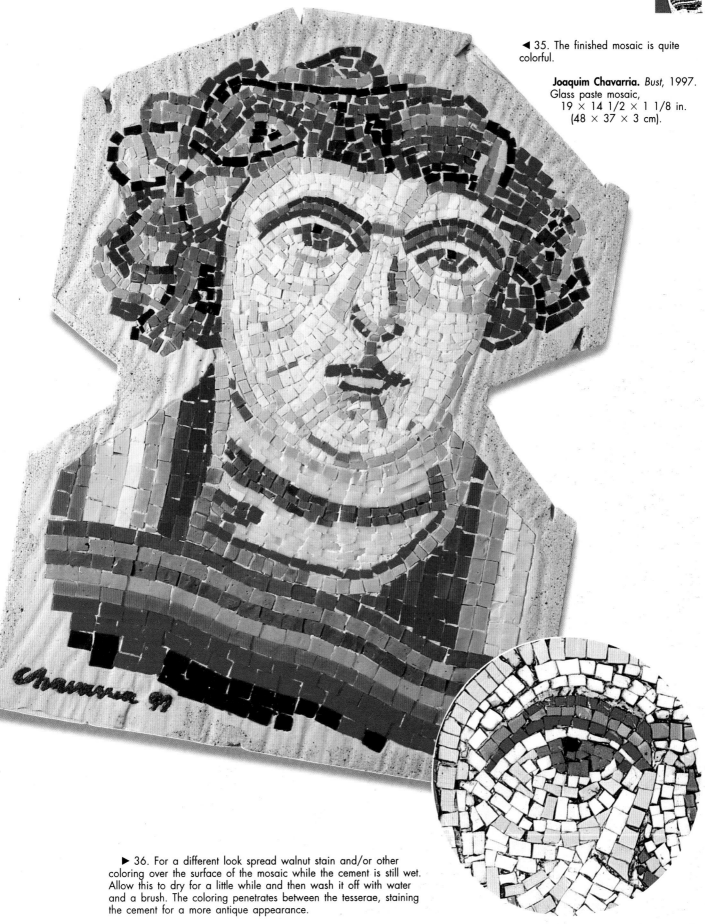

◄ 35. The finished mosaic is quite colorful.

Joaquim Chavarria. *Bust,* 1997.
Glass paste mosaic,
19 × 14 1/2 × 1 1/8 in.
(48 × 37 × 3 cm).

► 36. For a different look spread walnut stain and/or other coloring over the surface of the mosaic while the cement is still wet. Allow this to dry for a little while and then wash it off with water and a brush. The coloring penetrates between the tesserae, staining the cement for a more antique appearance.

Abstract Relief Using the Indirect Method, Direct Technique

Mosaics in relief are not very common, since a mosaic is usually designed as a flat surface. The basic approach to a mosaic of this type consists of modeling a relief with recesses into which the tesserae are laid, to produce different depths that will contrast with the colors produced by the tesserae.

For this project, knowing how to prepare the mold is just as important as modeling the form. The procedures for this mosaic are done in a slightly different order than with other methods.

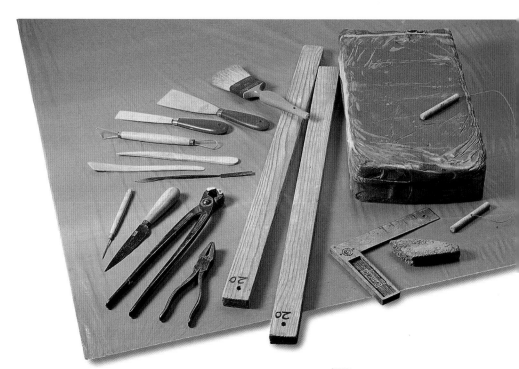

▲ 1. You'll need modeling clay, paintbrush, scrapers, modeling tools, nippers, 3/4-in. (2 cm) strips of wood, L-square, and clay-cutting wire. You'll also need a plant mister, tile cutter, tile separator, wire netting, straightedge, chisel, and wooden mallet.

▲ The design has been roughly sketched out with colored pencils.

▼ 3. Lay out the slabs to form the general outline of the base on which to model the relief.

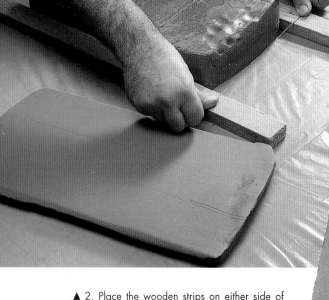

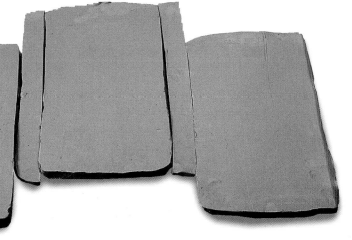

▲ 2. Place the wooden strips on either side of the clay. Pull the cutting wire toward you to slice slabs of clay 3/4 in. (2 cm) thick.

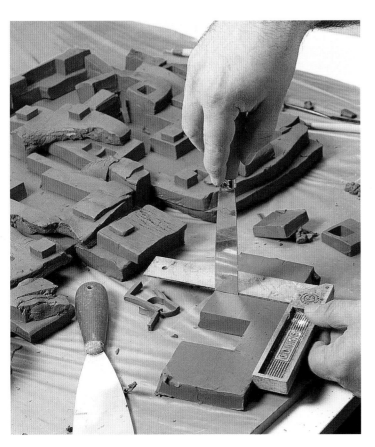

◄ 4. Using different thicknesses of clay, create small reliefs with your hands or the scraper and L-square, placing them on the surface of the slab.

▼ 5. Continue modeling the relief, leaving several areas to accommodate the tesserae.

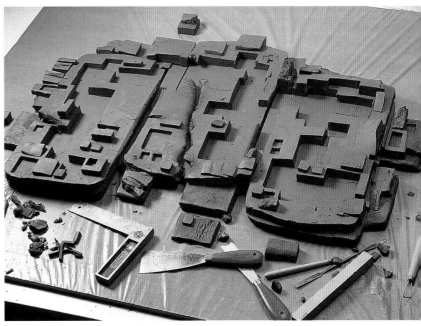

◄ 6. Using the end of a piece of wood, press down on the clay to form recesses for inserting the tesserae.

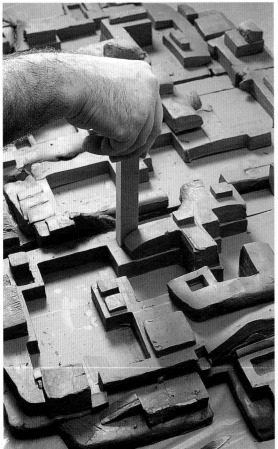

▼ 7. The finished relief must be dampened with the plant mister to keep the clay from drying and shrinking, which would dislodge the tesserae.

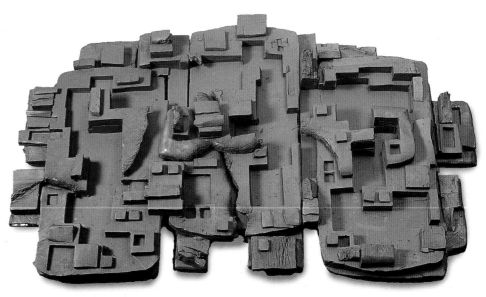

107

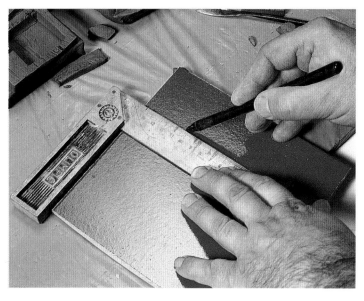

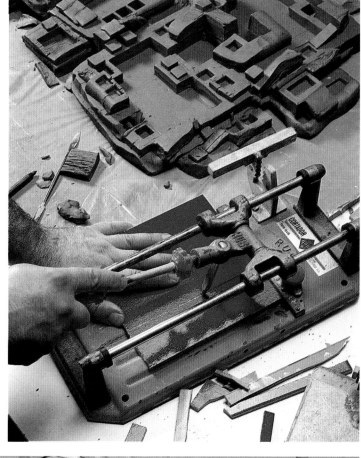

▲ 8. Prepare the red tile tesserae that will cover the base. Mark a cutting line on the tile with the aid of an L-square and felt-tip pen.

▶ 9. Score the tile along the marked line with the tile cutter.

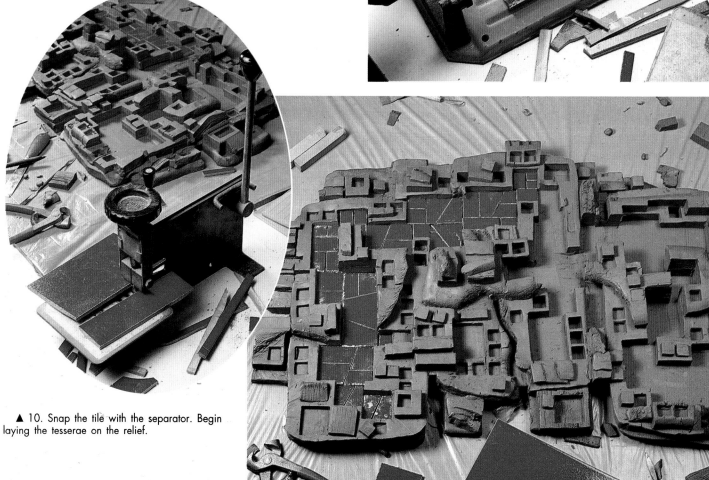

▲ 10. Snap the tile with the separator. Begin laying the tesserae on the relief.

▶ 11. Continue laying the tesserae to fill in the background.

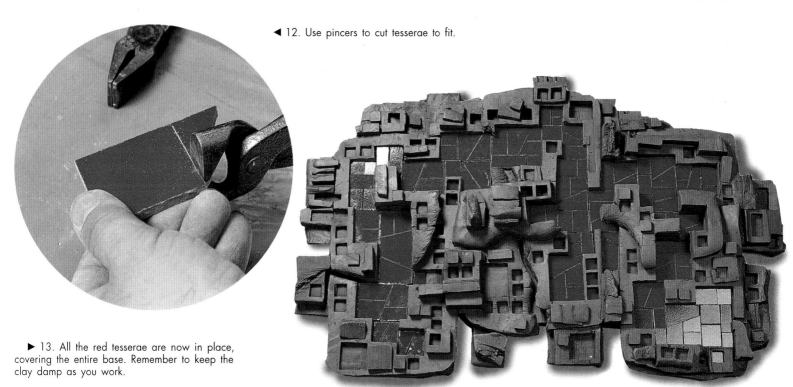

◄ 12. Use pincers to cut tesserae to fit.

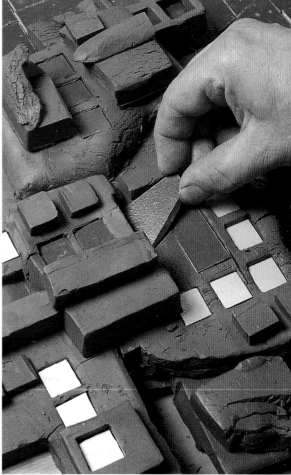

► 13. All the red tesserae are now in place, covering the entire base. Remember to keep the clay damp as you work.

▼ 14. Cut all the various colors of tesserae and line them up around the relief in position.

► 15. Begin laying the tesserae in the relief. They should fit perfectly into the spaces.

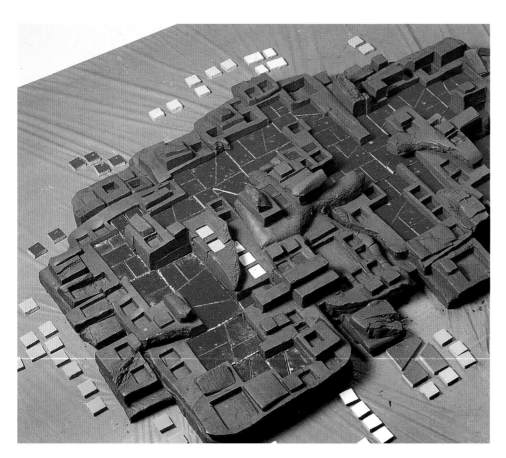

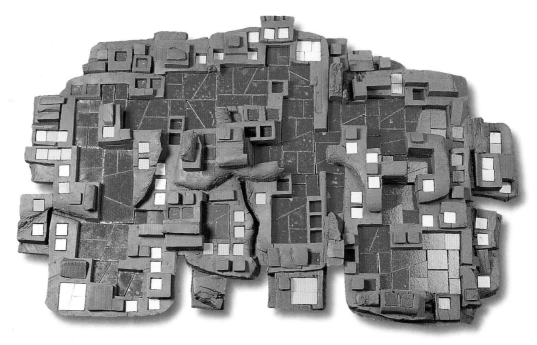

▶ 16. The finished relief is now ready for the water-soluble glue and paper base.

▼ 17. Brush the glue over the surface of the tesserae and place the paper on top.

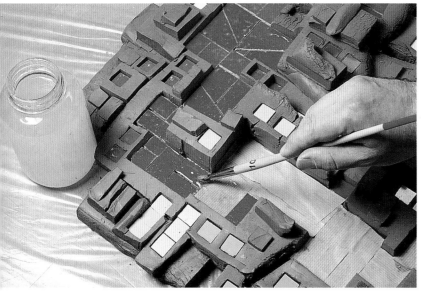

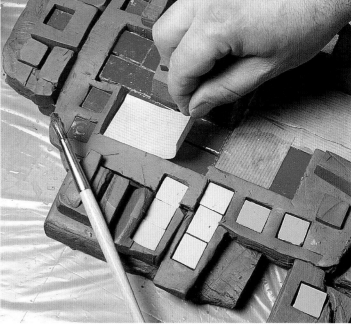

▲ 18. Press the paper down so that it adheres fully without any air bubbles. Repeat with a second layer of paper.

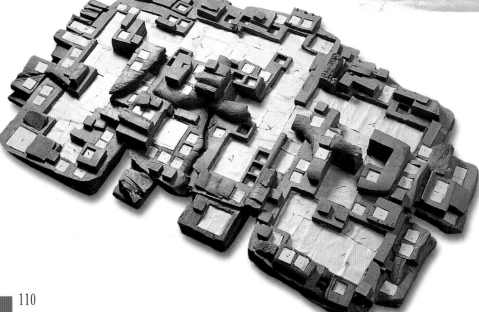

◀ 19. All the tesserae are now covered with two layers of paper.

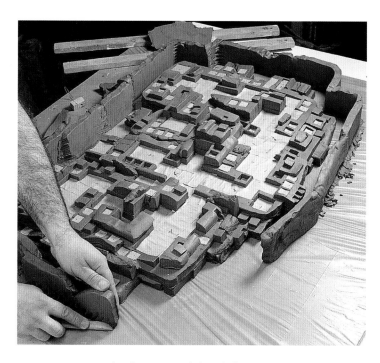

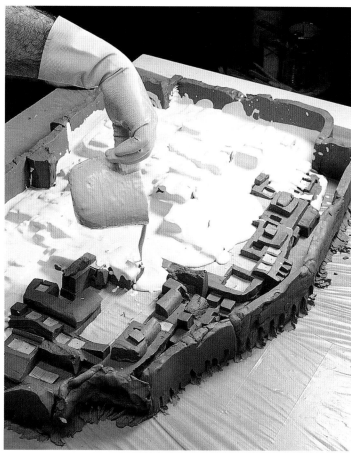

▲ 20. Prepare a clay frame around the relief, 3/8 in. (1 cm) thick and 2 in. (5 cm) high, leaving a gap of 1 1/8 in. (3 cm) between the frame and the relief.

▶ 21. Prepare the plaster and pour it straight onto the relief.

▼ 22. Pour on a second layer of plaster to cover the relief completely.

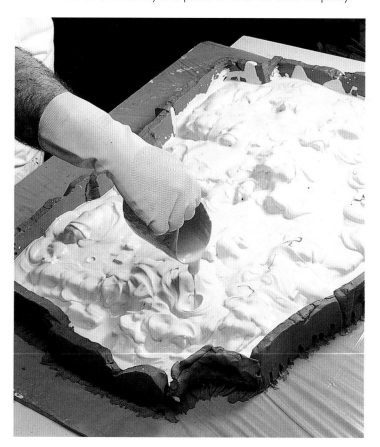

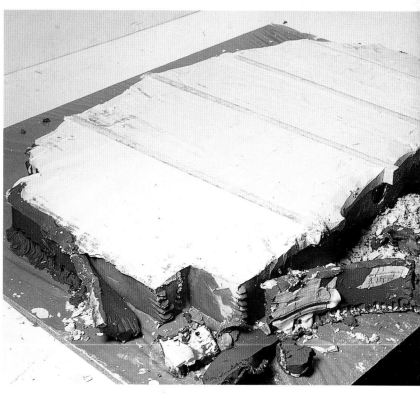

▲ 23. Since the relief is fairly long, reinforce the mold with strips of wood.

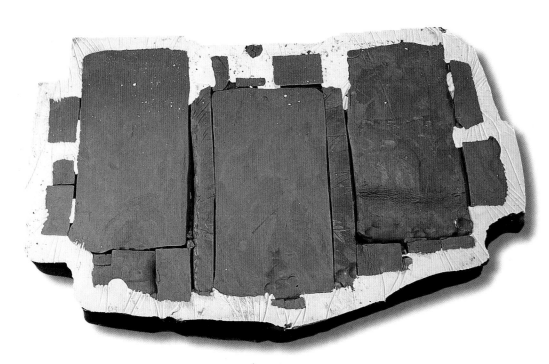

► 24. Seen from the underside, the mold is clearly visible around the perimeter of the relief.

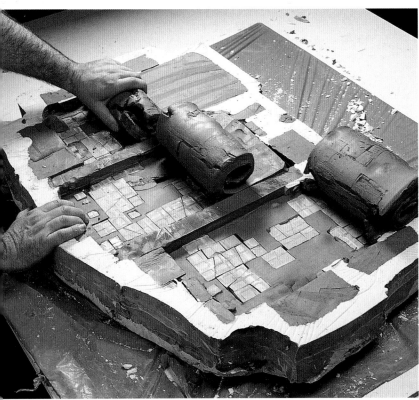

▲ 25. Begin to remove the clay slabs, rolling them up carefully and making sure the tesserae do not come away at the same time.

► 26. Use the clay scooper to remove the clay from between the tesserae. This part requires more care because it is easy to jostle the tesserae.

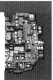

▼ 27. With the scooper, remove the rest of the clay from the lowest part of the relief.

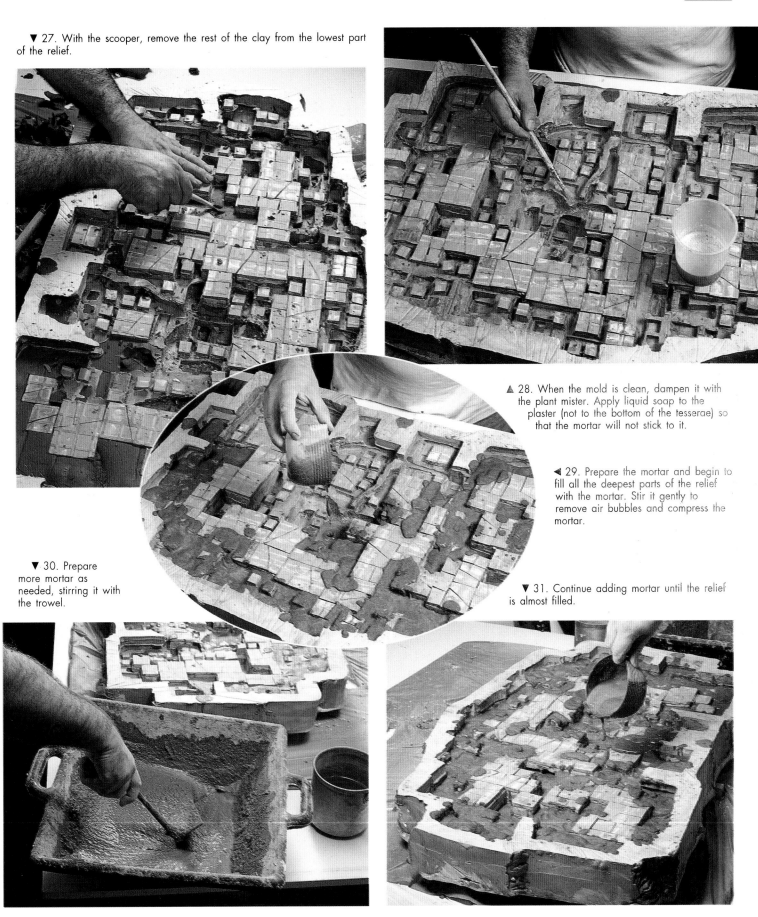

▲ 28. When the mold is clean, dampen it with the plant mister. Apply liquid soap to the plaster (not to the bottom of the tesserae) so that the mortar will not stick to it.

◄ 29. Prepare the mortar and begin to fill all the deepest parts of the relief with the mortar. Stir it gently to remove air bubbles and compress the mortar.

▼ 30. Prepare more mortar as needed, stirring it with the trowel.

▼ 31. Continue adding mortar until the relief is almost filled.

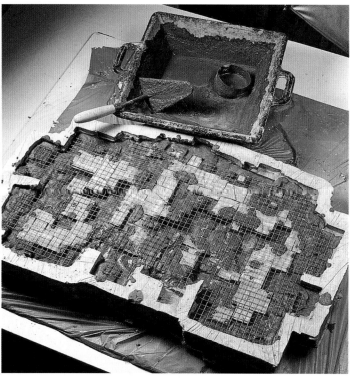

▲ 32. Cut the wire reinforcement netting to fit, leaving a gap of 3/8 in. (1 cm) between it and the edges of the mold.

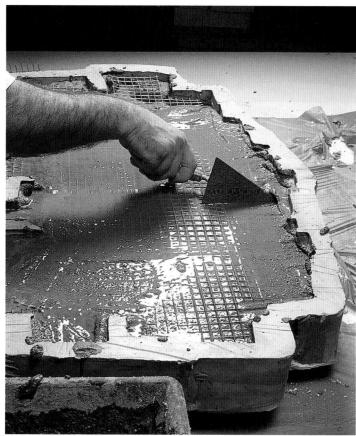

▲ 33. After inserting the netting, fill in the mold with more mortar.

◀ 34. Run a straightedge over the surface to level it.

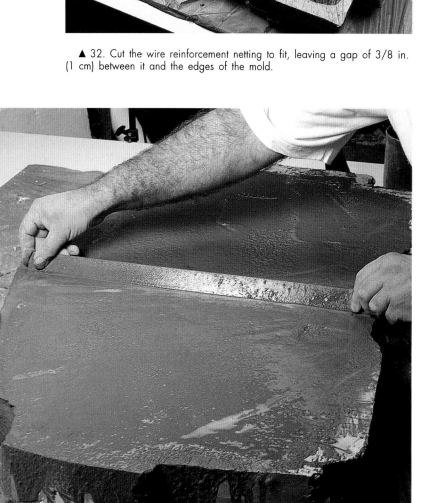

▲ 35. Cover the piece with a damp cloth to keep the mortar moist.

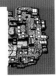

wor

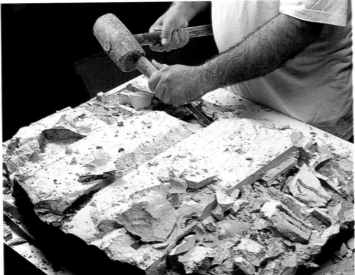

mod

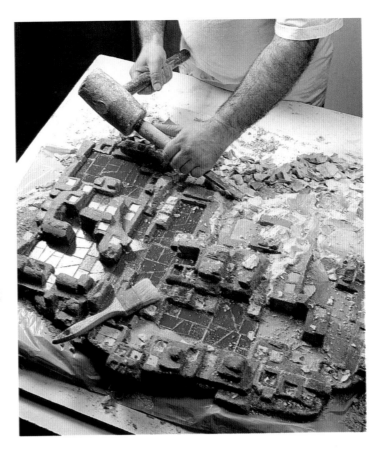

▲ 36. Let the mold sit for at least 72 hours before handling it. Once it is set, break open the mold with a chisel and wooden mallet.

▶ 37. The relief gradually begins to appear.

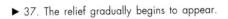

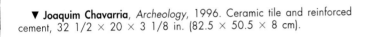

▼ **Joaquim Chavarria**, *Archeology*, 1996. Ceramic tile and reinforced cement, 32 1/2 × 20 × 3 1/8 in. (82.5 × 50.5 × 8 cm).

along
of w

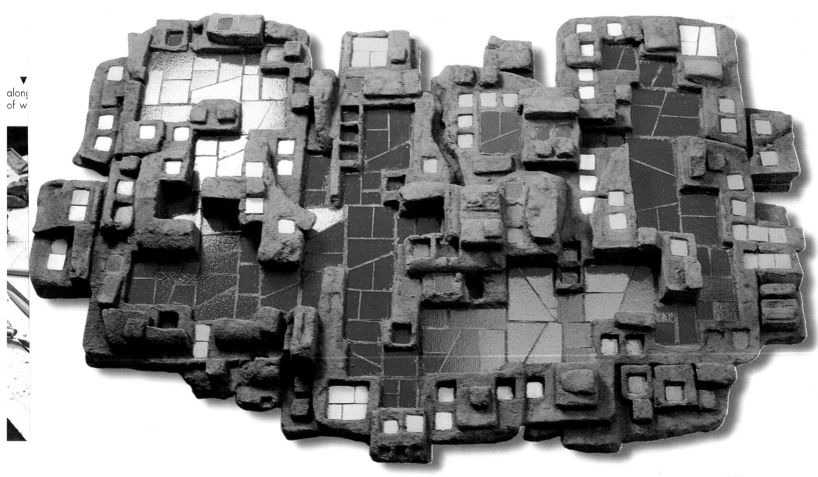

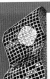

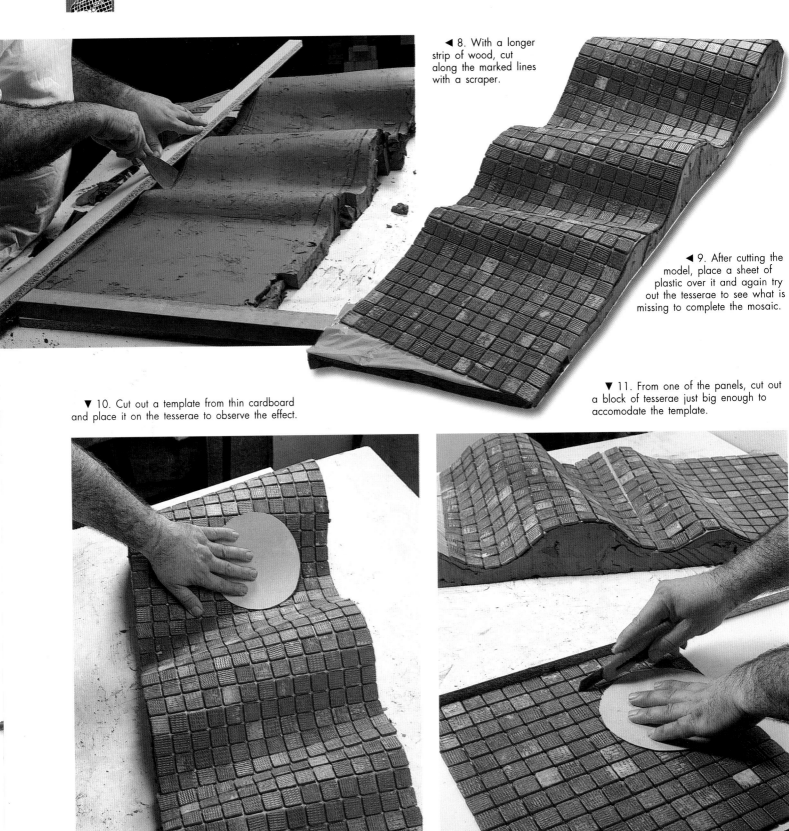

◄ 8. With a longer strip of wood, cut along the marked lines with a scraper.

◄ 9. After cutting the model, place a sheet of plastic over it and again try out the tesserae to see what is missing to complete the mosaic.

▼ 10. Cut out a template from thin cardboard and place it on the tesserae to observe the effect.

▼ 11. From one of the panels, cut out a block of tesserae just big enough to accomodate the template.

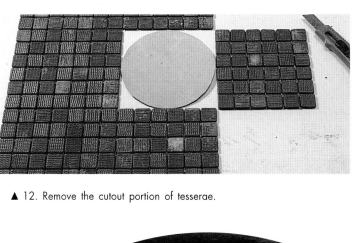

▲ 12. Remove the cutout portion of tesserae.

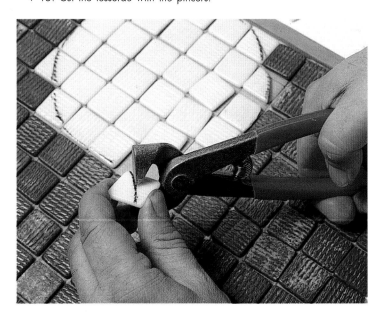

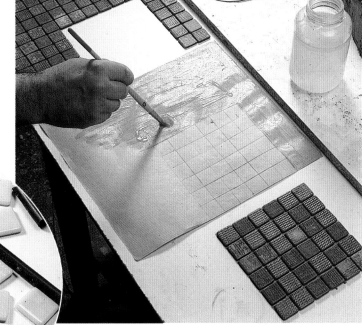

▲ 13. Mark off the cutout portion on a piece of brown paper. Brush the rest of the paper with water-soluble glue and adhere the blue tesserae face down.

◄ 14. Position the white tesserae face down, without glue.

▼ 15. Cut the tesserae with the pincers.

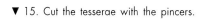

▼ 16. Lay out the blue and white tesserae in the moon area.

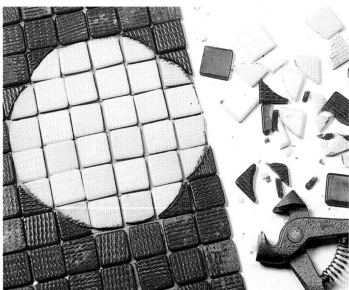

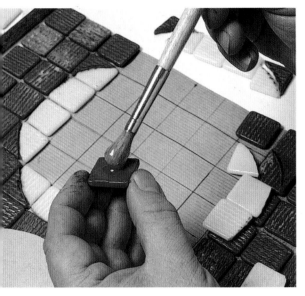

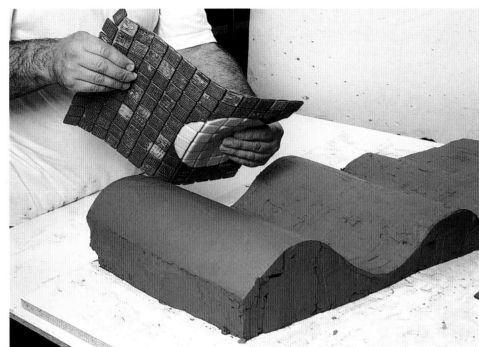

▲ 17. Brush glue on the tesserae and stick them in place. As you can see, the grid pattern on the brown paper helps to situate each tesserae exactly.

▲ 18. When the glue has dried, begin to lay the tesserae panels on the clay.

◄ 19. The tesserae are laid face down, with the glued paper facing up.

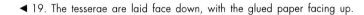

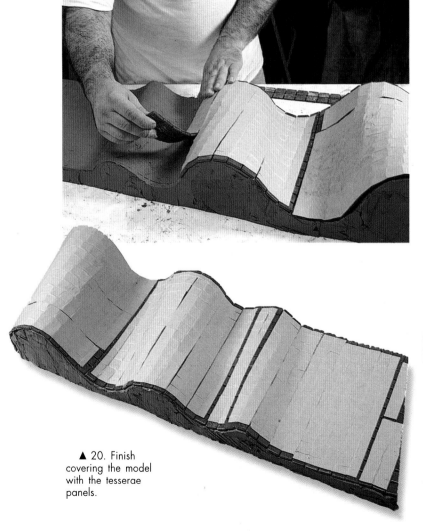

▼ 21. Check the work for any gaps that need to be filled with spare tesserae.

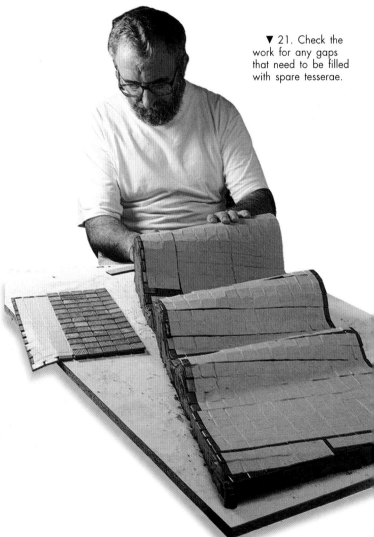

▲ 20. Finish covering the model with the tesserae panels.

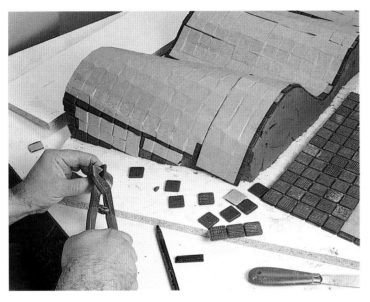

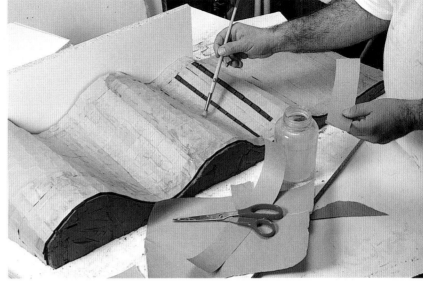

▲ 22. Use the pincers to cut tiles to fit along the edge.

▲ 23. Glue strips of brown paper over the uncovered areas and let them dry.

▶ 24. Place a sheet of plastic over the brown paper and secure it with masking tape.

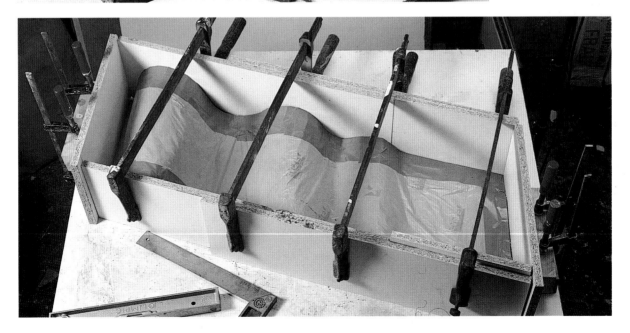

▶ 25. Prepare a frame of melamine-coated boards and clamp them together around the piece.

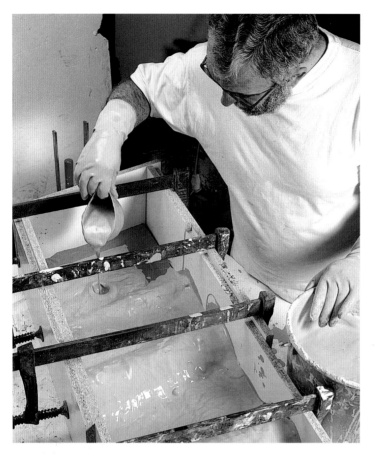

◀ 26. Prepare the plaster and pour the first layer. It helps to tint the first layer of plaster to indicate where the model is.

▼ 27. Smooth out the first layer of plaster somewhat.

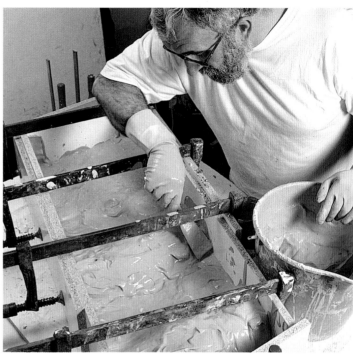

◀ 28. Pour the second layer of plaster. To strengthen the mold, add wood rods covered with packing tape.

▼ 29. After the mold has been allowed to set, turn it over to make a countermold on the wave side. Since the mosaic is quite long, it helps to first place several steel rods to reinforce the structure. Fill these gaps with white plaster and add some wooden rods

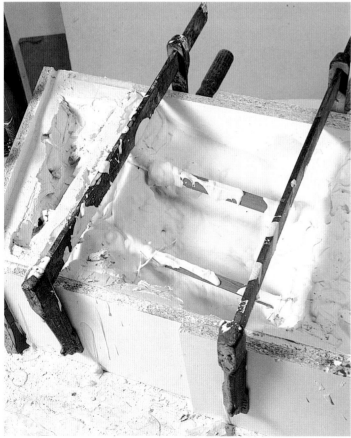

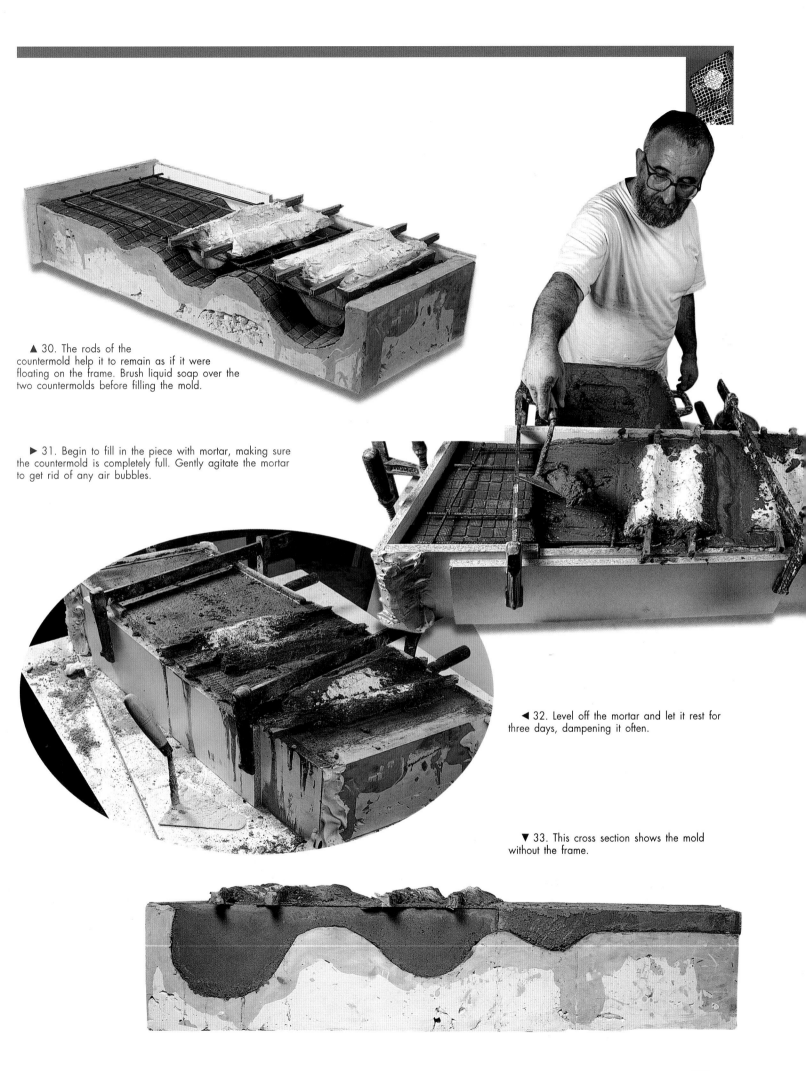

▲ 30. The rods of the countermold help it to remain as if it were floating on the frame. Brush liquid soap over the two countermolds before filling the mold.

▶ 31. Begin to fill in the piece with mortar, making sure the countermold is completely full. Gently agitate the mortar to get rid of any air bubbles.

◀ 32. Level off the mortar and let it rest for three days, dampening it often.

▼ 33. This cross section shows the mold without the frame.

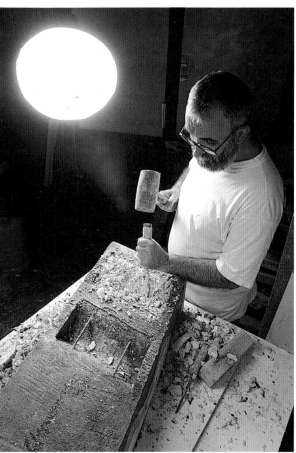

◄ 34. Great care must be taken when breaking open the mold to avoid damaging the mortar. The countermolds are broken first.

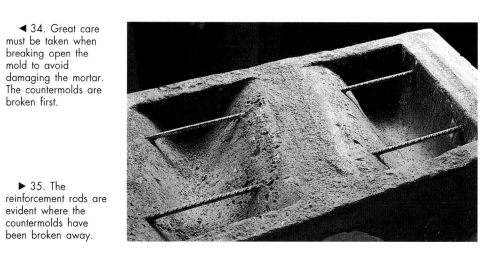

► 35. The reinforcement rods are evident where the countermolds have been broken away.

► 36. After the countermolds are removed, carefully remove the mold.

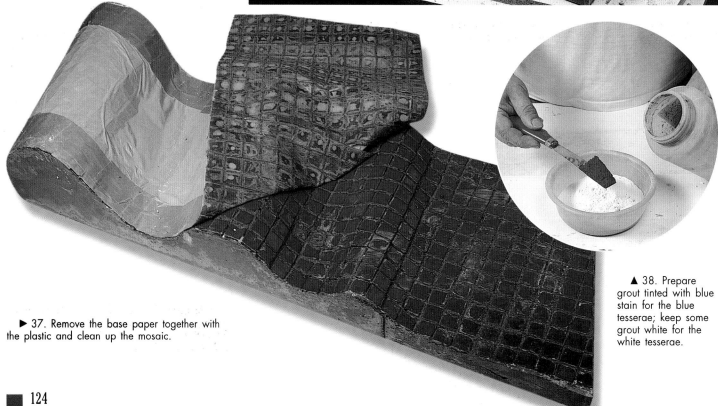

► 37. Remove the base paper together with the plastic and clean up the mosaic.

▲ 38. Prepare grout tinted with blue stain for the blue tesserae; keep some grout white for the white tesserae.

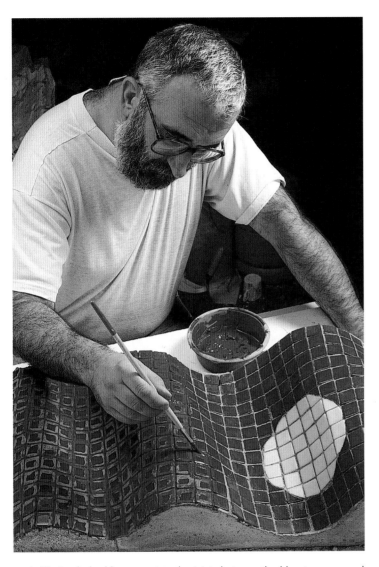

▲ 39. Brush the blue grout into the joints between the blue tesserae, and the white grout between the white tesserae. Let it dry for 45 minutes.

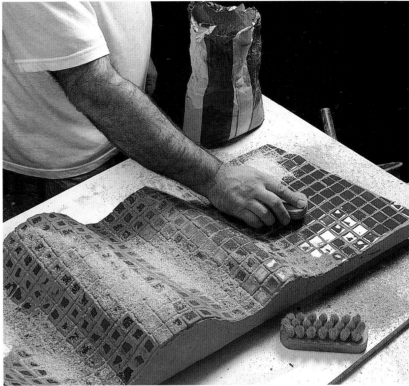

▲ 40. Cover the piece with fine sawdust and scrub gently with a hard bristle brush or a dry cloth to remove any excess grout. Never use water for this step.

◄ **Joaquim Chavarria**. *Sea and Moon*, 1997.
Glass paste tesserae and mortar,
38 5/8 × 13 3/8 × 5 1/2 in.
(98 × 34 × 14 cm).

Circular Wall Sculpture Using the Indirect Method, Reverse Technique

This relief is designed to be made with strips of marble measuring 2 x 3/4 in. (5 x 2 cm) and slabs of marble and granite 1/2 in. (1.2 cm) thick, cut with a water-cooled electric cutter fitted with a diamond disc. Because this process will wet the tesserae, the drawing must be waterproofed. Also, since the water may wash off the cutting lines, place a strip of adhesive tape along the lines before cutting.

Since this method uses the reverse technique, another drawing must be prepared, as explained on page 60. Place the strips of clay or plasticine on the drawing and lay the marble or granite strips or tesserae on these strips at whatever depth is wanted for the desired relief. If a smooth surface is wanted instead of a relief, you can lay the strips directly on the reverse of the drawing, and the mosaic together with the mortar can then be embedded in the floor like a paving mosaic.

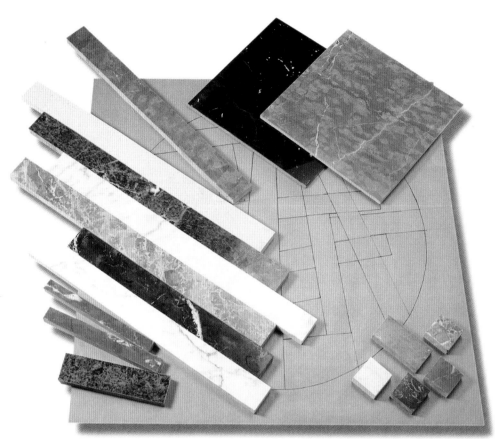

▲ 1. This project requires strips and slabs of marble and granite, as well as thinner strips and tesserae cut from them.

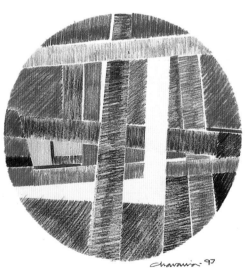

▲ I've sketched out the preliminary design in colored pencils.

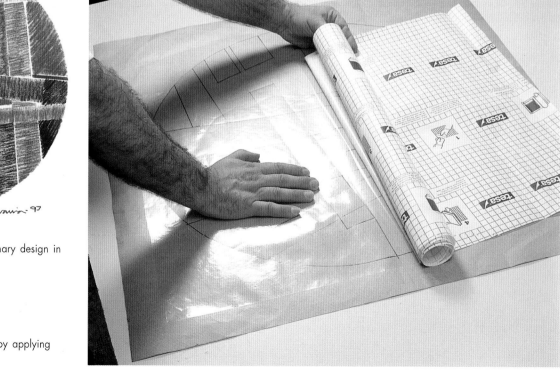

▶ 2. Waterproof the drawing by applying clear adhesive paper.

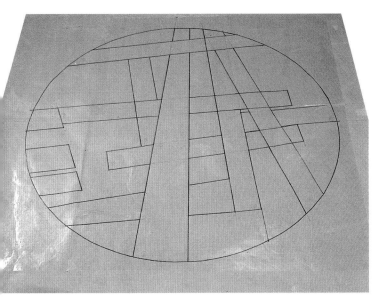

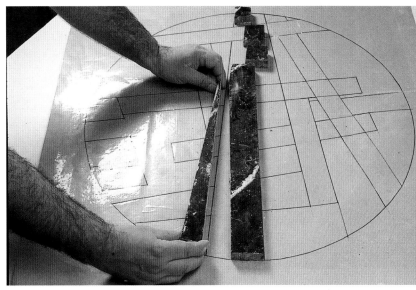

▲ 3. The protected drawing is now ready to accept the damp strips of marble and granite.

▲ 4. Cut the strips and tesserae from the black marble and position them on the drawing.

◄ 5. Continue with the green marble, placing the pieces to coincide exactly with the drawing.

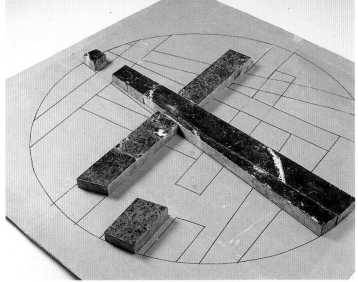

▼ 6. Notice how the strip of marble is laid for an oblique cut.

▼ 7. As with the other colors of marble, use a felt-tip pen and L-square to mark the cutting line on the red marble, then place a piece of tape along the line. Remove the tape before placing the piece on the drawing.

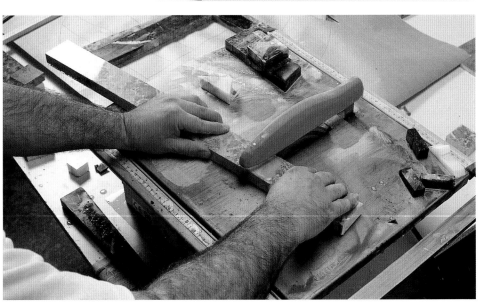

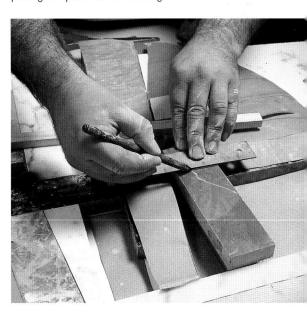

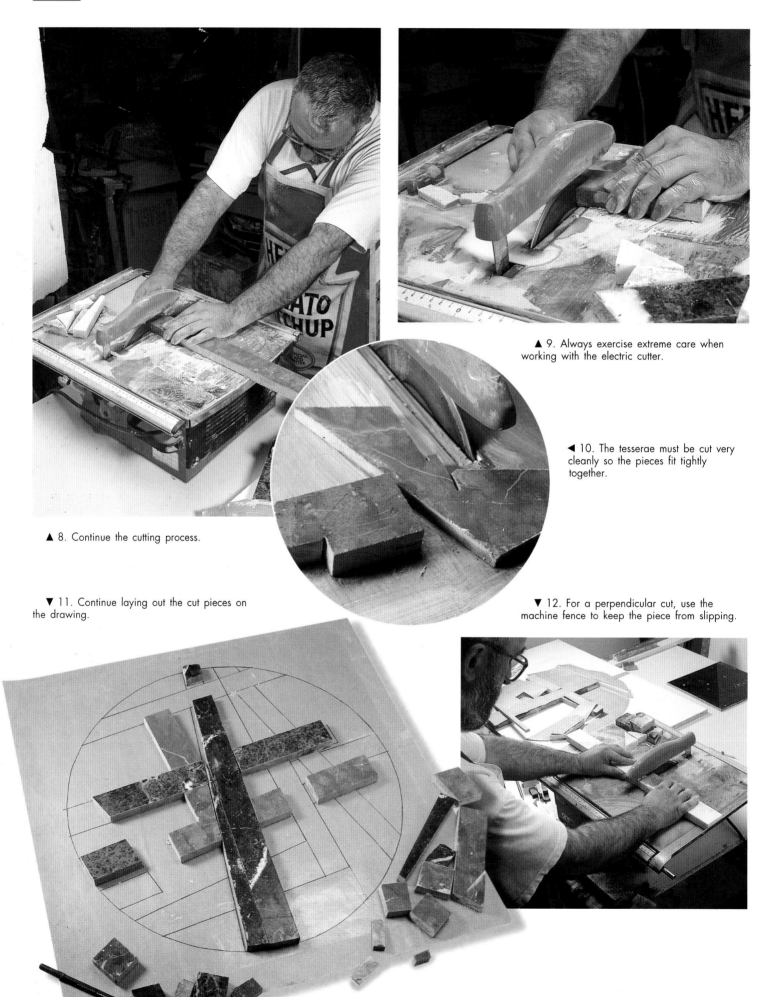

▲ 8. Continue the cutting process.

▲ 9. Always exercise extreme care when working with the electric cutter.

◀ 10. The tesserae must be cut very cleanly so the pieces fit tightly together.

▼ 11. Continue laying out the cut pieces on the drawing.

▼ 12. For a perpendicular cut, use the machine fence to keep the piece from slipping.

▼ 13. Cut the white marble following the same process.

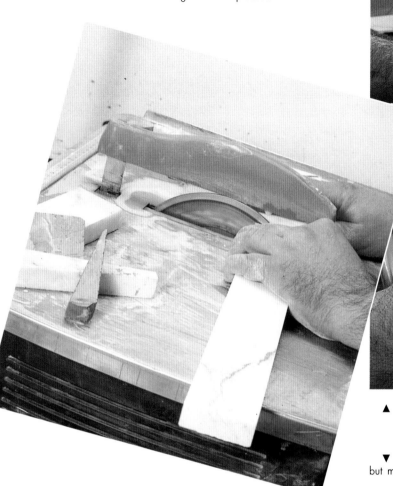

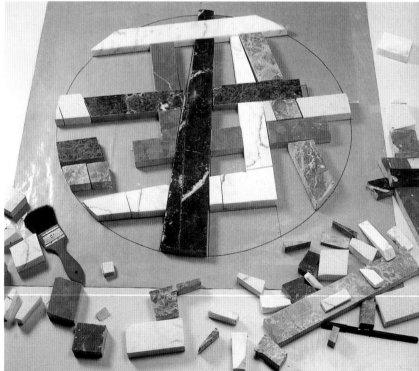

▲ 14. This particular strip of white marble will be cut into three pieces.

▼ 16. Some of the leftover fragments may still be large enough to use, but most will be too small for this project.

▼ 15. The work is progressing steadily.

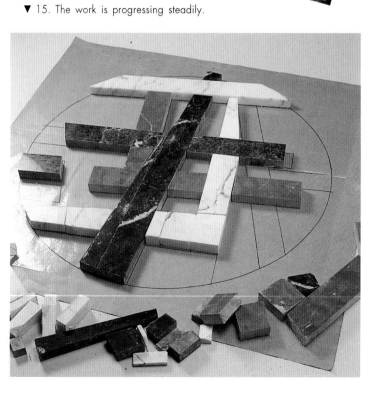

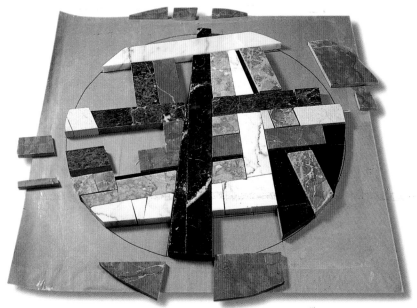

◀ 17. At this stage the 3/4 in. (2 cm) thick strips are finished and the remaining areas will be filled with tesserae cut from 3/8 in. (1 cm) slabs, which are seen here lined up around the drawing.

▼ 18. The layout is almost complete.

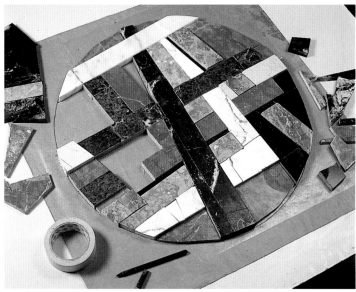

◀ 19. Notice the strip of adhesive tape, which acts as a cutting line.

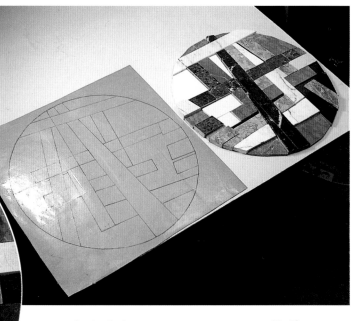

◀ 20. The finished mosaic can now be glued directly onto a laminated wood base or slab of cement fiberboard, using the right adhesive. It could also be attached to a wall using adhesive cement. But with these methods, it would lack relief.

▲ 21. The mirror-image drawing must also be covered with a sheet of clear adhesive paper.

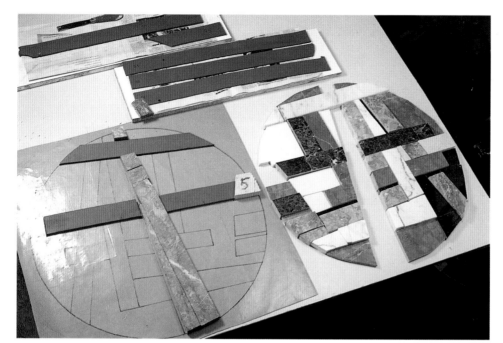

◄ 22. Prepare the clay strips and position them on the mirror-image drawing.

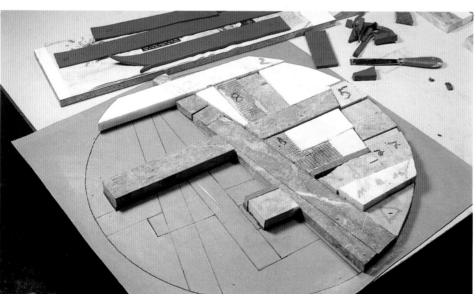

▲ 23. Continue cutting strips of clay, using the tesserae as templates. Once the clay is placed on the drawing, place the tesserae face down on top.

▲ 24. The clay strips are beginning to add different levels of relief to the piece.

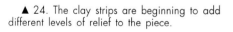

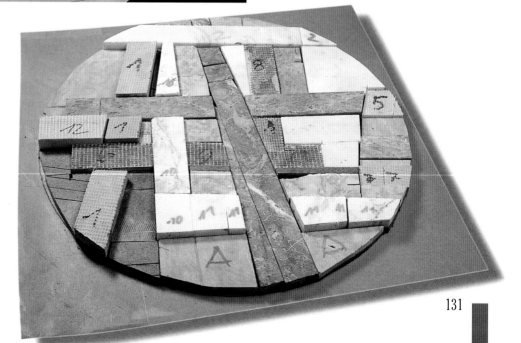

► 25. Notice that the back of each piece has been marked with a number or letter as a guide to the position of each piece.

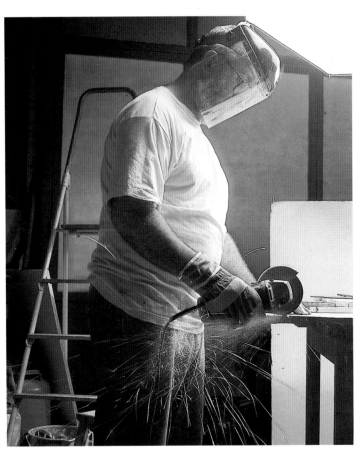

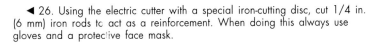

◀ 26. Using the electric cutter with a special iron-cutting disc, cut 1/4 in. (6 mm) iron rods to act as a reinforcement. When doing this always use gloves and a protective face mask.

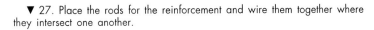

▼ 27. Place the rods for the reinforcement and wire them together where they intersect one another.

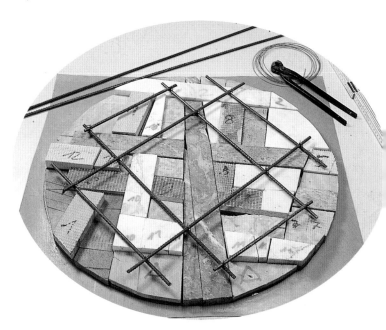

◀ 28. Prepare the frame using an aluminum band held together with plastic tape. Seal the joint with plaster to prevent any water from leaking out the bottom edge.

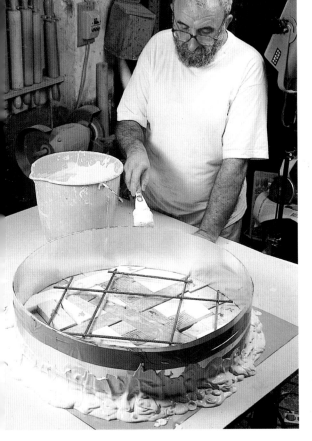

▶ 29. When the plaster has set, prepare the mortar. The first layer should be runny so it penetrates into all the joints; the second should be firmer. Once the iron reinforcement is covered with a layer 5/8 in. (1.5 cm) deep, the work is finished.

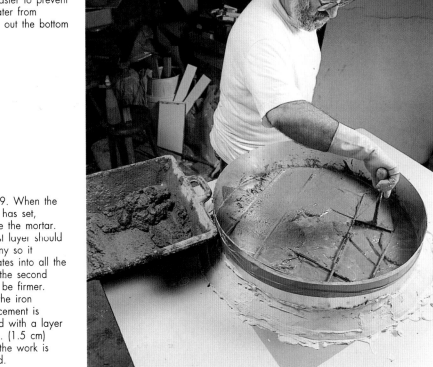

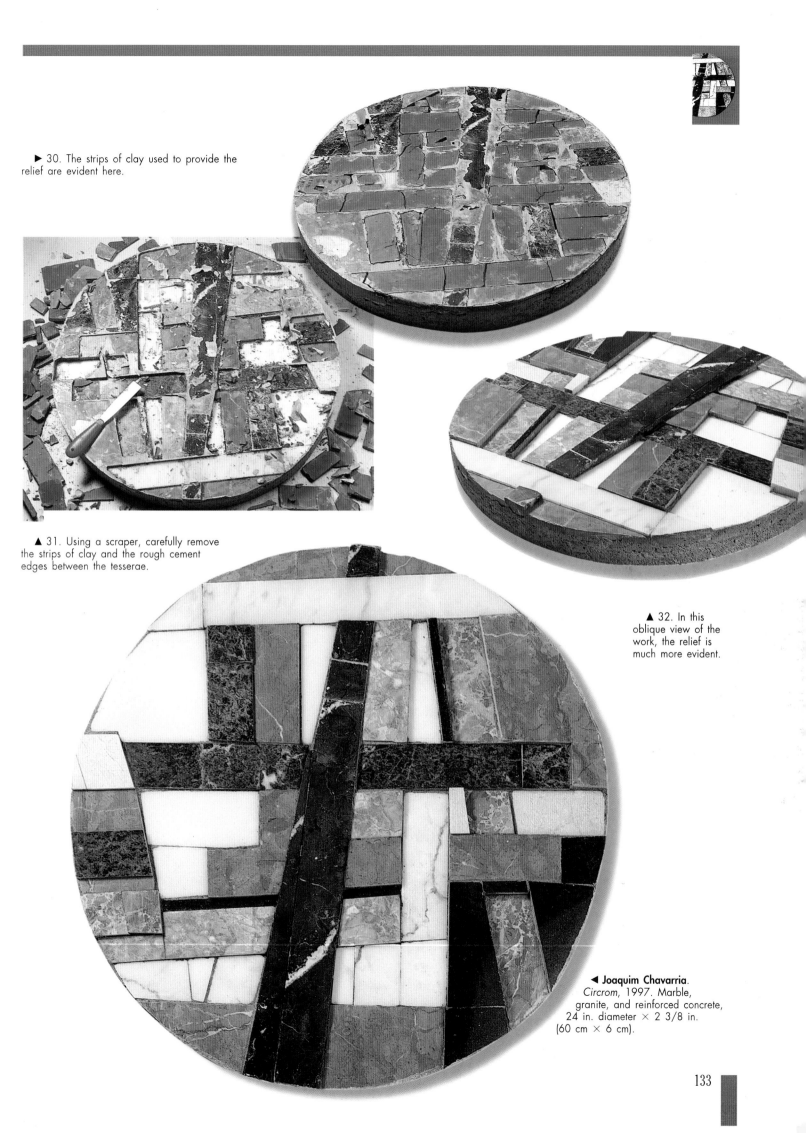

▶ 30. The strips of clay used to provide the relief are evident here.

▲ 31. Using a scraper, carefully remove the strips of clay and the rough cement edges between the tesserae.

▲ 32. In this oblique view of the work, the relief is much more evident.

◀ **Joaquim Chavarria**. *Circrom*, 1997. Marble, granite, and reinforced concrete, 24 in. diameter × 2 3/8 in. (60 cm × 6 cm).

Temple Sculpture Using the Direct Method

The previous projects that employed this system for laying the tesserae used a piece of laminated wood and a slab of cement fiberboard as a definitive base. For this project, I have chosen terra-cotta.

First I have prepared a model of a small temple, modeled in two parts: the base and the temple itself. The base, which is 22 in. (55 cm) in diameter by 3 1/2 in. (9 cm) high, is formed from three cylinders with the addition of modeled steps leading to the upper surface, where the sculpture proper starts. The surface of the whole sculpture is covered with fragments of multicolored tiles fitted perfectly over them, which requires preparing a large number of tesserae to cover the entire surface smoothly. This is admittedly a rather painstaking process, but I believe the results are worthwhile. For information on making your own tiles, see the following project.

▲ 1. Choose ceramic tiles of various colors to prepare the tesserae.

▲ Preliminary sketch for the project in watercolor, colored pencils, and lead pencil.

▼ Terra-cotta model of the temple.

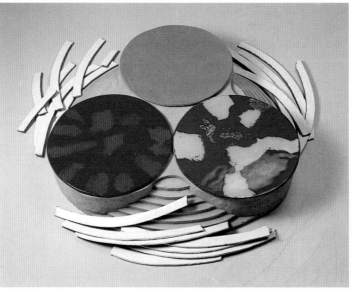

▲ 2. For the upper surface of the base, prepare three round slabs of clay by firing and enameling them. Also prepare several semicircular strips for the steps in the same way.

◄ 3. Check the fit of the three discs on the base.

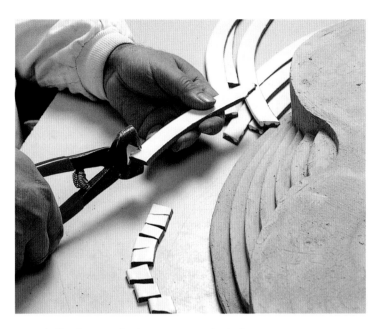

▲ 4. Cut the strips for the stairs into individual tesserae.

▶ 5. To adhere the stair tesserae, brush glue both on the base and on the back of the tesserae.

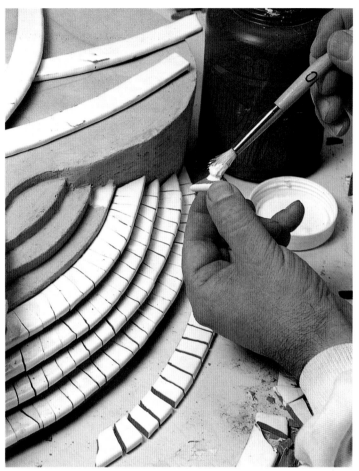

◀ 6. Use a metal pick to help align the tesserae.

▼ 7. Once all the steps have been covered, begin preparing the tesserae for the walls of the base cylinders. These tesserae have been cut with a hand cutter.

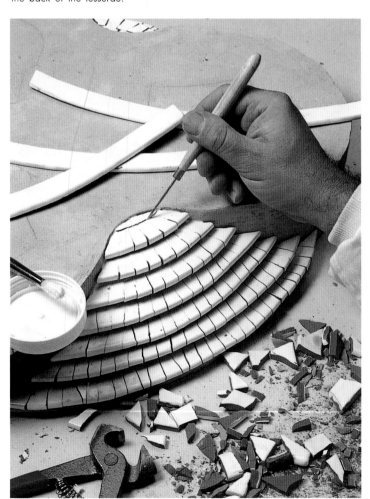

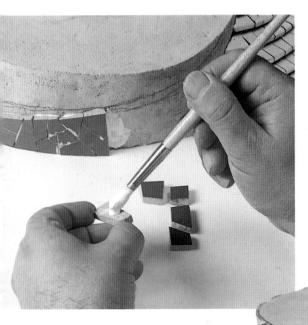

◀ 8. Glue the tesserae over the lower part of the one of the cylinders.

▶ 9. Add a strip of tesserae in a second color.

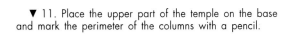

▶ ▼ 10. Continue this process until all the cylinder sides are covered. The circular slabs will be added later.

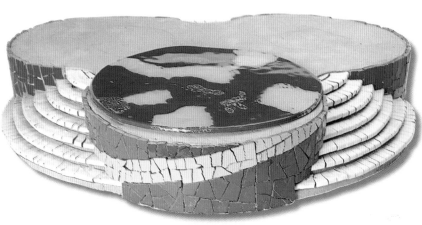

▼ 11. Place the upper part of the temple on the base and mark the perimeter of the columns with a pencil.

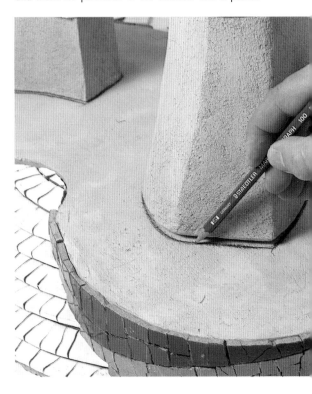

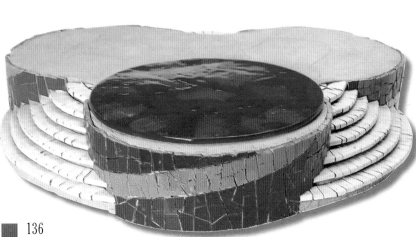

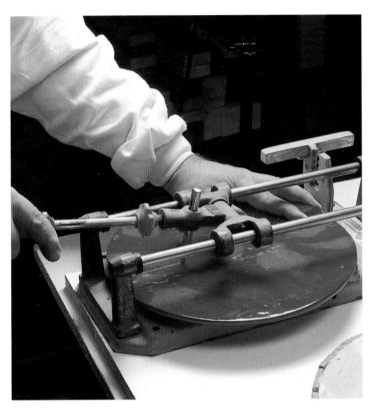

▲ 12. Use the hand cutter to score one of the round slabs.

▶ 13. Split the slab in two.

▼ 14. Cut the slab into tesserae and glue them in place.

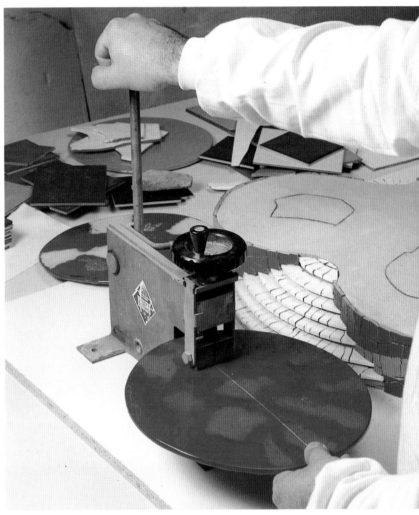

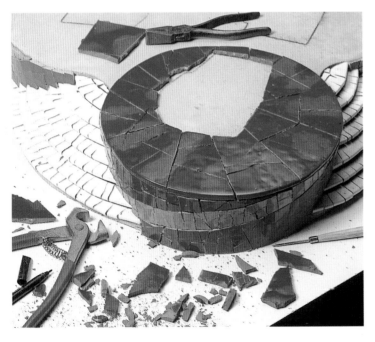

▶ 15. Proceed in the same manner with the other two slabs.

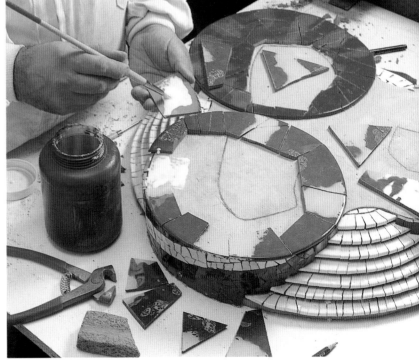

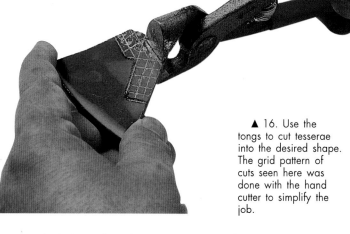

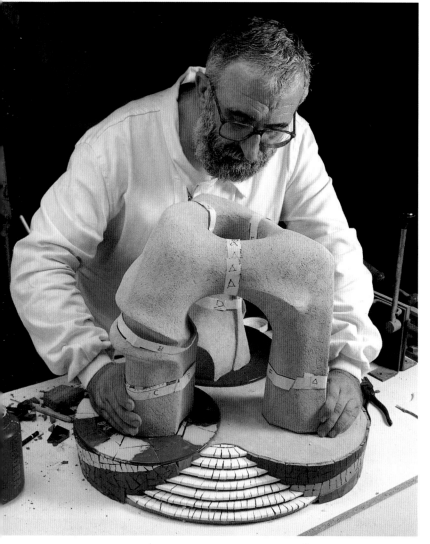

▲ 16. Use the tongs to cut tesserae into the desired shape. The grid pattern of cuts seen here was done with the hand cutter to simplify the job.

◀ 17. Check the work, making sure the columns fit perfectly into the slabs.

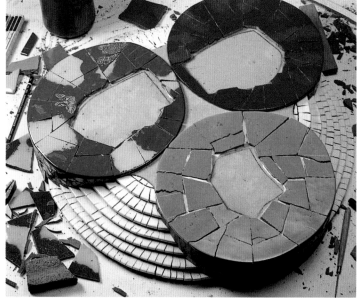

▲ 18. The three triangular areas between the slabs and the fourth triangle in the middle will be covered with the same material as the stairs.

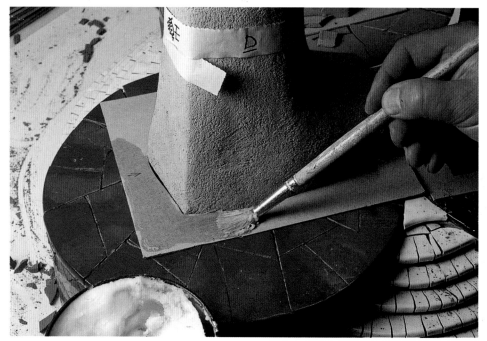

◀ 19. Prepare cardboard templates to fit around the bottom of the columns. Set the columns in place and brush wax over the cardboard, which is used to separate the tesserae that cover the columns and the base. The wax will keep the glue from sticking to the cardboard.

▼ ▶ 20 and 21. Begin laying the tesserae over the columns.

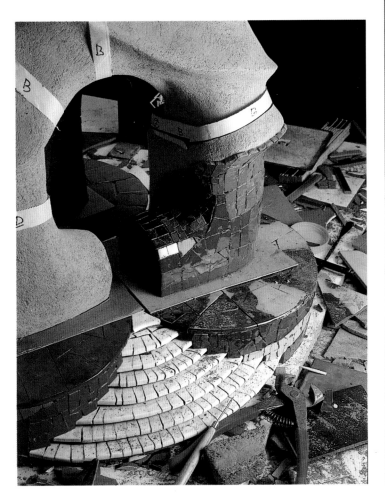

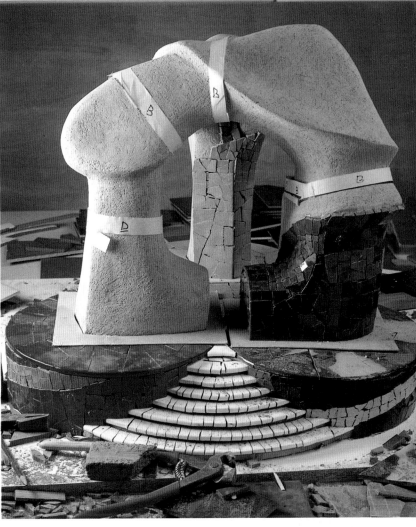

▲ 22. Hold a piece of cardboard against one of the walls and mark the outline with a felt-tip pen.

▶ 23. Cut out the cardboard shape to use as a template and place it on one of the red tiles, drawing around it with the pen.

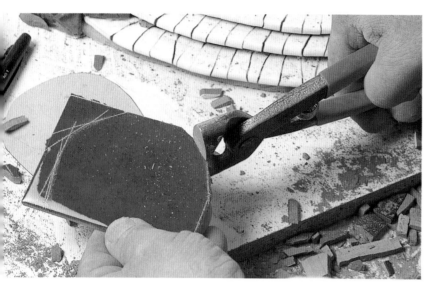

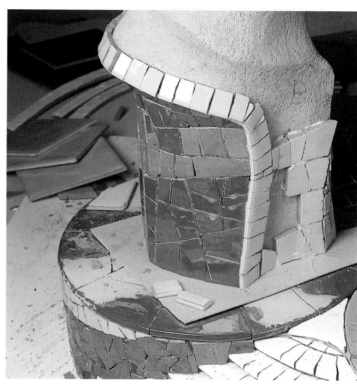

▲ 24. Score the cutting lines and break off the tile accordingly. Cut up the tile into the tesserae.

▶ 25. Place the yellow tessera, following the outside lines of the green tesserae.

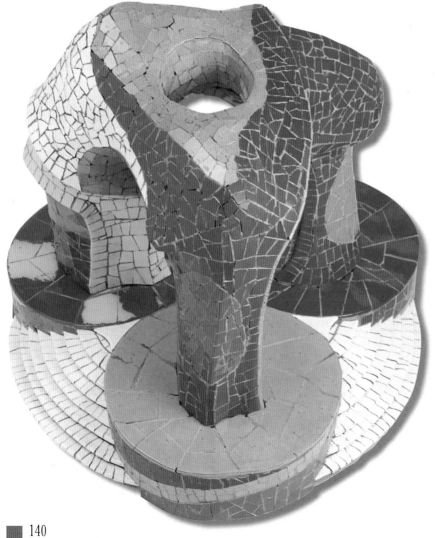

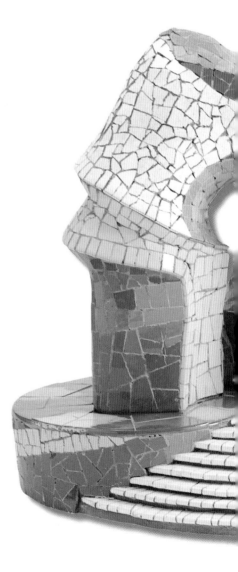

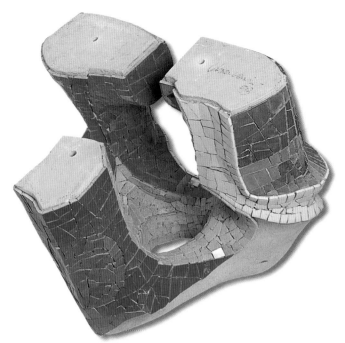

▲ 26. Finish covering all exposed surfaces with tesserae.

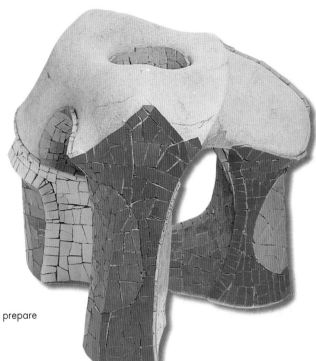

▶ 27. After laying all the tesserae, prepare grout tinted black to fill in the joints.

◀ ▶ 28. Two different views of the finished work show how carefully all the tesserae fit together.

Joaquim Chavarria. *Temple,* 1997. Ceramic tile and terra-cotta, 19 in. high × 22 in. diameter (49 × 55 cm).

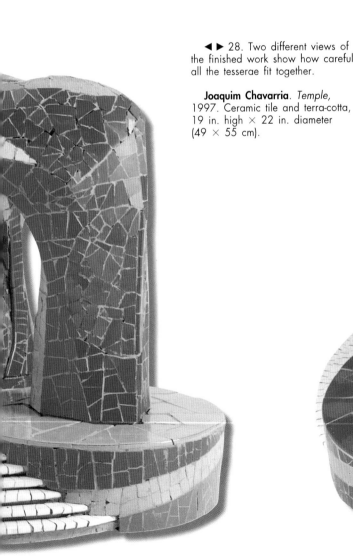

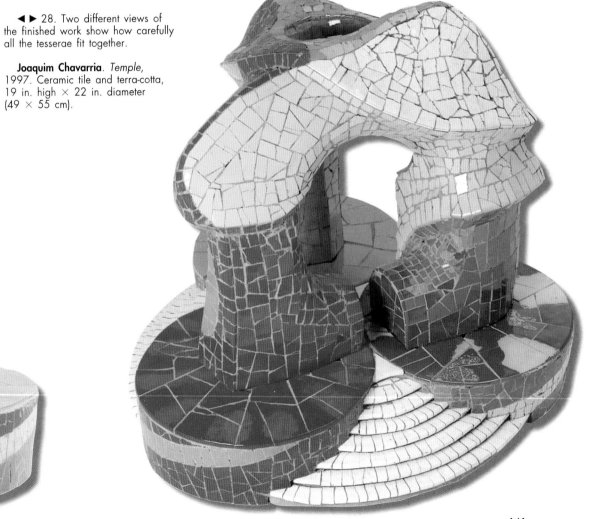

Small Pool Using the Indirect Method, Direct Technique

In addition to using preexisting materials, mosaicists can make their own tesserae. The best choice for this is high- or low-temperature ceramic pastes, which can be modeled and, when hard, can be easily cut. This method requires drying and firing, or two firings in this case: one to bake the ceramic paste and another to enamel, or glaze, the tesserae. These enamels, along with ceramic pastes, can be bought in specialty ceramic stores.

This project can be made with one of two systems. The one described here is the more difficult of the two, as far as laying the vertical tesserae covering the walls of the pond are concerned; the easiest solution would be to use adhesive cement and then break the mold.

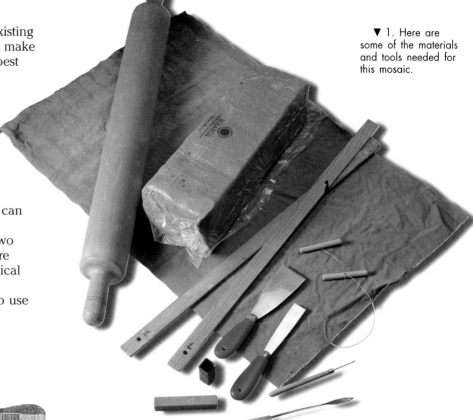

▼ 1. Here are some of the materials and tools needed for this mosaic.

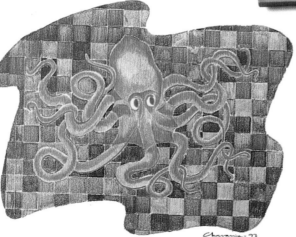

◄ Preliminary sketch drawn in colored pencil. The octopus, a common feature in Roman mosaics, provides an interesting, sinuous motif.

▼ 2. Prepare stoneware clay and lay out rolls of it on a cloth. Join the rolls with your fingers.

▼ 3. Place a 1/4 in. (7 mm) strip of wood on either side of the clay and flatten it with a wooden roller until the clay is the same thickness as the strips of wood.

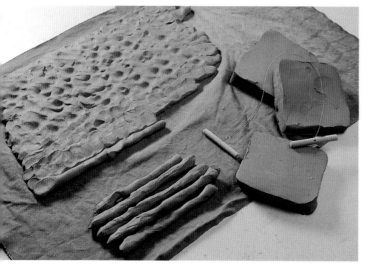

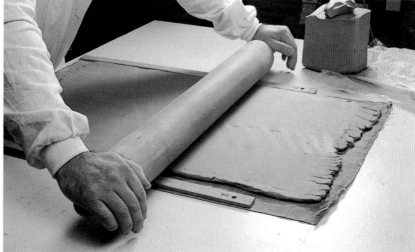

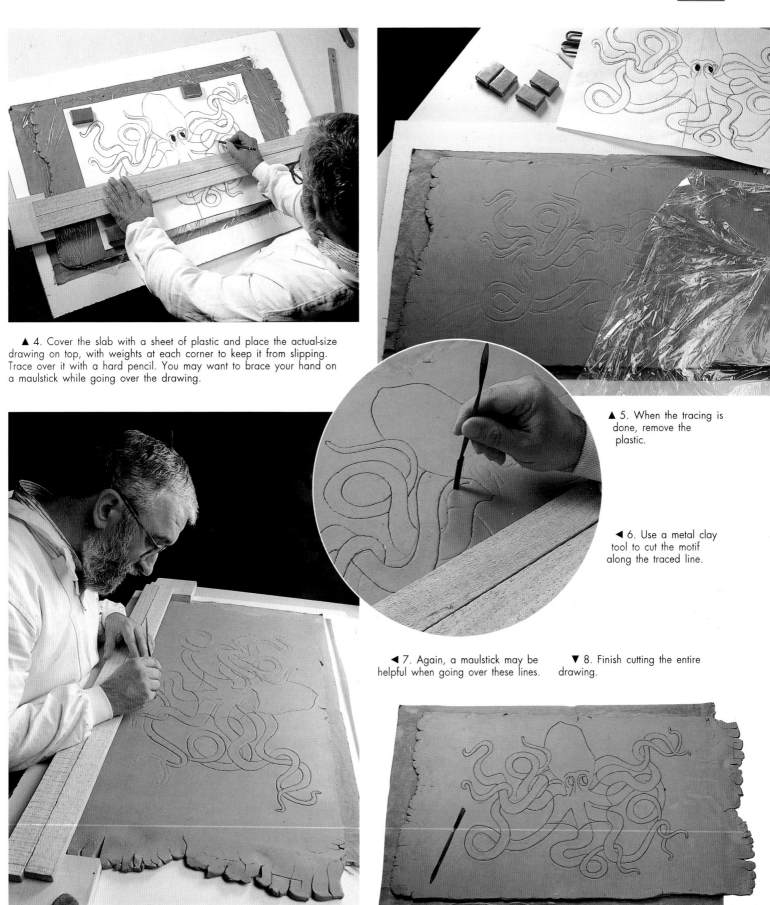

▲ 4. Cover the slab with a sheet of plastic and place the actual-size drawing on top, with weights at each corner to keep it from slipping. Trace over it with a hard pencil. You may want to brace your hand on a maulstick while going over the drawing.

▲ 5. When the tracing is done, remove the plastic.

◄ 6. Use a metal clay tool to cut the motif along the traced line.

◄ 7. Again, a maulstick may be helpful when going over these lines.

▼ 8. Finish cutting the entire drawing.

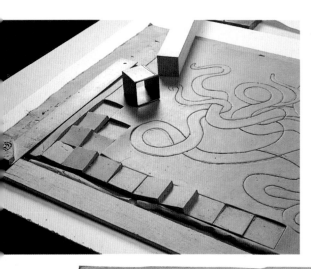

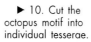

◄ 9. Place a strip of wood on the slab, forming a right angle with an L-square. Begin to cut the background tesserae with a metal die measuring 1 5/8 × 1 5/8 in. (4 × 4 cm).

► 10. Cut the octopus motif into individual tesserae.

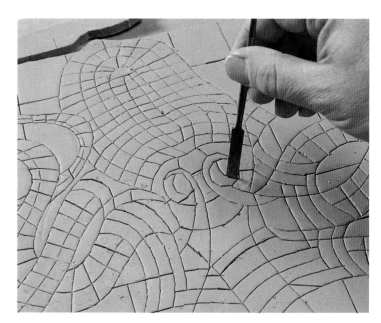

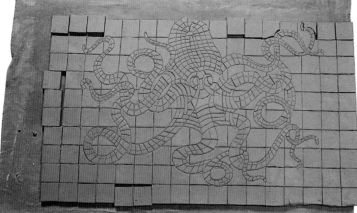

▲ 11. Continue cutting until the whole surface has been segmented.

► 12. Cut out the perimeter of the pond from a thin piece of cardboard and place it on the slab.

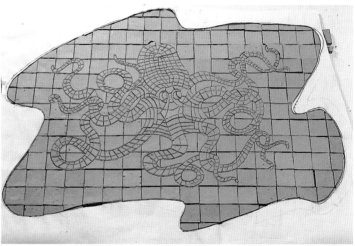

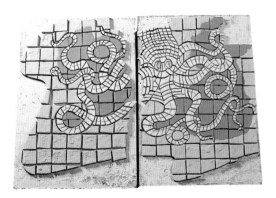

▲ 13. Enameling the slabs. Here the sea blue background color and the octopus have been enameled, though not the light blue.

► 14. The mosaic is placed on firing boards and fired at 2300°F (1260°C). Note that extra tesserae have been made to cover the vertical walls later.

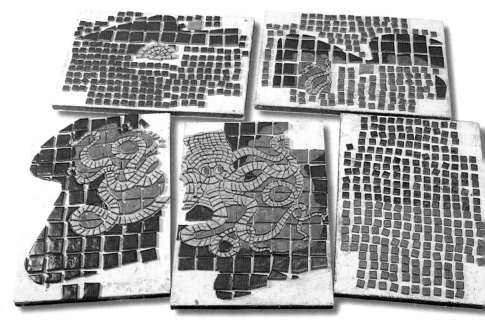

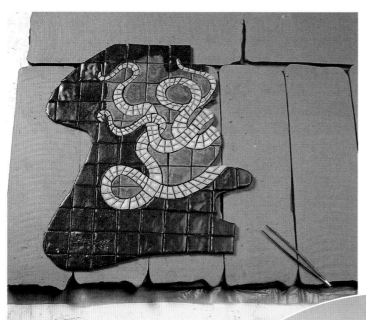

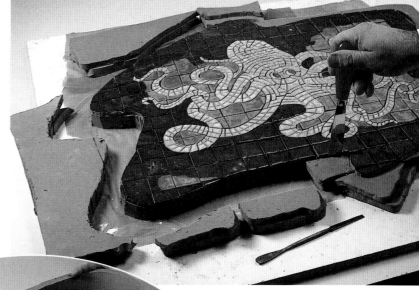

▲ 15. Prepare the provisional base for the mosaic with the stoneware and set it up. The strips are 3/4 in. (2 cm) thick.

▲ 16. Once the mosaic has been mounted, use the scraper to cut away excess material from the provisional base.

▶ 17. Prepare a strip of stoneware 3 1/2 in. (8 cm) high and place it around the mosaic.

▼ 19. Using water-soluble glue and brown kraft paper, cover the vertical tesserae as well as the tesserae that form the base.

▼ 18. Model the outer wall of the pond and begin to lay the tesserae over the vertical wall.

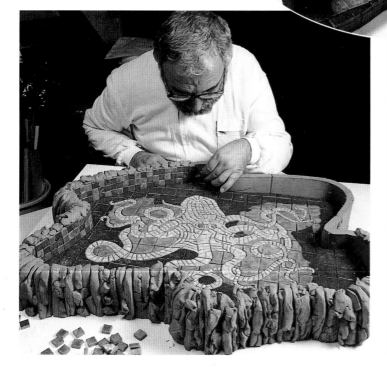

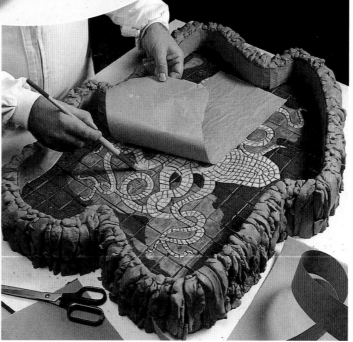

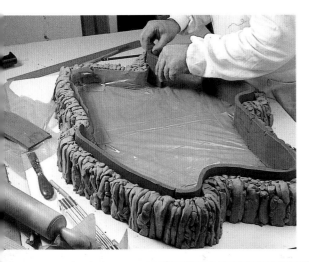

◄ 20. Cover the entire interior with a sheet of plastic and place a 3 1/2 in. (8 cm) strip of clay against the inside wall to separate the different parts of the mold.

► 21. Because of its wavy shape, it's best to divide the pond into several parts. Place partitions to separate the different parts of the mold and prepare plaster tinted with red stain. Spread it over the modeled surface with the scraper until it forms a layer about 3/8 in. (1 cm) thick.

▼ 22. Here you can see that two sections of the mold are covered with tinted plaster, and the other four with white plaster (added in the next step).

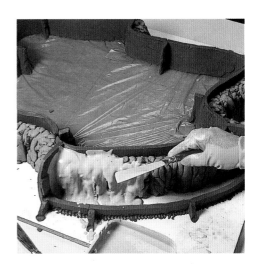

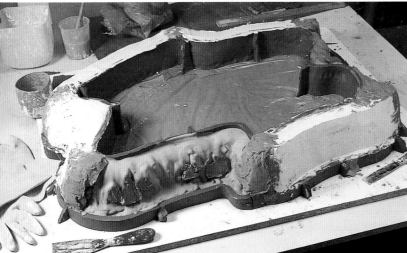

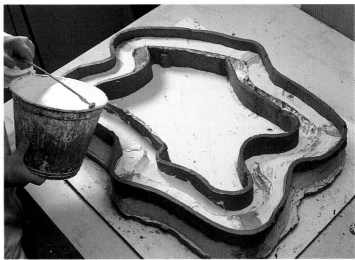

▲ 23. After finishing the outer part of the mold, remove the inner wall of clay and pour a layer of white plaster 3/4 in. (2 cm) thick inside the mold on top of the plastic. Place the strip of clay on top of this layer of plaster, separating it some 1 1/8 in. (3 cm) from the wall. Also place a strip of clay 1 1/8 in. (3 cm) high around the perimeter and apply liquid soap to the upper part of the finished mold. Fill the pond interior within the two strips of clay with the white plaster. This part will be attached to the inner plaster, but not to the outer part due to the soapy surface.

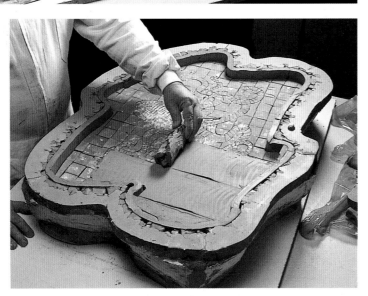

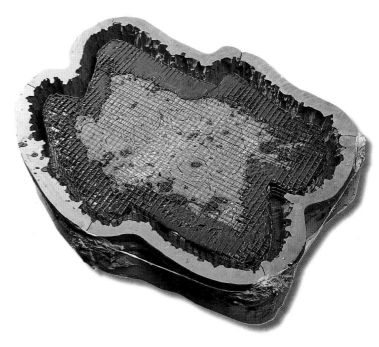

▲ ► 24 and 25. When the plaster has set, remove all the clay and open the mold. Remove any remains of clay from the mold and soap it. Remount the mold and seal the joints with plaster. Also tie a piece of string around the mold to keep it from opening when the mortar is added. Cut wire netting to fit and place this reinforcement on top. Pour in the cement so that it penetrates into the crevices between the tesserae.

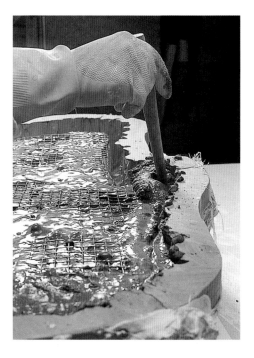

◄ 26. After covering the base, pour mortar around the sides, stirring it with a round stick and making sure it fills in all the relief on the outside of the pond. Fill the base and level it. Let it sit for 72 hours.

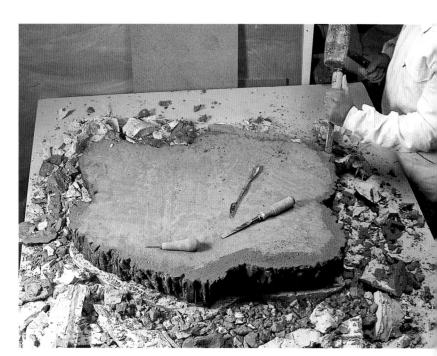

► 27. After that time, break open the mold. First remove the white plaster and then the colored plaster that covers the walls.

Joaquim Chavarria. *Pond,* 1997. Tesserae modeled from stoneware and enameled, 30 × 23 × 4 in. (76 × 58 × 10 cm).

▼ 28. The finished piece is quite striking.

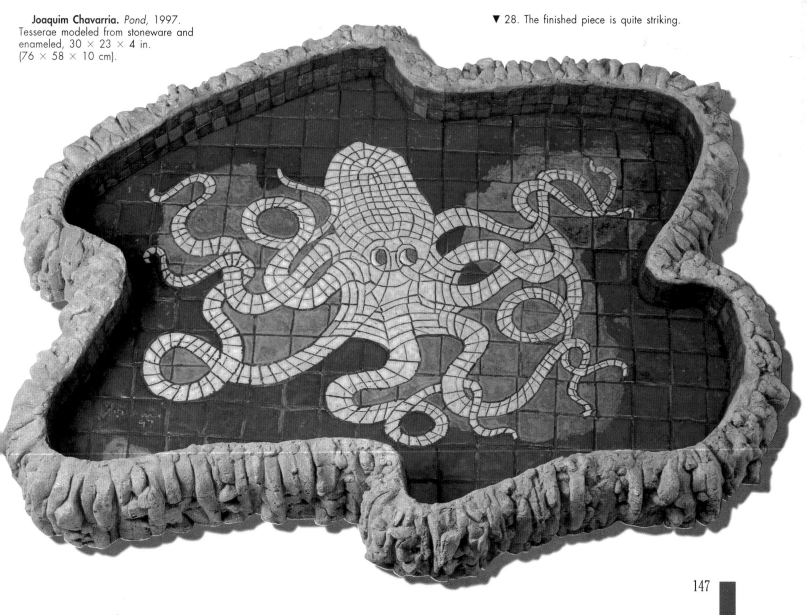

Paving Mosaic Using the Indirect Method, Reverse Technique

Paving mosaics require hard-wearing materials to endure being walked on. The best choices are stones such as marble and granite or, as in this case, stoneware tiles. Two methods can be used for creating paving mosaics: the direct and indirect method (reverse technique). This project uses the second method, which allows for the preparation of large-scale slabs that are still manageable and can be placed in the ground more quickly and easily. I have used both an electric and a hand cutter for this work, depending on the size and shape of the tesserae.

The only part of the mosaic prepared here is the *emblema*—the main motif of the mosaic. The entire mosaic, which covers a floor area approximately 15 ft. x 10 1/2 ft. (450 x 320 cm), is shown in the watercolor below. The proportions of both the emblem and the entire mosaic are based on the harmonic rectangle.

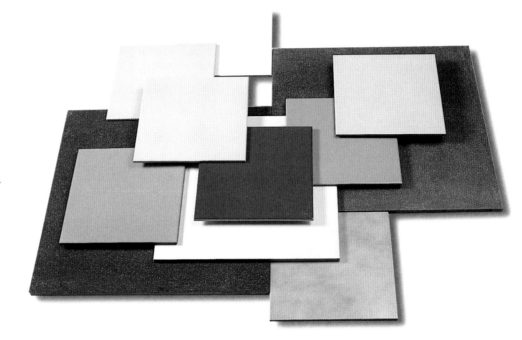

▲ 1. These are the stoneware tiles that will be used for this mosaic.

◄ ▼ 2 and 3. Place a piece of brown kraft paper and carbon paper under the drawing and trace over it with a hard pencil.

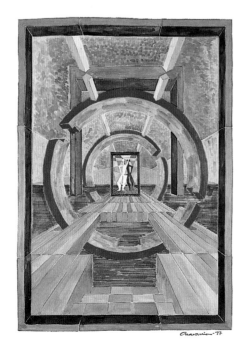

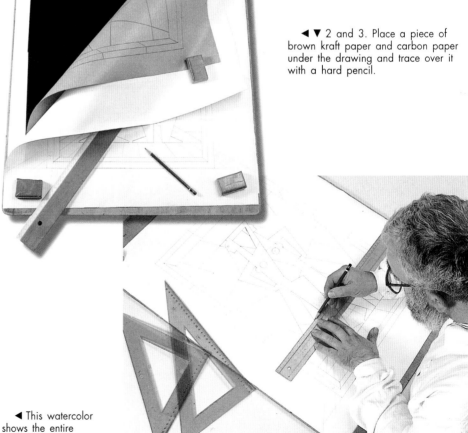

◄ This watercolor shows the entire design.

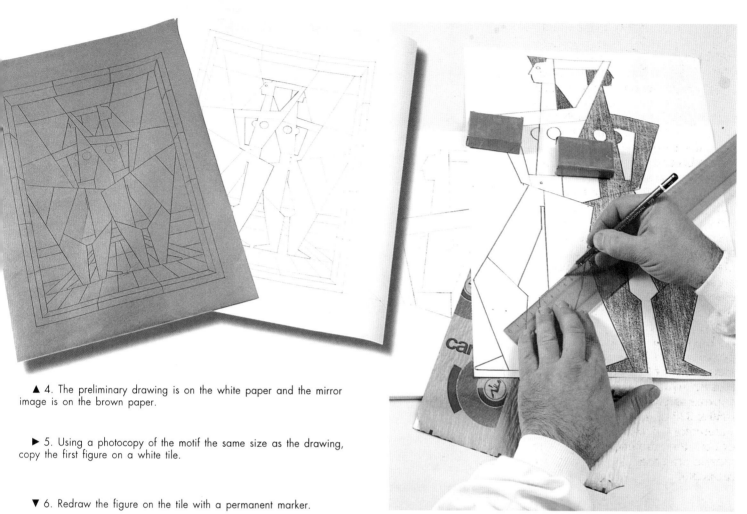

▲ 4. The preliminary drawing is on the white paper and the mirror image is on the brown paper.

▶ 5. Using a photocopy of the motif the same size as the drawing, copy the first figure on a white tile.

▼ 6. Redraw the figure on the tile with a permanent marker.

▶ 7. Use the electric cutter to split the tile between the two halves of the figure.

▼ ▶ 8 and 9. Begin to cut out the figure by gradually removing the rest of the tile, then cut the tesserae that form the figure.

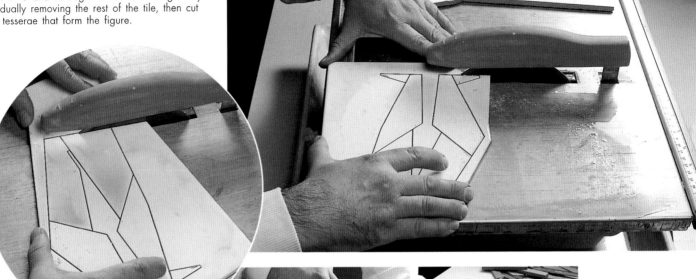

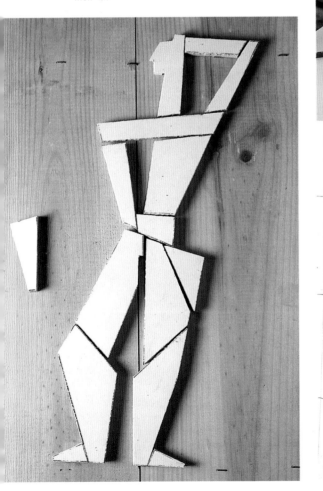

▼ 10. Once all the tesserae for the first figure have been cut, place them together to check their fit.

◀ 11. Cut the tesserae for the black figure.

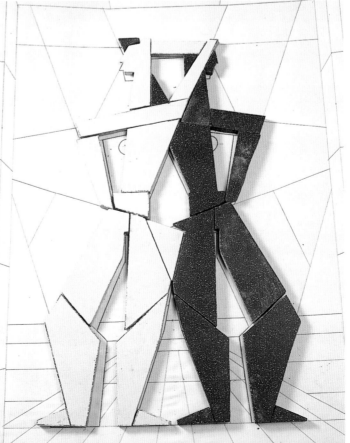

◀ 12. Place the two figures on the drawing.

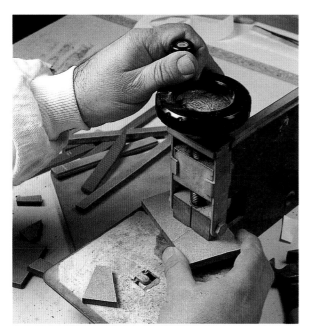

◀ 13. Center an ochre-colored tile (for the figures' foreground) in the cutter to snap it along the cutting line scored with a manual cutter.

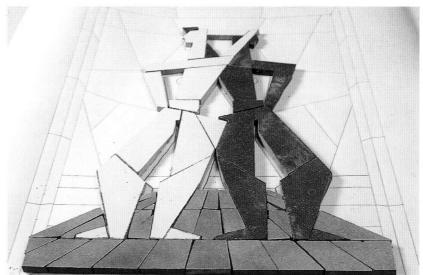

▲ 14. Position the ochre tesserae on the drawing.

◀ 15. Continue the process, next laying the dark blue tesserae.

▶ 16. Here I am cutting the light blue tile with the electric cutter.

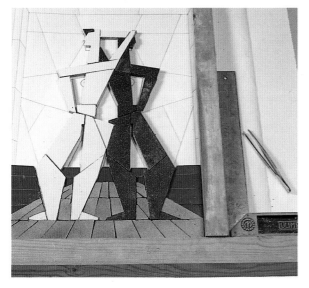

▼ 17. All the tesserae, except for the frame area, have now been laid out on the drawing.

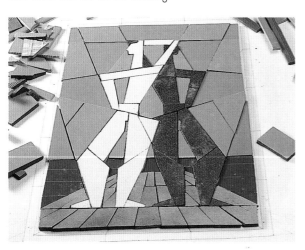

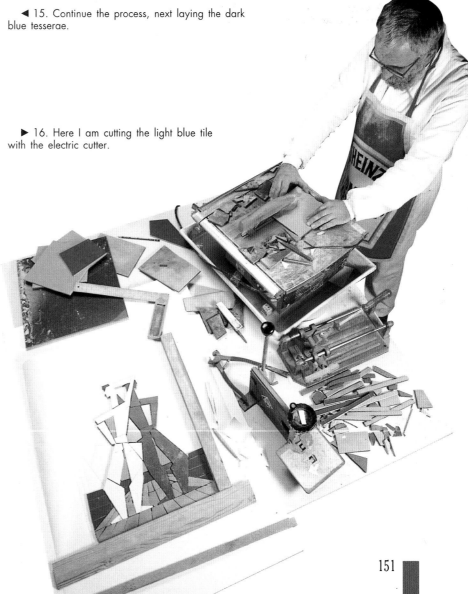

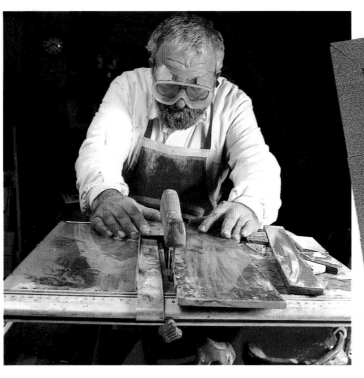

▲ 18. Use the electric cutter to cut strips of shiny black stoneware to form the tesserae for the interior of the frame. Remember to use safety goggles.

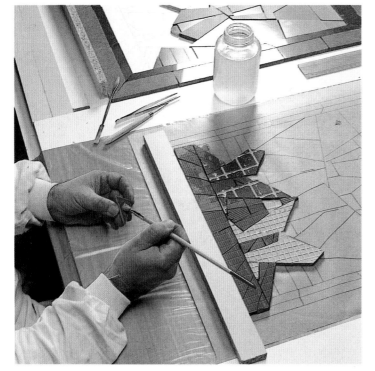

▲ 19. With the frame in position, the first stage of the mosaic is complete.

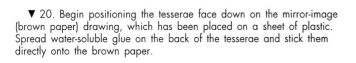

▼ 20. Begin positioning the tesserae face down on the mirror-image (brown paper) drawing, which has been placed on a sheet of plastic. Spread water-soluble glue on the back of the tesserae and stick them directly onto the brown paper.

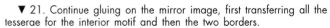

▼ 21. Continue gluing on the mirror image, first transferring all the tesserae for the interior motif and then the two borders.

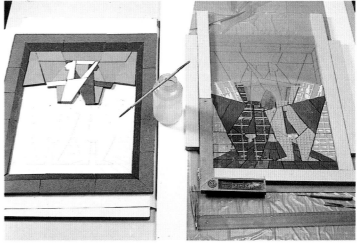

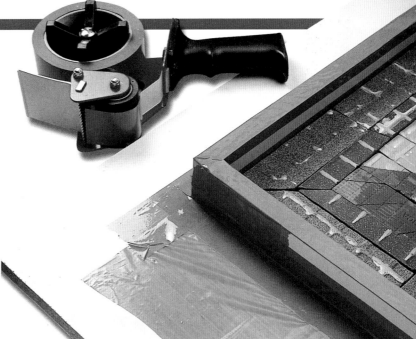

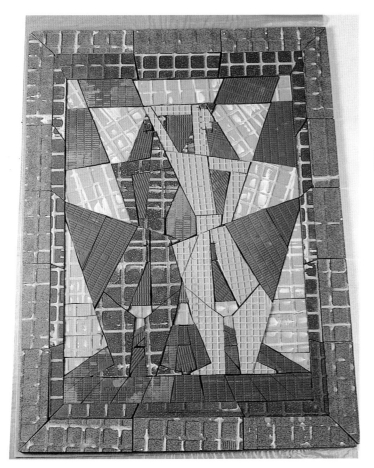

▲ 22. The reversed mosaic is now complete.

▲ 23. Prepare a wooden frame to fit snugly around the mosaic. Waterproof it with plastic packing tape and set it around the mosaic. Use the same tape to seal the entire outer perimeter so that the water does not leak out.

▼ 25. Prepare the mortar and spread it on the mosaic with a trowel, making sure it penetrates the joints between the tesserae.

▼ 24. Prepare the reinforcement with steel wire netting. Dampen the surface of the mosaic with the plant mister so that the mortar will adhere well.

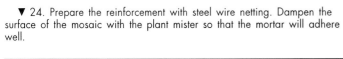

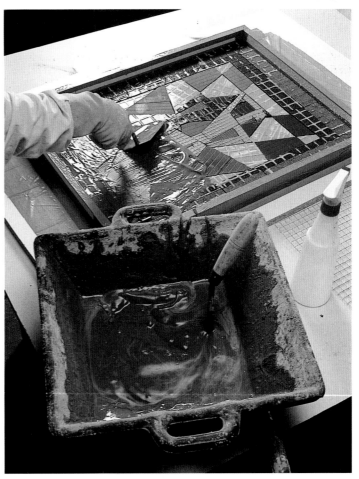

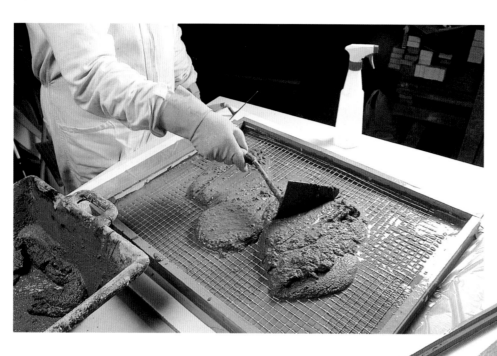

◀ 26. Place the reinforcement on the mosaic and add more mortar, spreading it with the trowel until it forms a layer 1 in. (2.5 cm) thick.

▼ 27. Allow the mortar to set for three days. Keep it damp during this time by placing a damp cloth and a sheet of plastic over it.

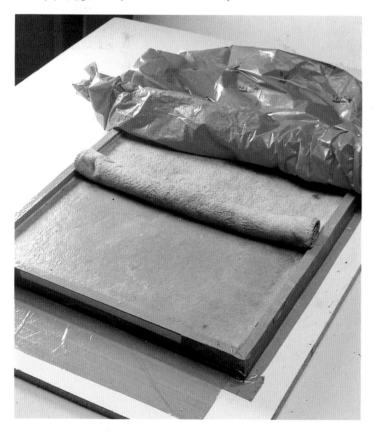

▲ 28. Cut the strips of tape that seal the frame and open it.

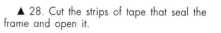

▶ 29. Remove the brown paper covering the mosaic. It should peel off easily since the dampness of the mortar dissolves the glue. Remove any remains of the mortar from the mosaic and clean it with a sponge.

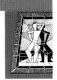

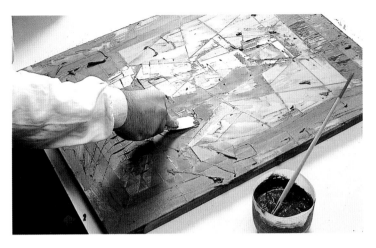

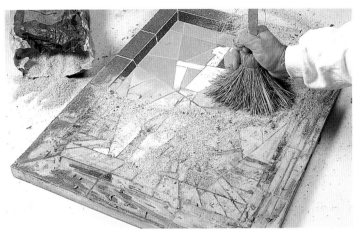

▲ 30. Prepare a little cement and fill in the joints with the scraper. Let dry.

▲ 31. Sprinkle fine, dry sawdust over the mosaic and remove any remaining mortar with a hard brush.

◄ 32. The piece is finished.

Joaquim Chavarria. *Emblema,* 1997. Stoneware tesserae, 25 × 19 × 1 in. (64 × 48 × 2.5 cm).

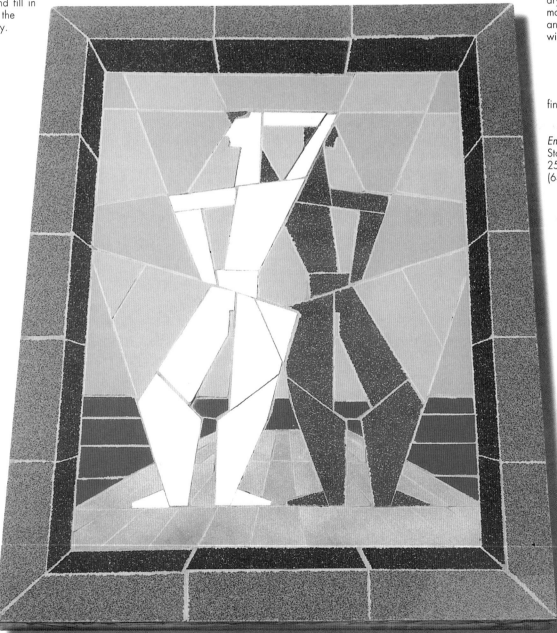

GLOSSARY

A

Alae. Roman living room opening onto the *atrium* on either side of the *tablinium.*

Atrium. Roman interior patio with a pond or *impluvium.*

B

Border. Ornamental surround for walls, pavements, and ceilings.

Brick paving. Pavement composed of bricks.

Bust. Artistic representation of the head and upper shoulders.

C

Cartoon. Actual-size design for a project.

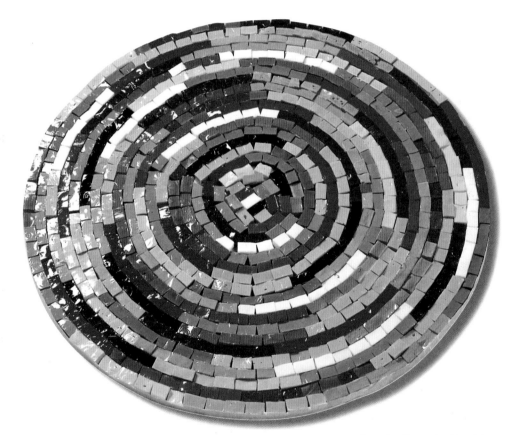

▲ **Joaquim Chavarria.** *Mandala,* 1987. Smalti on glass base, 16 in. (40 cm) diameter.

Cement. Substance used in the making of concrete or to fill the joints between tesserae; can be tinted to a particular color.

Ceramic paste. Mixture of different clays, minerals, and other nonplastic materials.

Checkered. Formed of squares in alternating colors.

Cobble. Small stone cut into a rectangular shape used for paving streets and roads.

Compluvium. Open space on the roof of an *atrium* that allows the rainwater to fall into the *impluvium*.

Concrete. Mixture of cement, gravel, sand, and water becomes extremely hard when set.

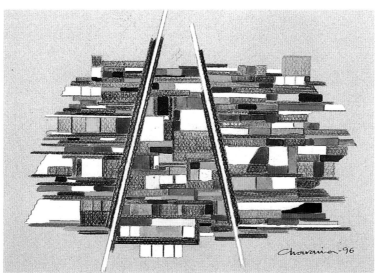

▲ Design for *Via Vitae* wall mosaic. Lead pencil, colored pencil, and watercolor.

D

Die. Sharp-edged tool in a particular shape for cutting out small pieces of thin clay or other soft material.

Draft. Preliminary sketch or study for a work, smaller than the actual mosaic will be but which defines the composition and colors.

Dry positioning. Placing the tesserae without applying any form of glue or adhesive.

E

Embed. To press a material into a surface.

Enamel. Finely ground glass, colored with oxides and smelted and then used as a paste to lend shine or color to a surface.

Exedra. Roman discussion room containing benches, opening onto the *peristile*.

F

Fillet. Fine ornamental line.

First firing. Initial firing of clay to harden the pieces before glazing them.

Flash. The rough edge left after cutting.

Frame. Removable mold that keeps mortar and/or concrete from running out while it sets.

Fretsaw. Very fine saw used in marquetry, jewelry, and for cutting precious stones.

Front. The main side of an object (the opposite of back).

G

Gravel. Very small broken stones, used for making concrete.

Grout. Mixture of lime, plaster, and cement that is place between the tesserae for extra strength; can be tinted to a particular color.

H

Harmonic rectangle. Rectangle with the proportions of the "golden section," a ratio of roughly three to five, measured in regard to the portion of the diagonal that would form a square within the rectangle.

I

Impluvium. Rectangular or square pond in the *atrium* of a Roman house for collecting rain water.

Insert. To introduce one item into another.

J

Joint. Crevice between tesserae, which may or may not be filled in, or pointed, depending on the design of the mosaic and its intended purpose. Filling the joints creates a contrast with the mosaic, and strengthens it. Cement or grout is used, both of which can be colored.

▲ Octopus pool filled with water.

Outline. Set of lines that define the profile of a figure or composition.

P

Paving. Artificial surface to provide a firm, solid support for walking.

Peristile. Interior courtyard of a Roman house, surrounded by columns.

Plasticine. Modeling clay made from natural clay and mineral oil; does not harden.

K

Kufic. Type of ancient Arabic writing with stiff, angular features, used as an ornamental motif.

L

Latericium. Work laid with bricks.

Leveler. Straight-edged object made of wood or other material used for leveling off a surface.

Log. Section of a tree trunk.

M

Maulstick. Long wooden stick braced on two supports against which to steady the hand while painting or drawing.

Melamine board. Wood with a plastified surface.

Model. Scale reproduction of a three-dimensional work.

Mold. Piece that forms a negative image of the desired figure.

O

Omeya. Arabic dynasty that combined Syrian, Coptic, and Byzantine art forms, the main example of which is the mosque, a structure often heavily decorated with mosaics.

Orle. Ornamental border that surrounds a shield without touching its edges.

▼ Line drawing for *Temple*. India ink.

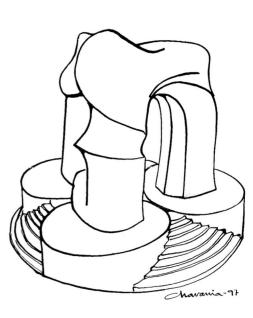

Pliny the Elder. Roman writer (23–79) whose outstanding works include the *Natural History,* which had a great influence on scientific and medical developments in Europe.

Preliminary sketch. Drawing or watercolor, generally smaller than the actual piece, that displays the projected idea for a mosaic and acts as a reference point during the work's development.

R

Red earth. Clay containing a large proportion of red (iron) oxide.

Reinforcement. Rigid structure formed by placing iron, steel rods, or wire netting inside a mold to strengthen the concrete.

Relief. Form of figure that stands out from the surface.

S

Scutula. Rhombus-shaped tessera.

Setting. The hardening of mortar, plaster, cement, or the like.

Sketch. Rough drawing showing the overall composition, without unnecessary detail.

Slab. Thin, flat piece of stone, clay, or other material.

Slanted. Cut at an oblique angle.

▲ Design for *Emblema.* Lead pencil and colored pencil.

Sledge hammer. Iron mallet with a long handle used for breaking stones.

Smalti. Small pieces of colored glass formed from glass paste.

Stoneware. Glazed ceramic material in which the clay and the glaze have fused, producing a vitreous, nonporous substance after firing at a temperature of over 2200°F (1200°C).

Stucco. Lime paste, washed sand, powdered marble, and casein, mixed in varying proportions.

T

Tablinium. Room in a Roman house located between the *alae* and the *atrium.*

Tarlatan. Starched muslin used in indirect laying.

Triclinium. Roman dining room equipped with couches (usually three, hence the name), on which diners reclined while eating.

Trough. Container for mixing cement, mortar, or the like.

Tufa. Limestone of volcanic origin, highly porous, light, and with a spongy appearance.

W

Wall mosaic. Artistic work in mosaic specifically designed to be mounted on a wall, either indoors or outdoors.

Warp. Twisting or bending of wood; generally to be avoided.

Selected Bibliography

Barral Altet, Xavier. *Els mosaics de paviment medievals a Catalunya.* Barcelona: Art Romànic, 1979.

Bertelli, Carlo. *Les Mosaïques.* Paris: Bordas, 1993.

Garcia Bellida, Antonio. *Arte Romano,* vol. 1 of *Enciclopedia Clásica.* Madrid: Higher Scientific Research Council, 1955.

Maltese, Corrado, et al. *Técnicas Artísticas.* Madrid: Ediciones Cátedra, 1980.

Papadopoulo, Alexandre. *El Islan y el Arte Musulmán.* Barcelona: Gustavo Gili, 1977.

Pijoan, Josep. *Summa Artis,* vols. 2 and 7. Madrid: Espasa Calpe, 1954.

Polvin, Manon. *L'Image Fragmentée.* Paris: Musée du Louvre, 1994.

Woods, Robert. *Pre-Columbian Art.* New York: Phaidon Publishers, 1957.